Expressions

Expressions

JOSE REYES

Copyright © 2016 by Jose Reyes.

Library of Congress Control Number:		2016904430
ISBN:	Hardcover	978-1-5144-7614-7
	Softcover	978-1-5144-7613-0
	eBook	978-1-5144-7612-3

All rights reserved. No part of this book may be reproduced or transmitted in any form or by any means, electronic or mechanical, including photocopying, recording, or by any information storage and retrieval system, without permission in writing from the copyright owner.

Any people depicted in stock imagery provided by Thinkstock are models, and such images are being used for illustrative purposes only. Certain stock imagery © Thinkstock.

Print information available on the last page.

Rev. date: 03/23/2016

To order additional copies of this book, contact:
Xlibris
1-888-795-4274
www.Xlibris.com
Orders@Xlibris.com
738511

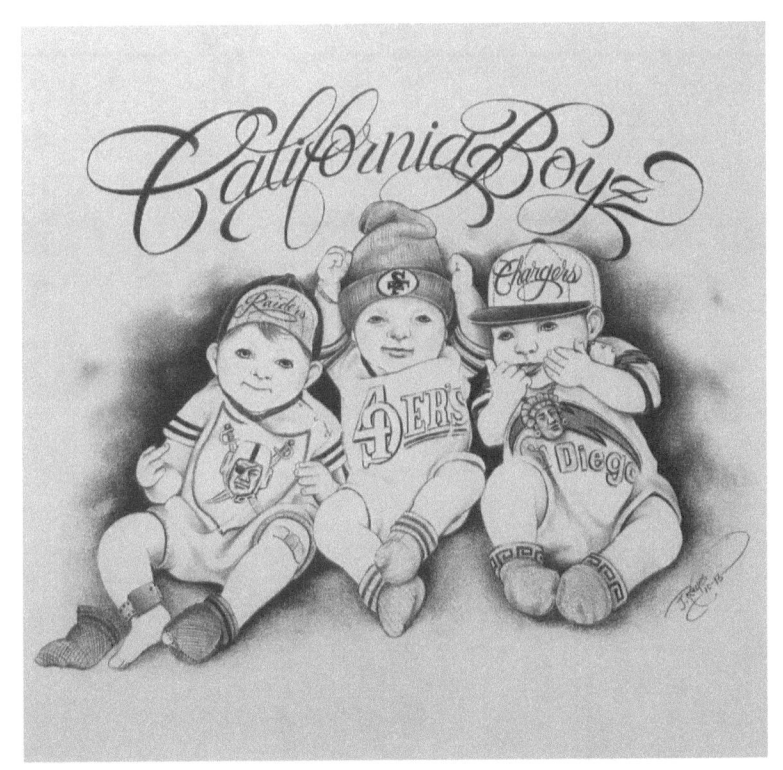

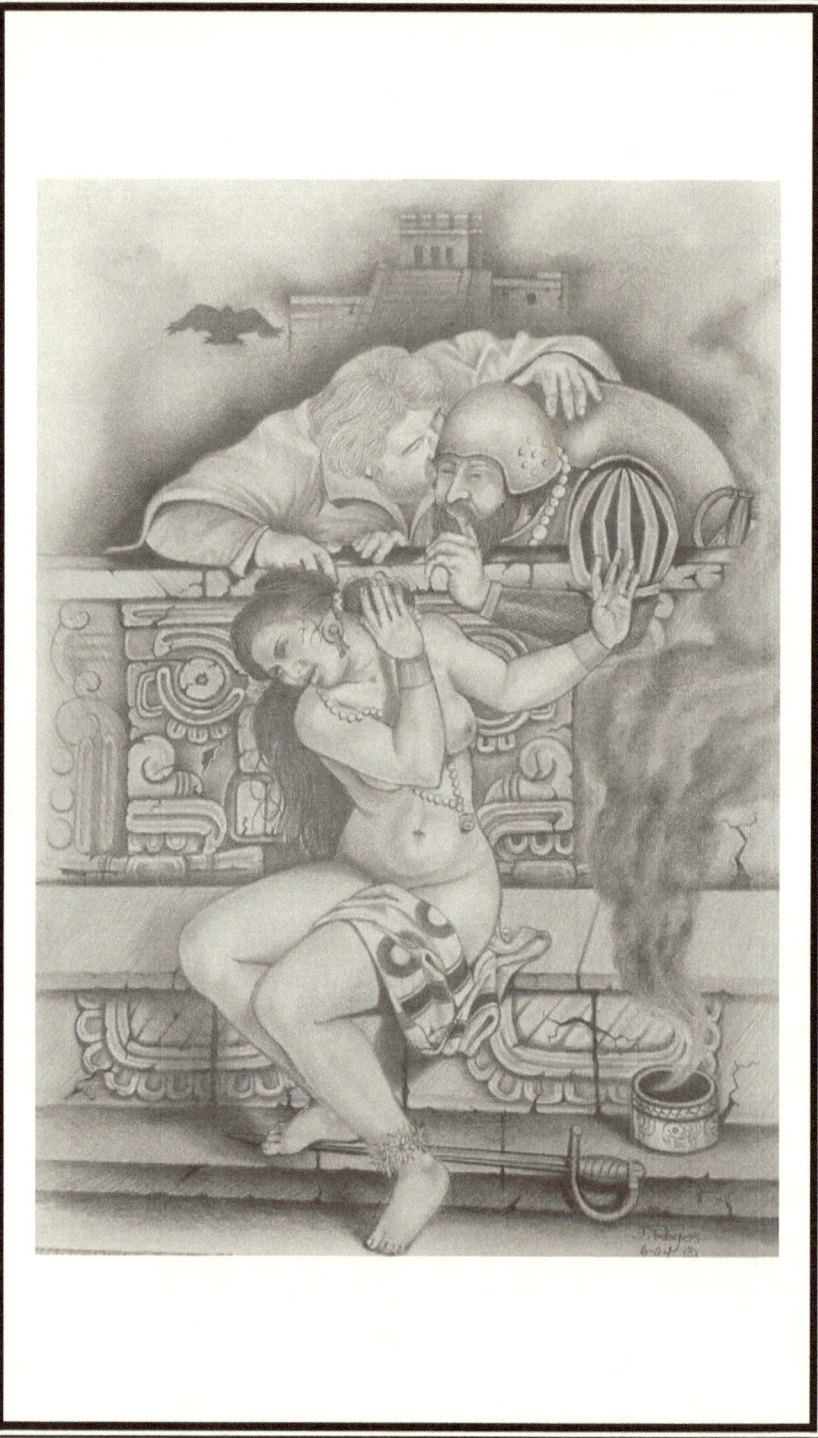

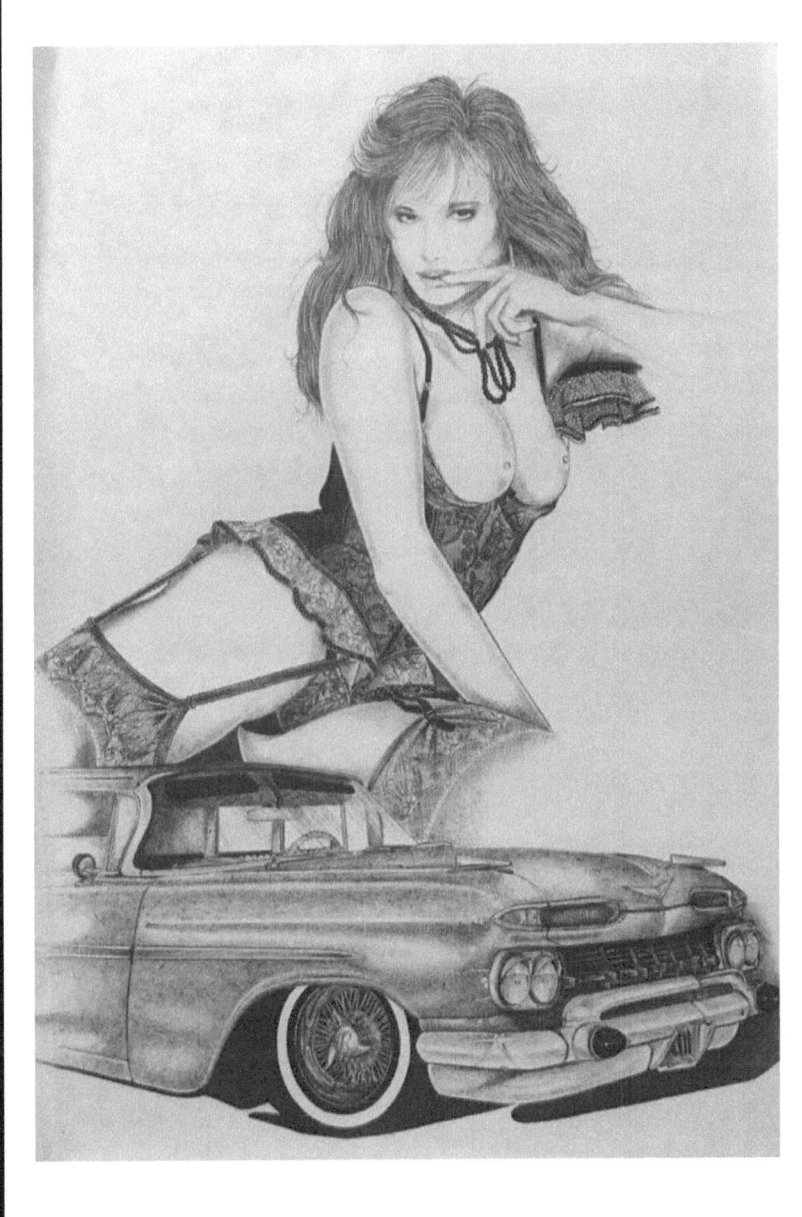

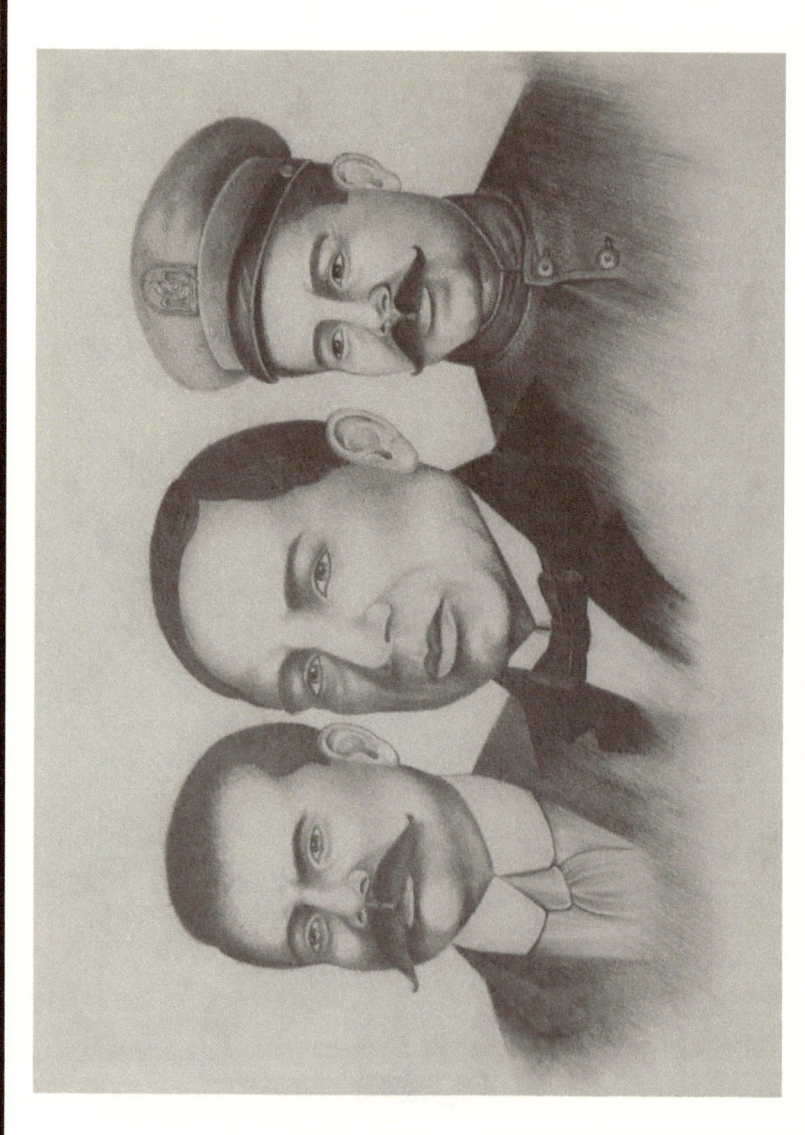

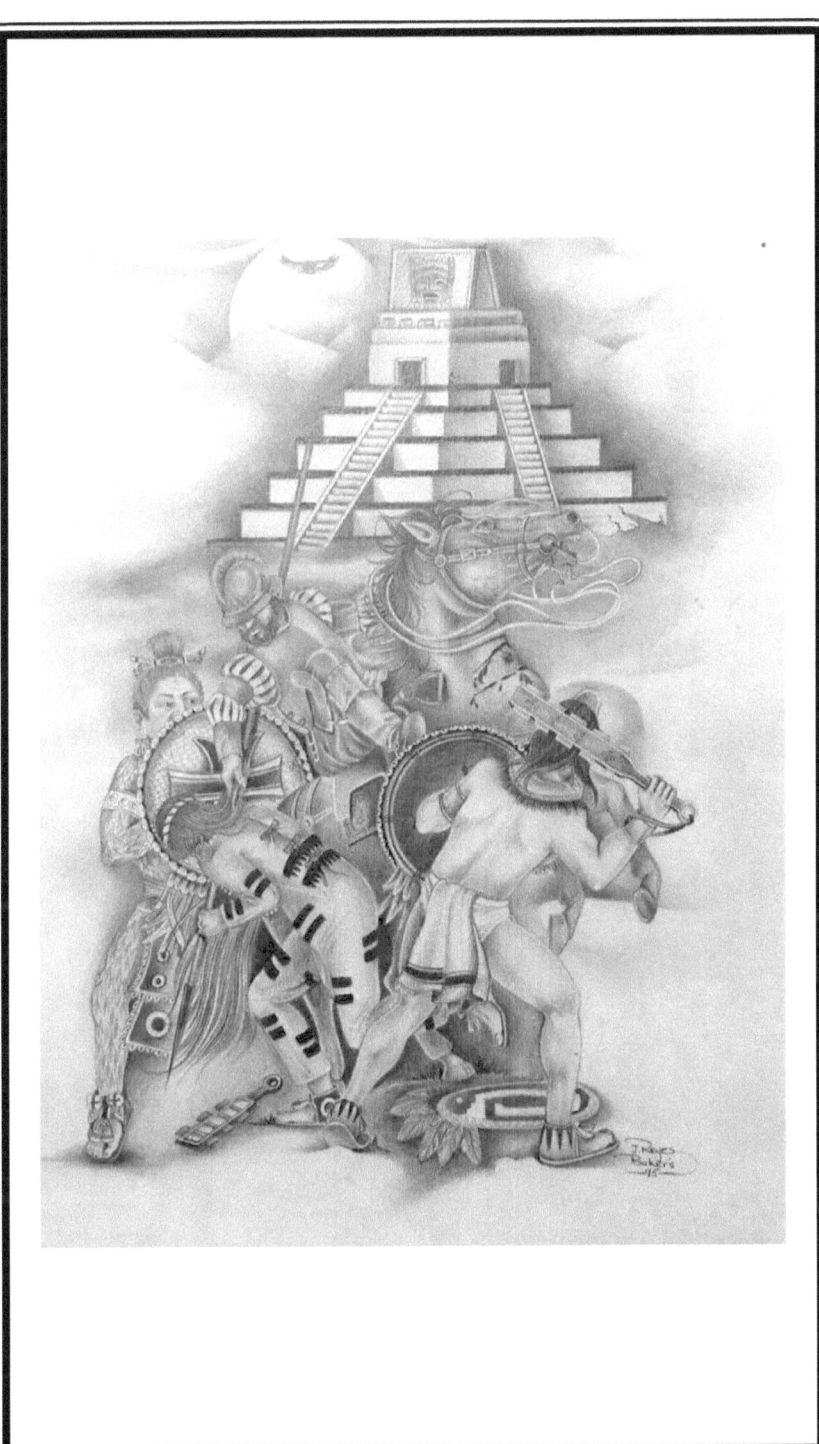

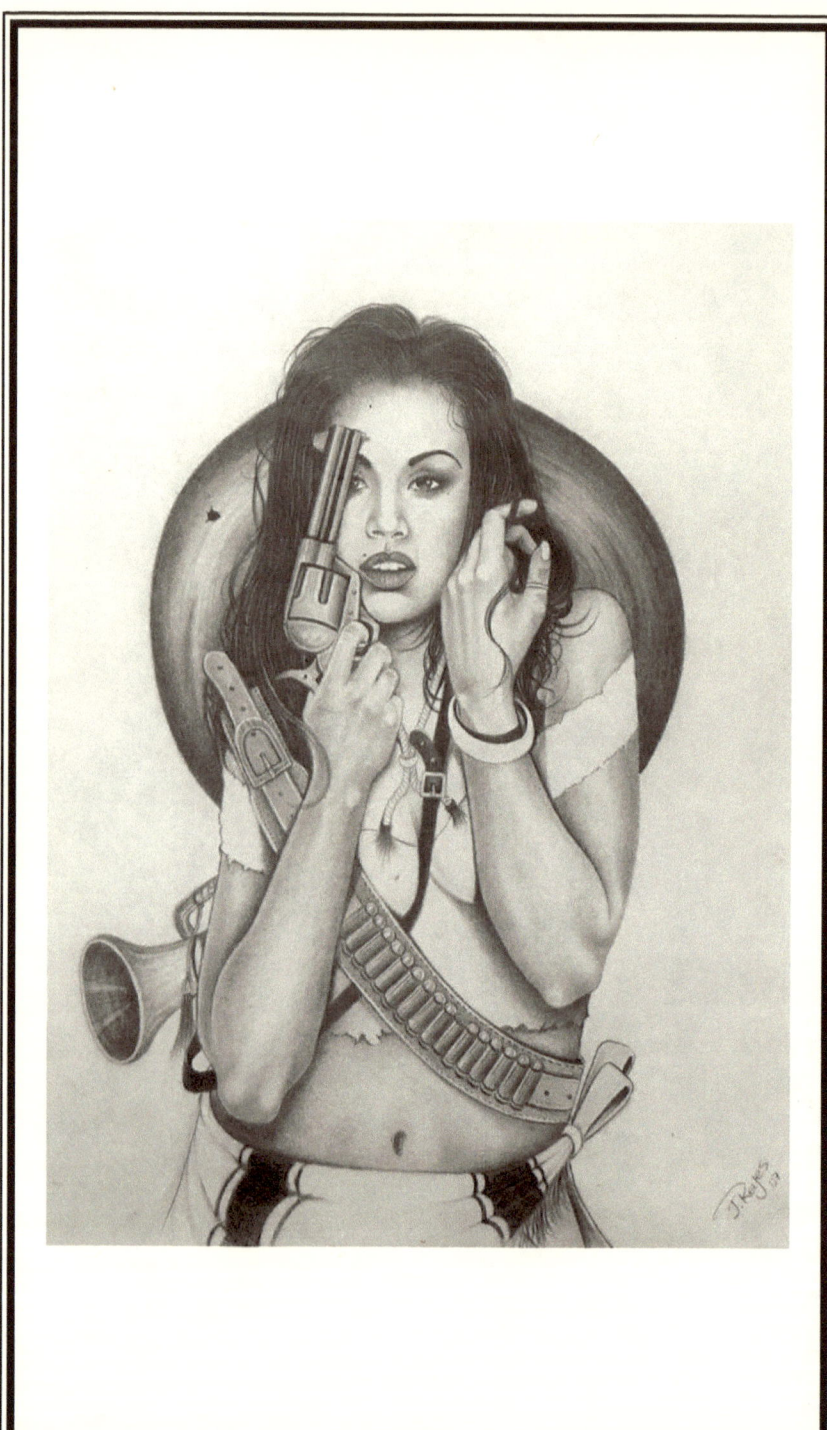

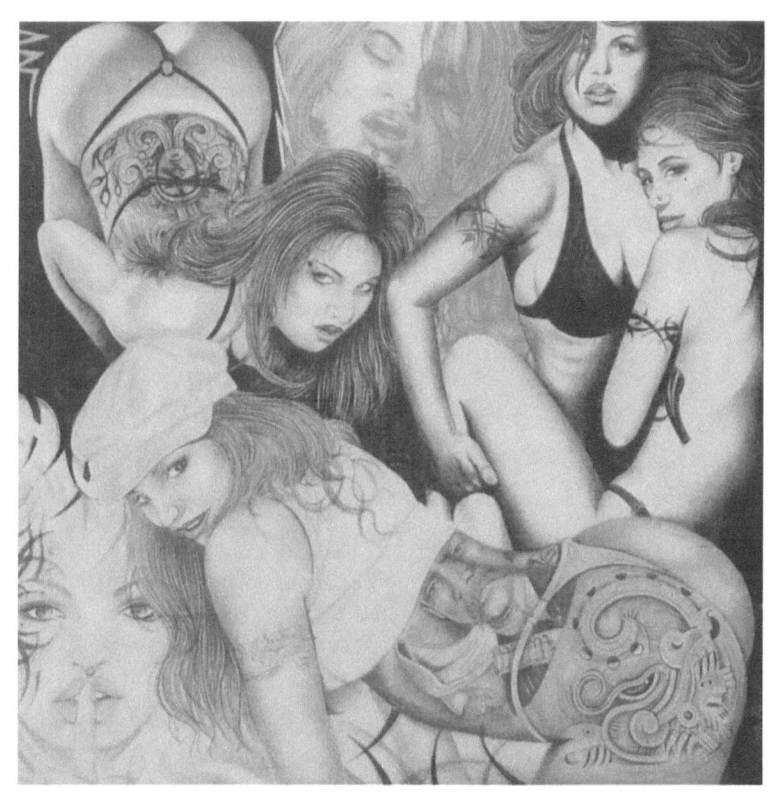

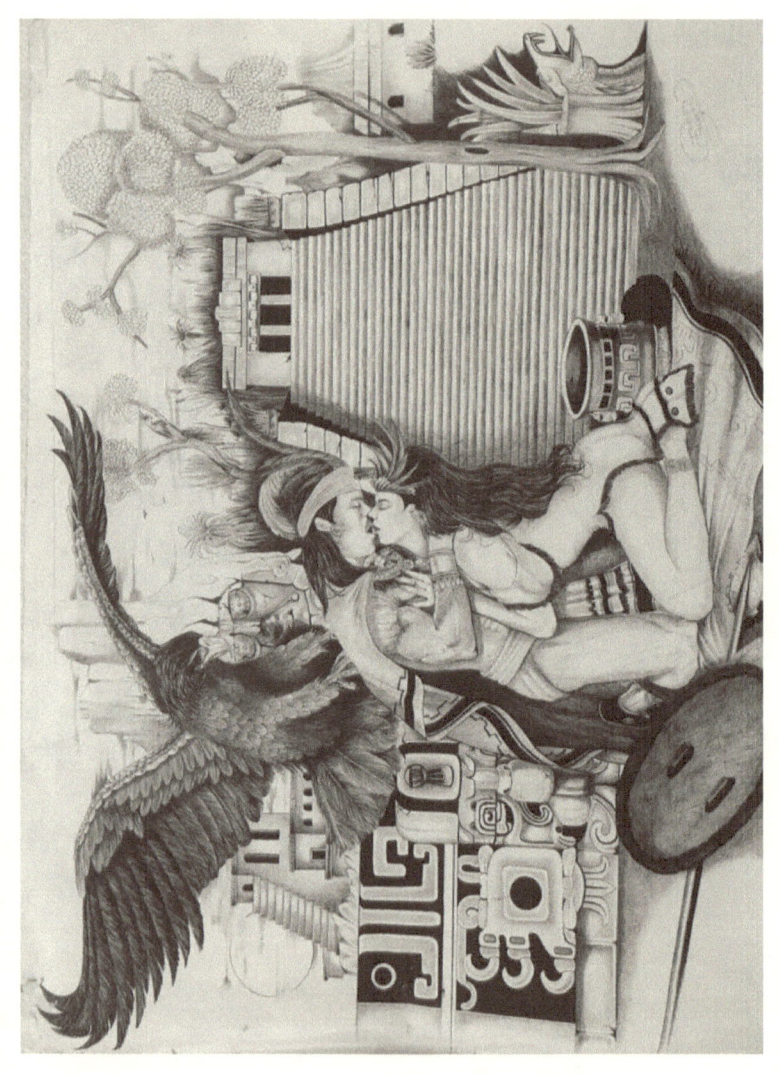

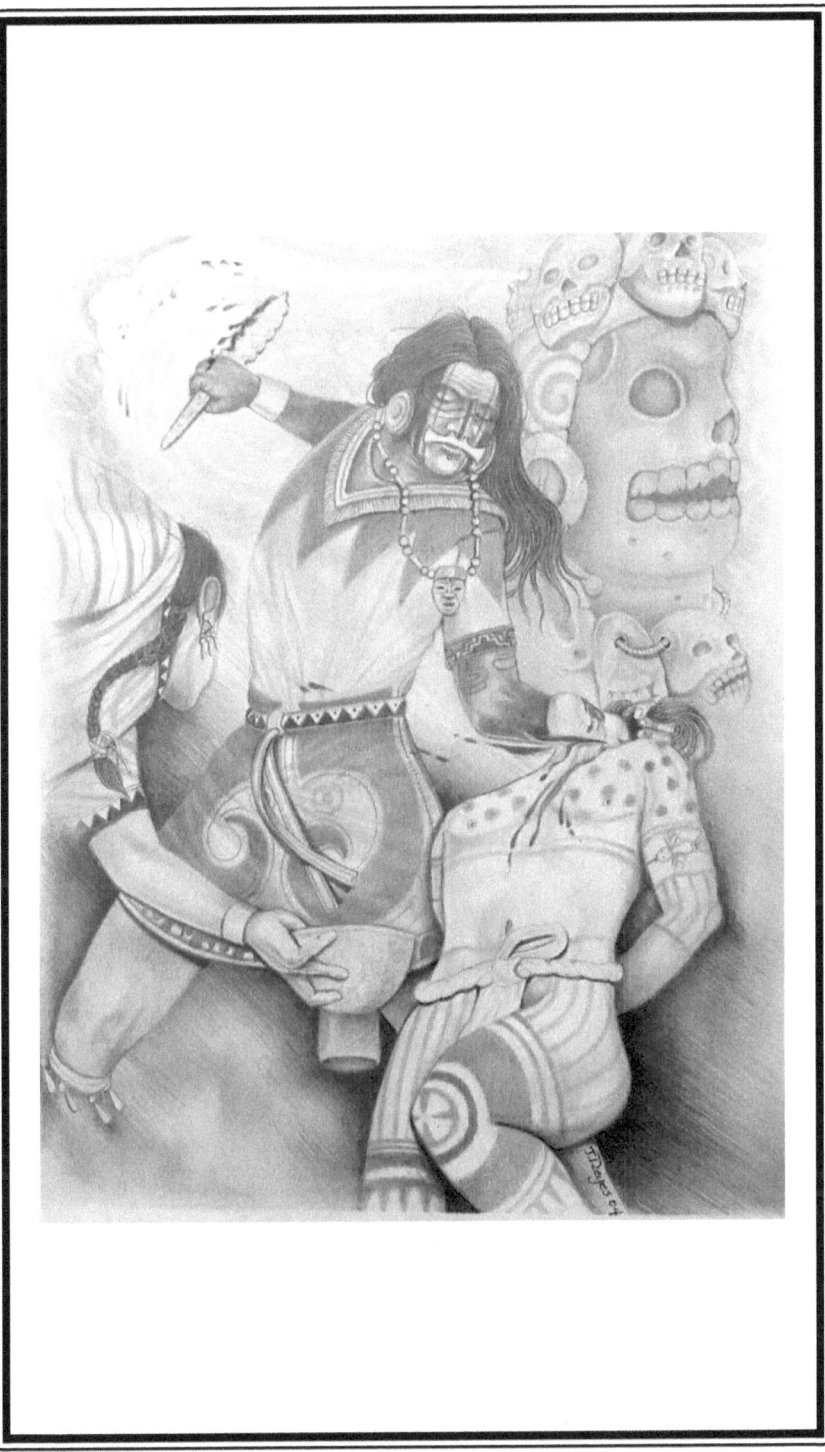

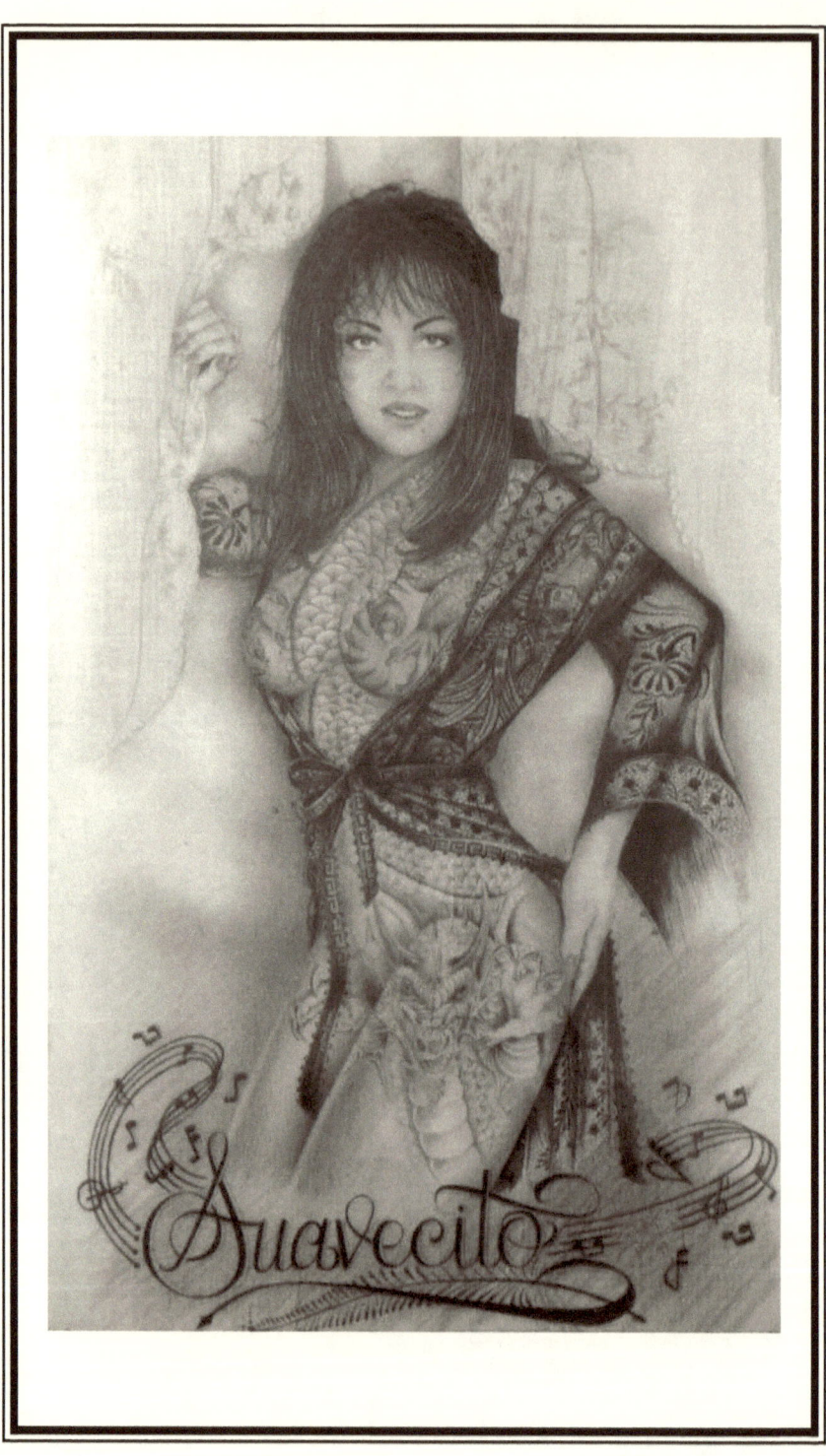

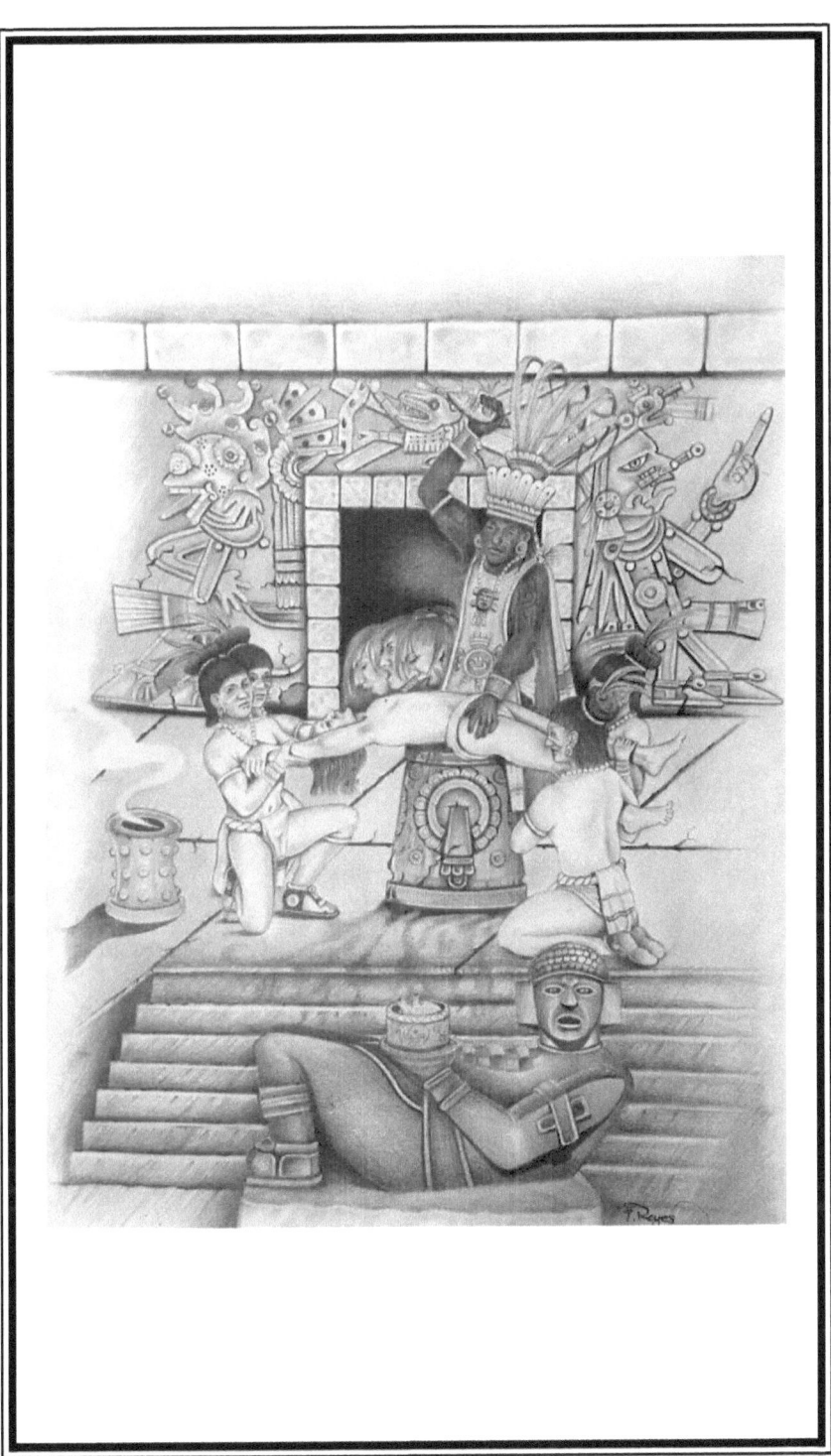

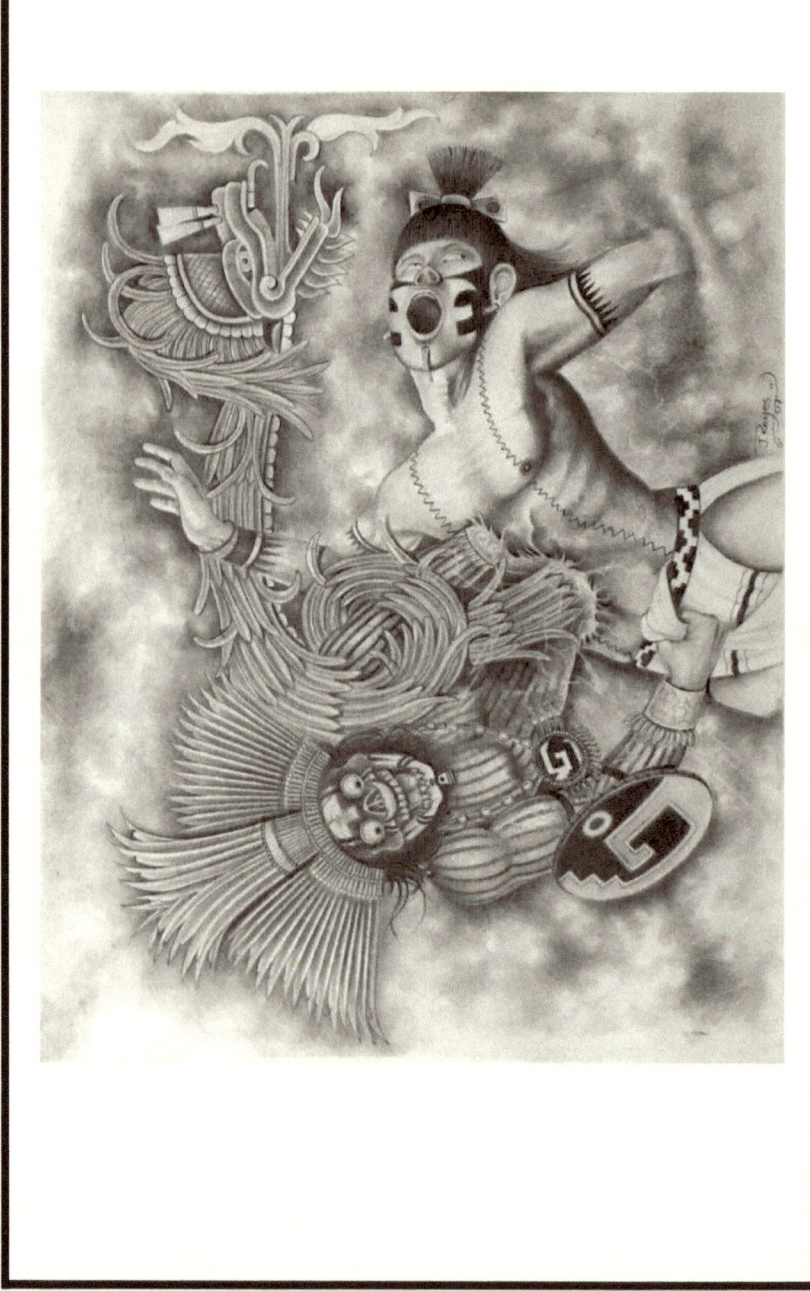

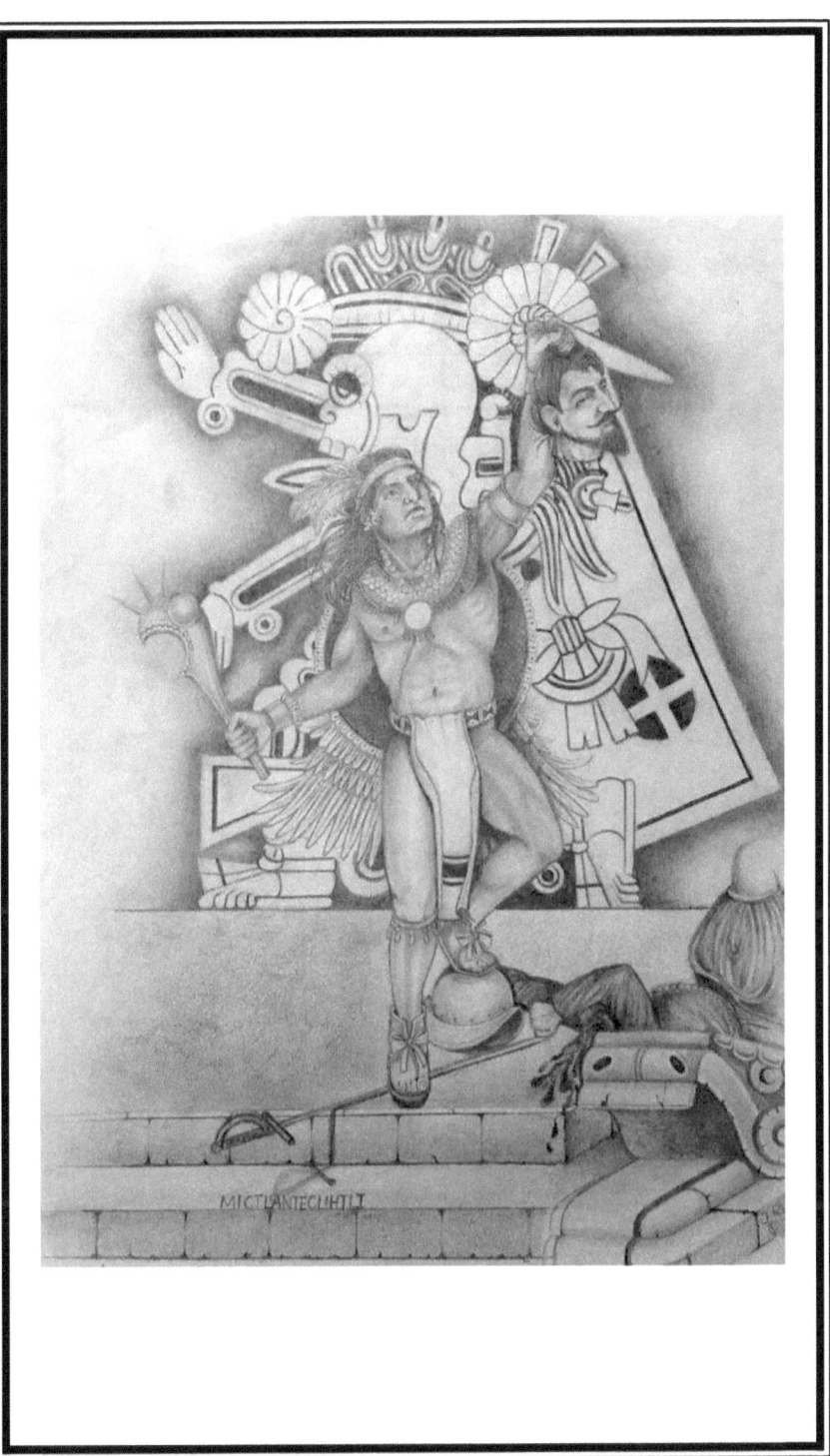

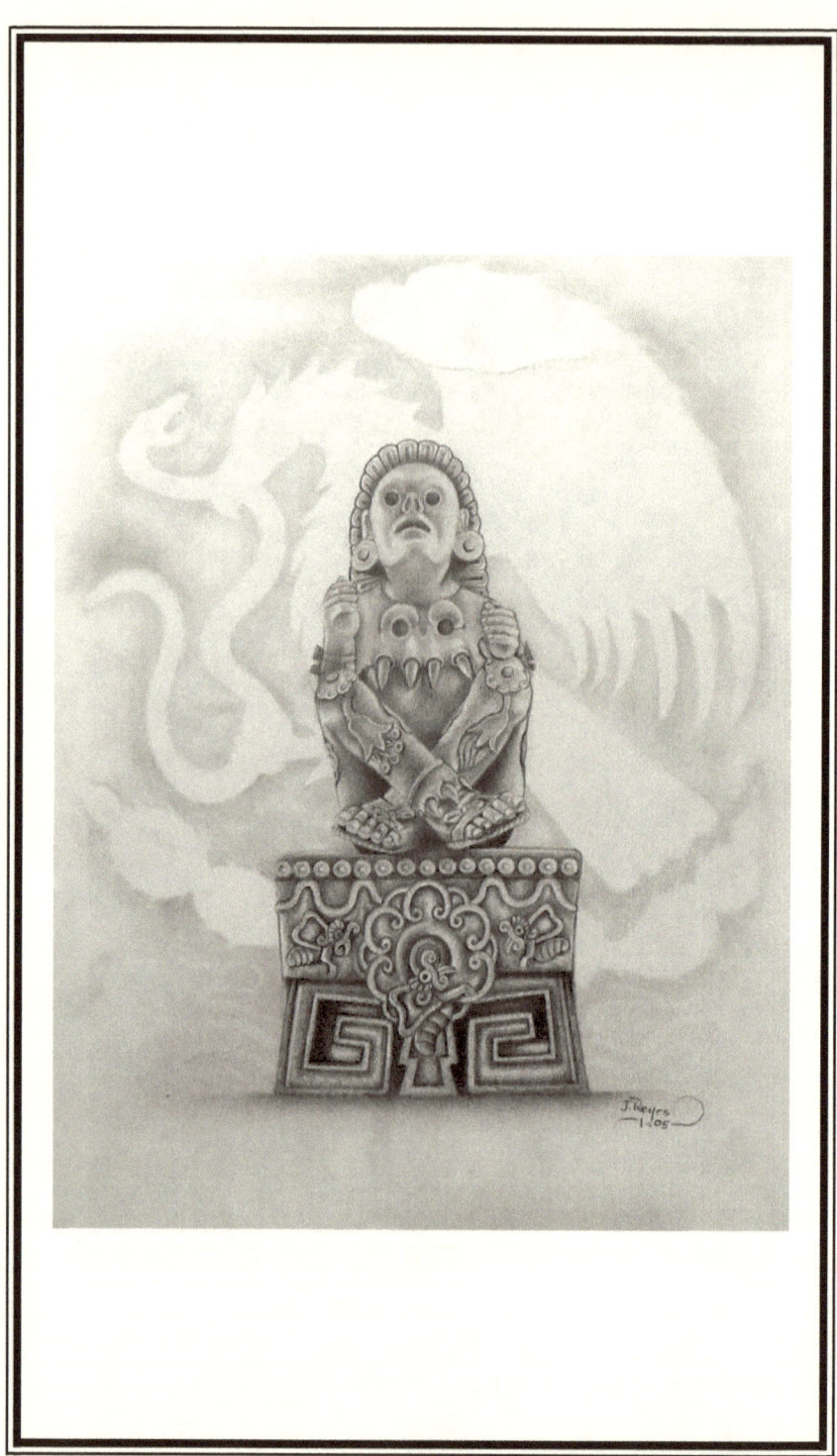

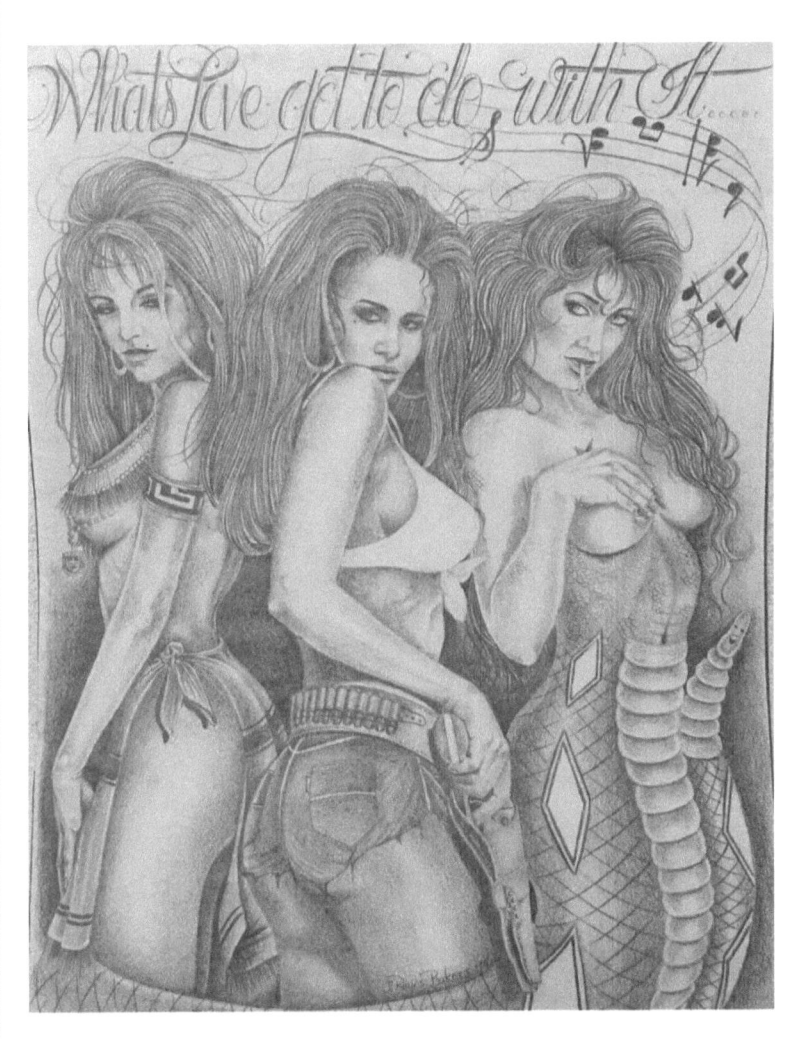

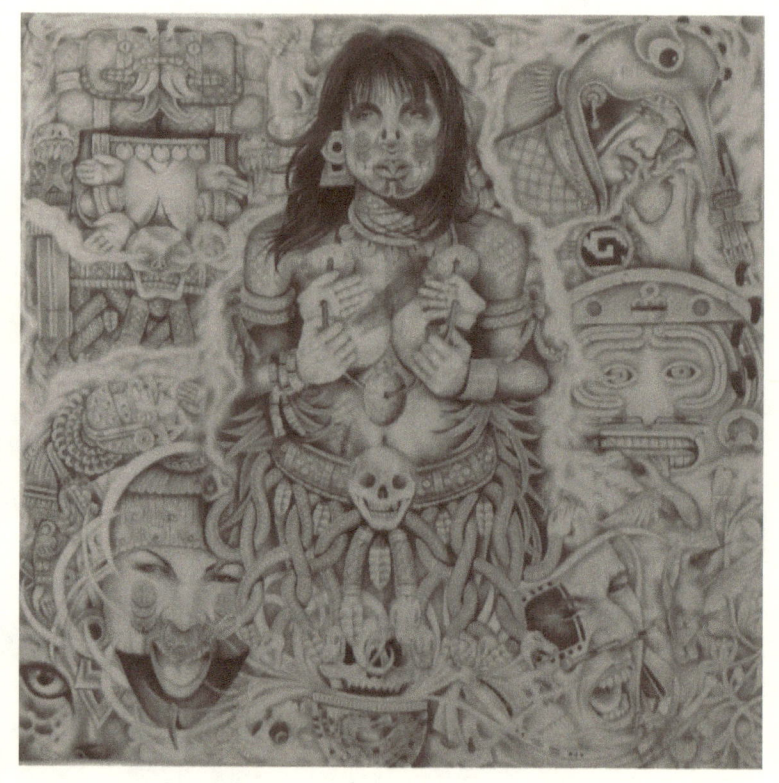

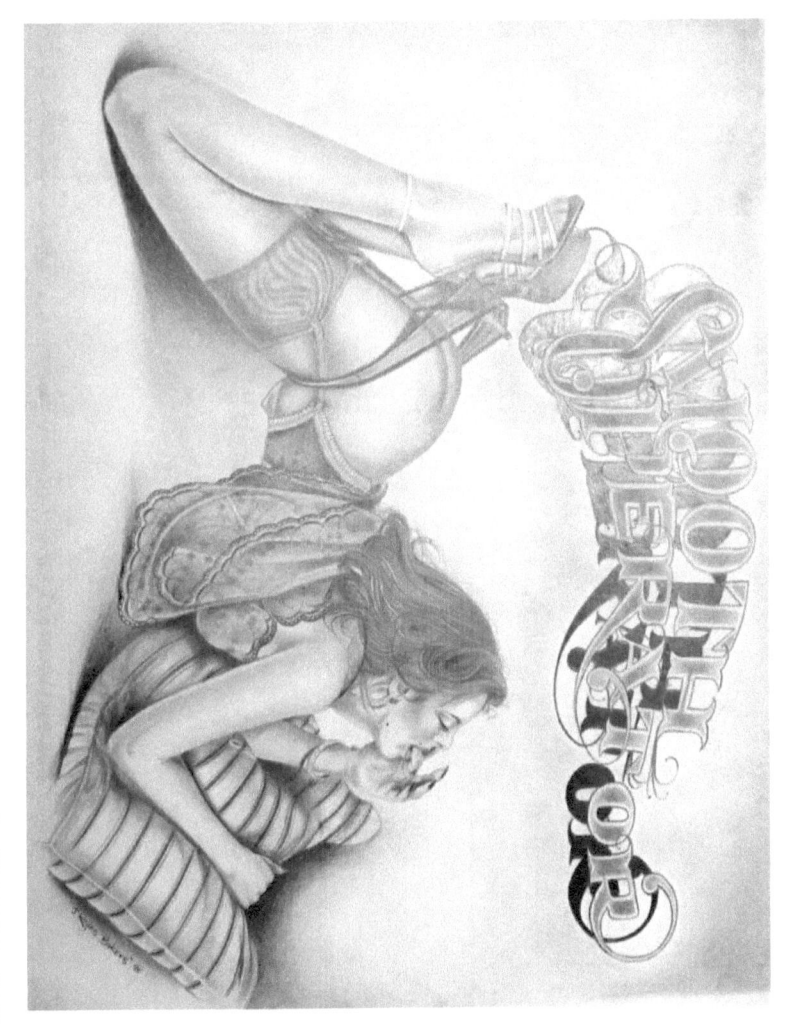

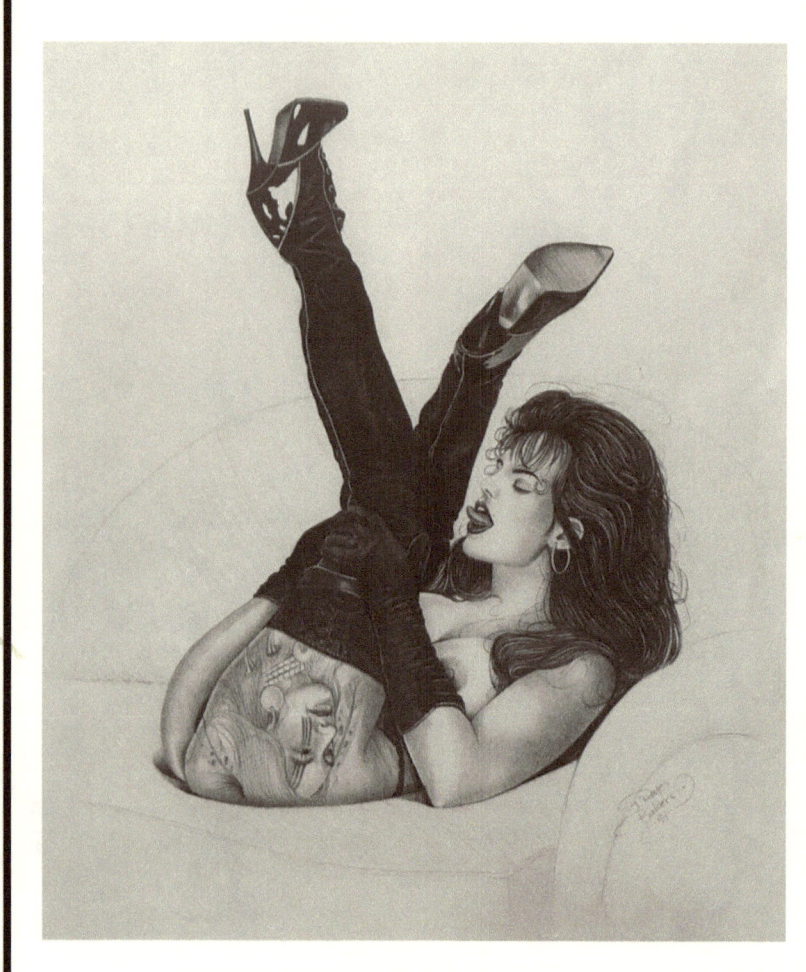

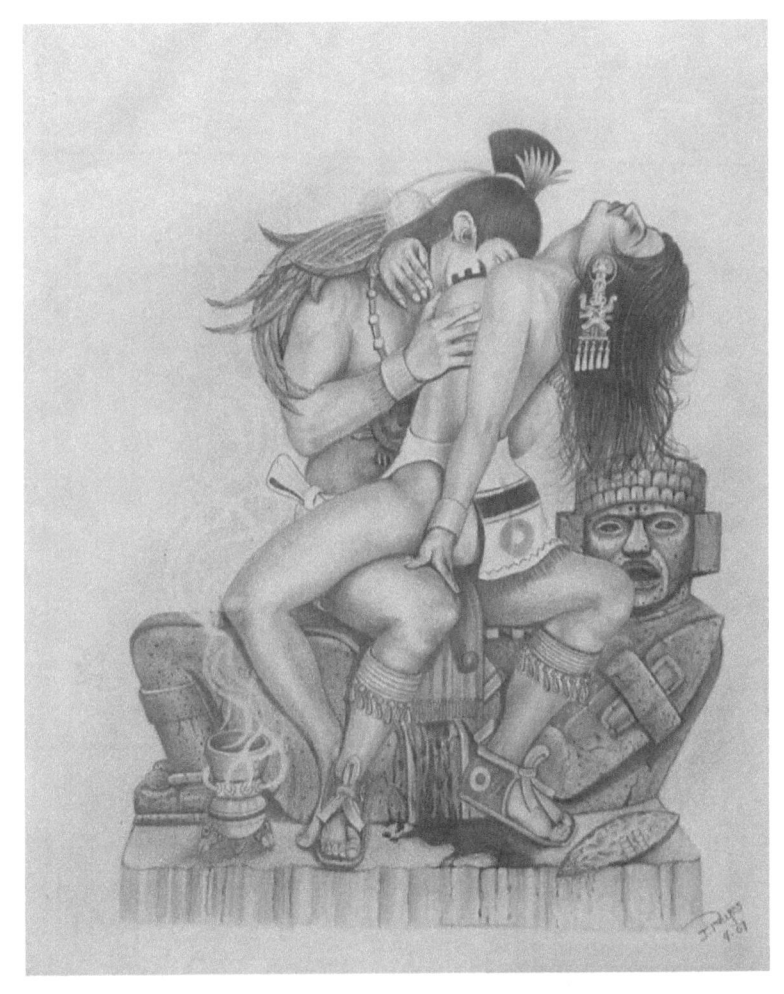

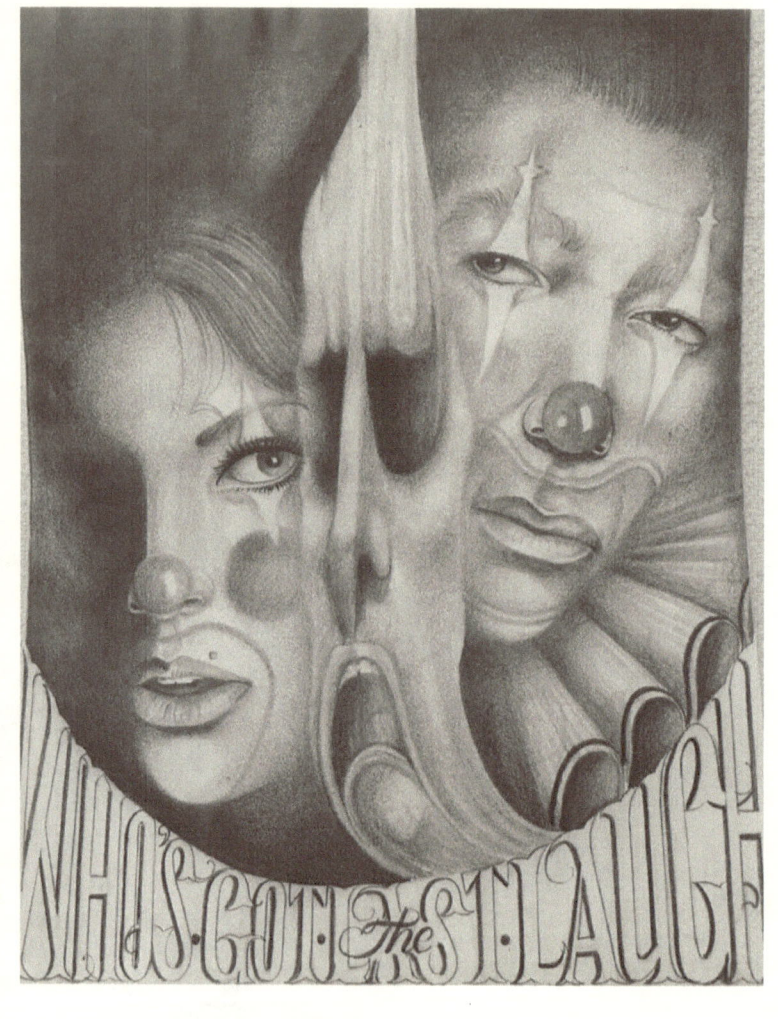

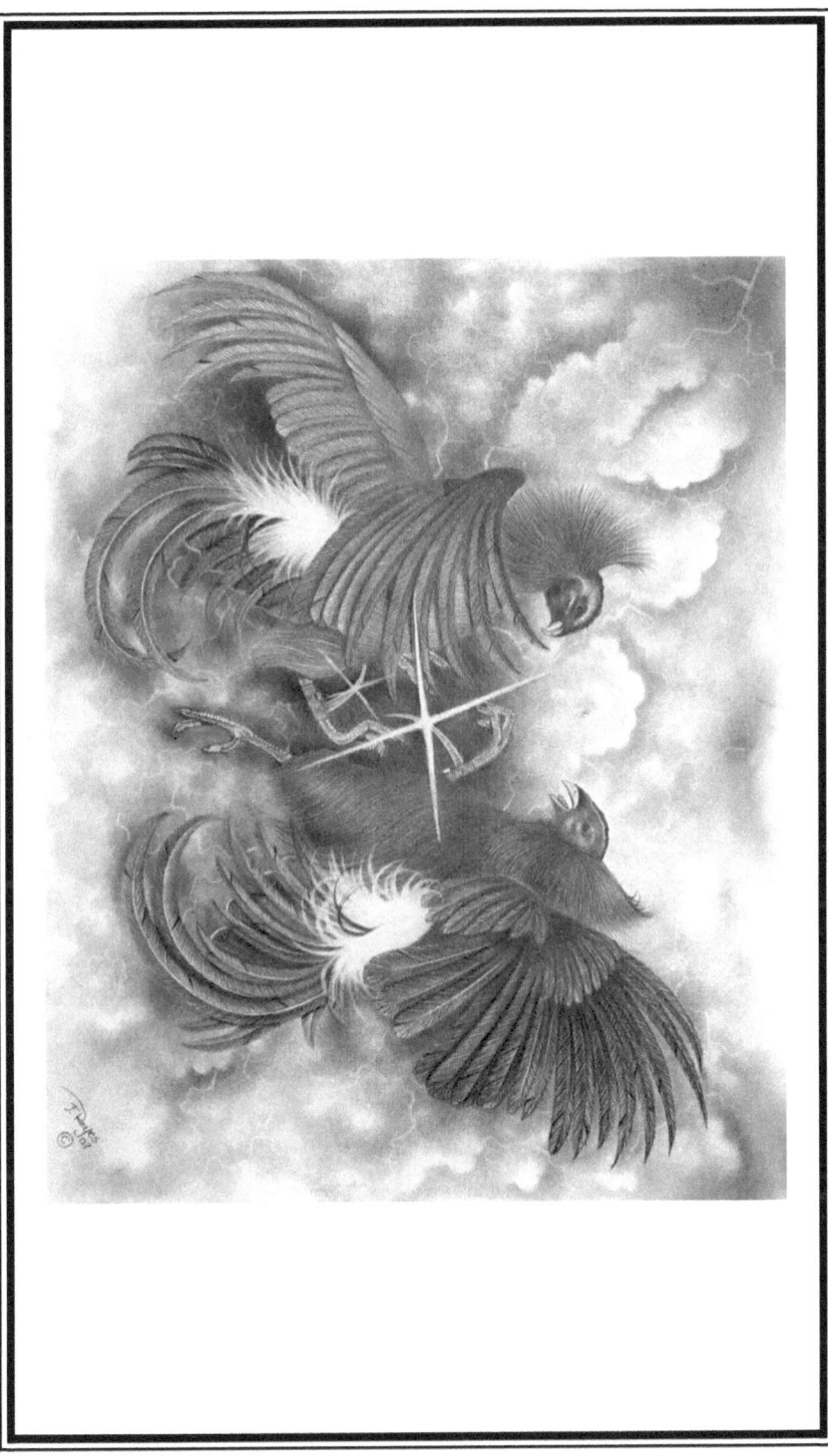

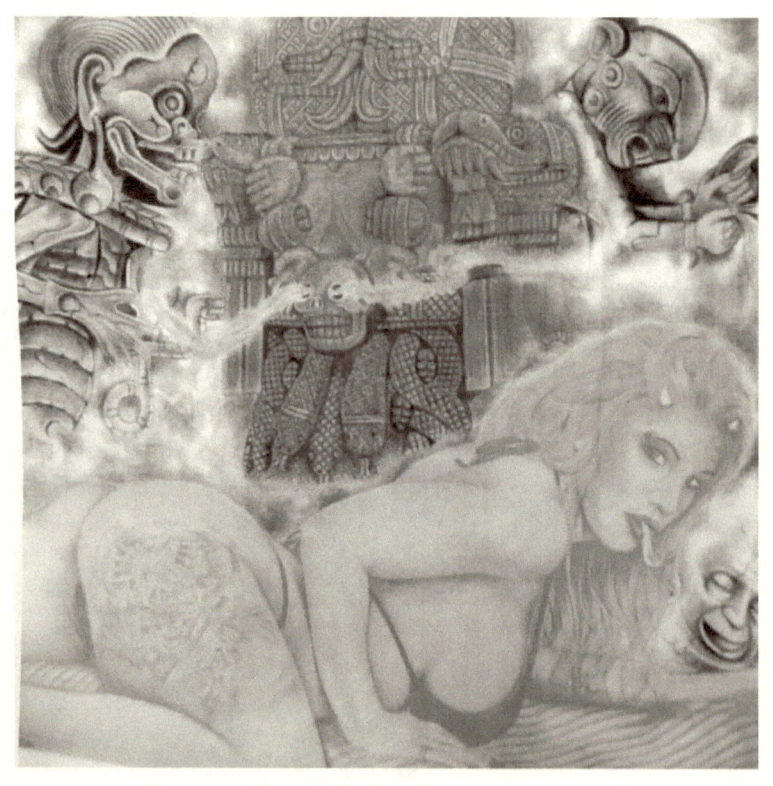

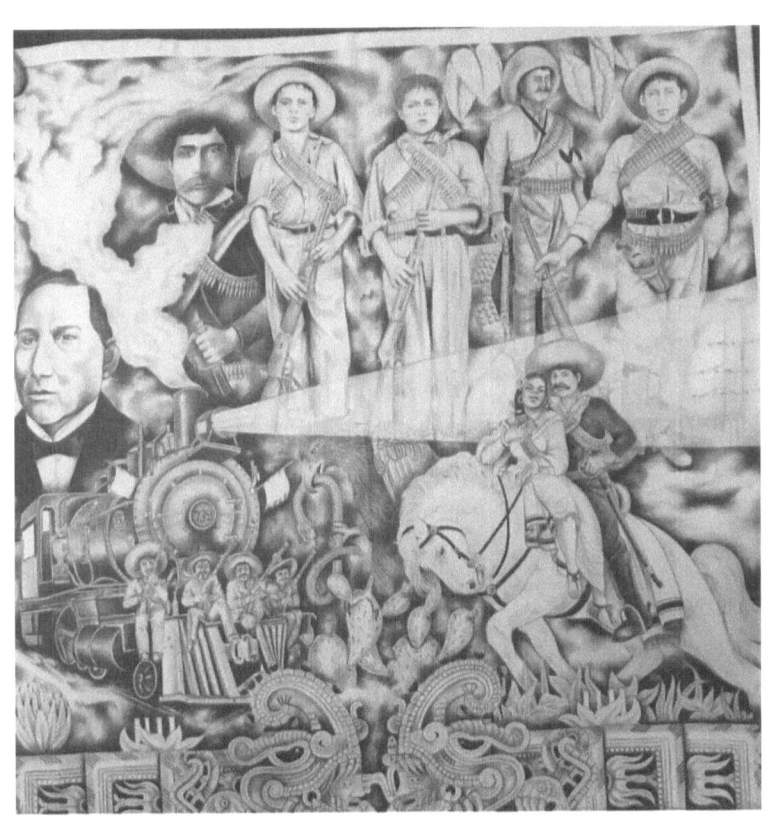

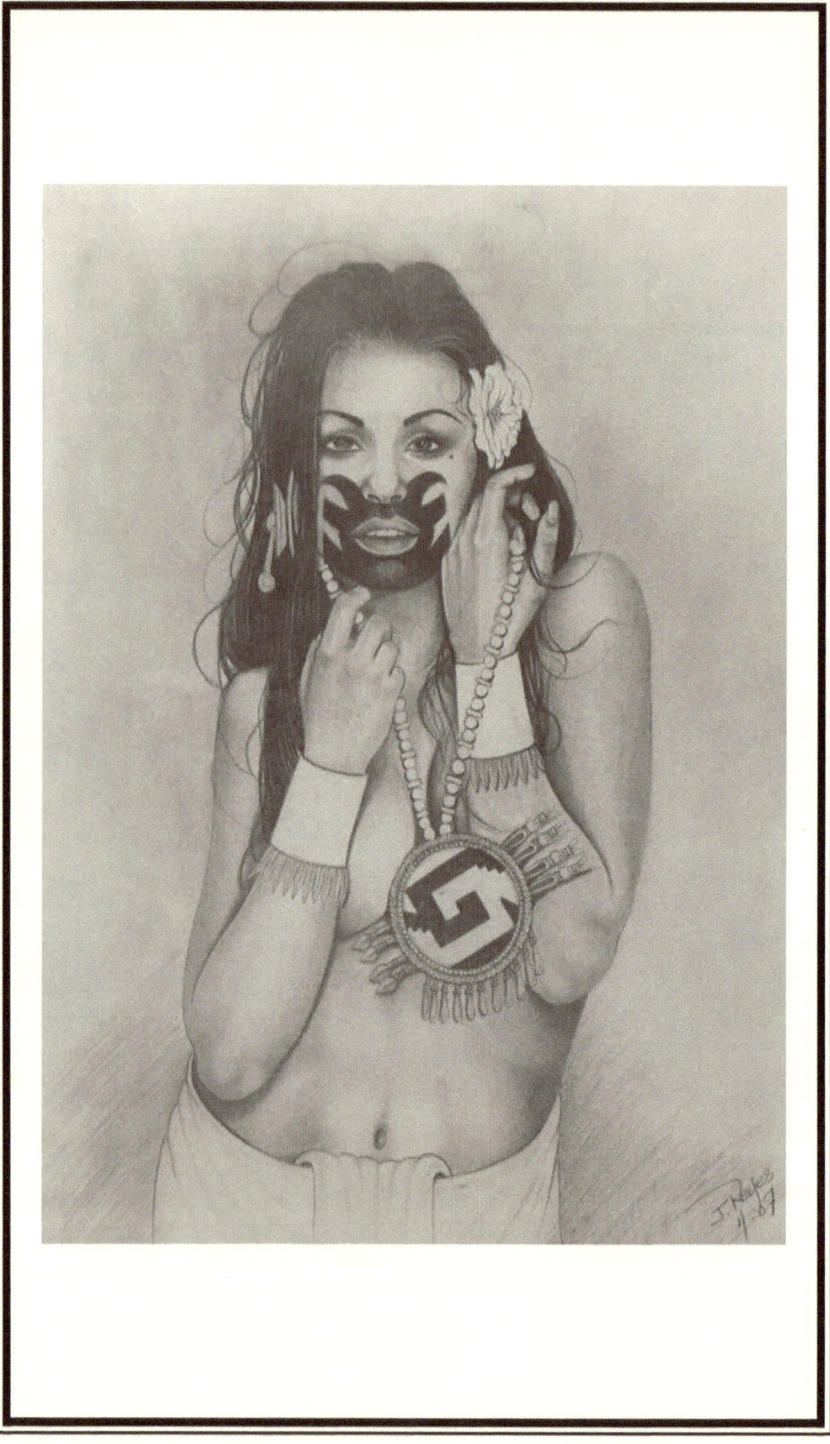

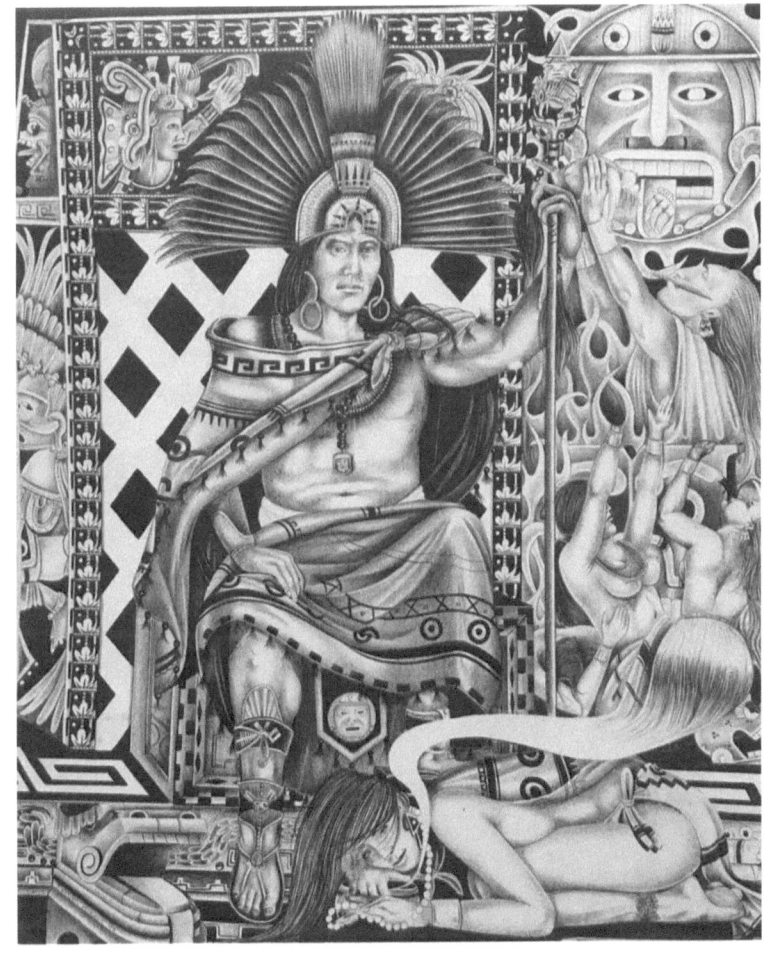

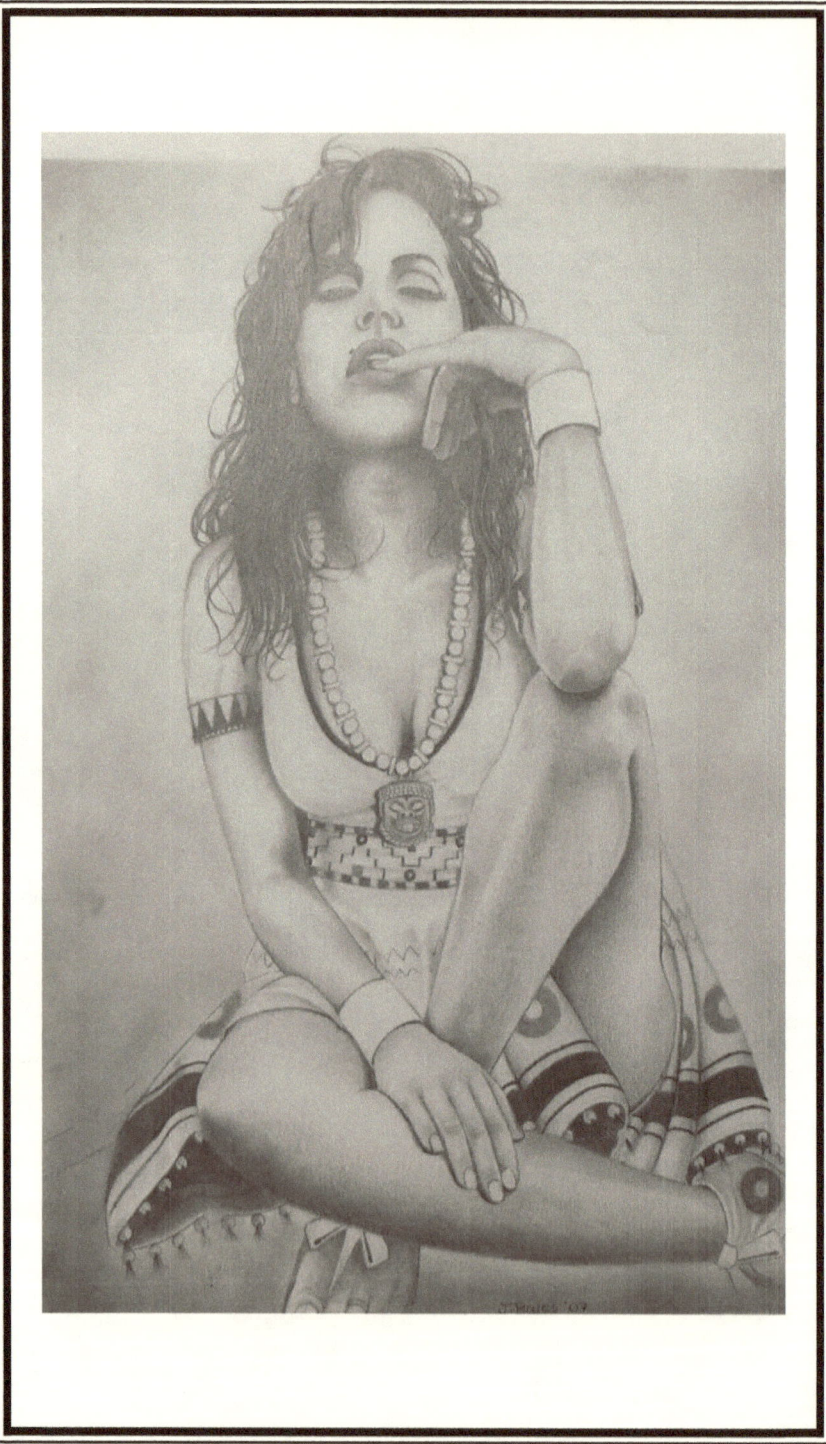

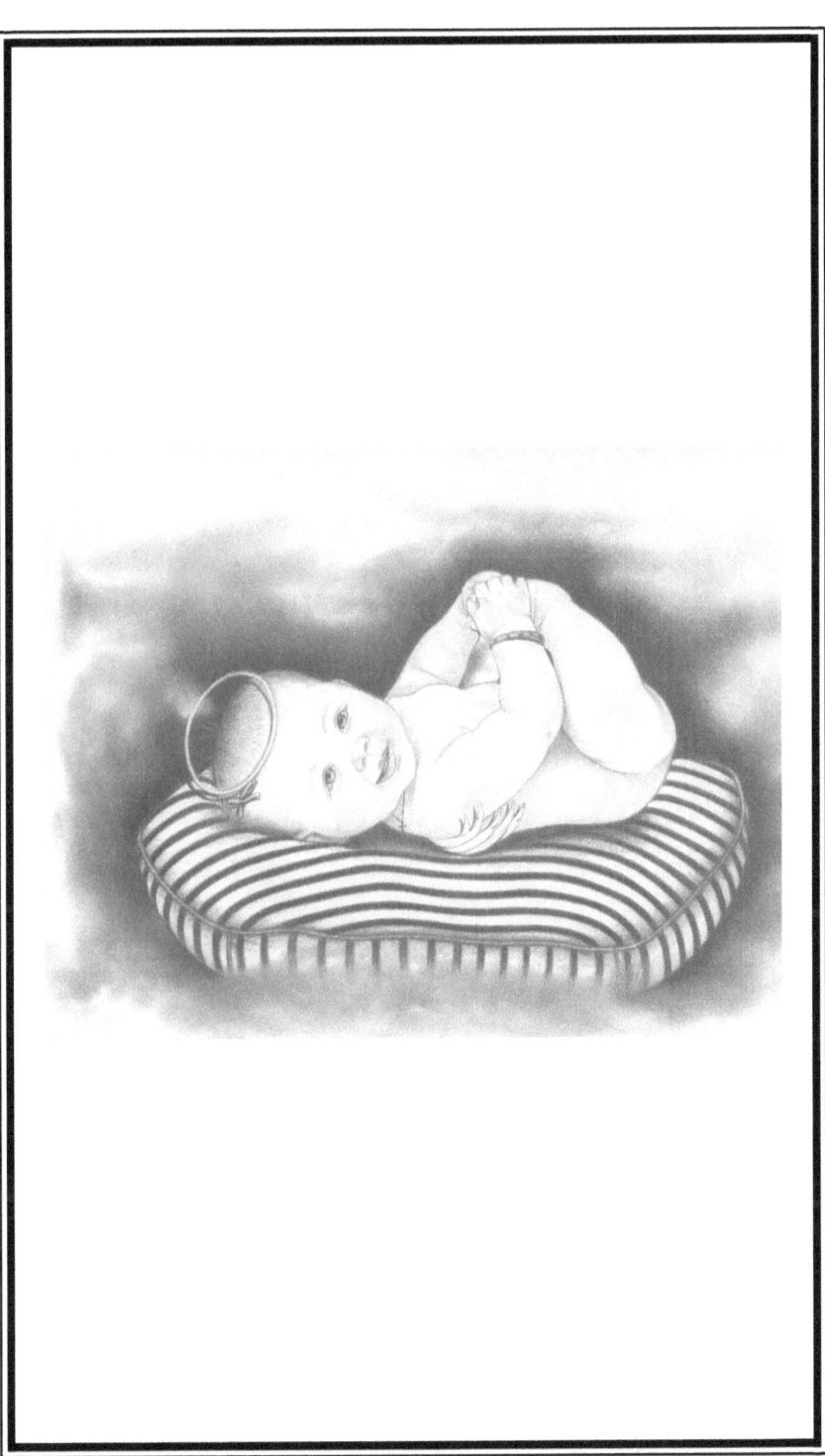

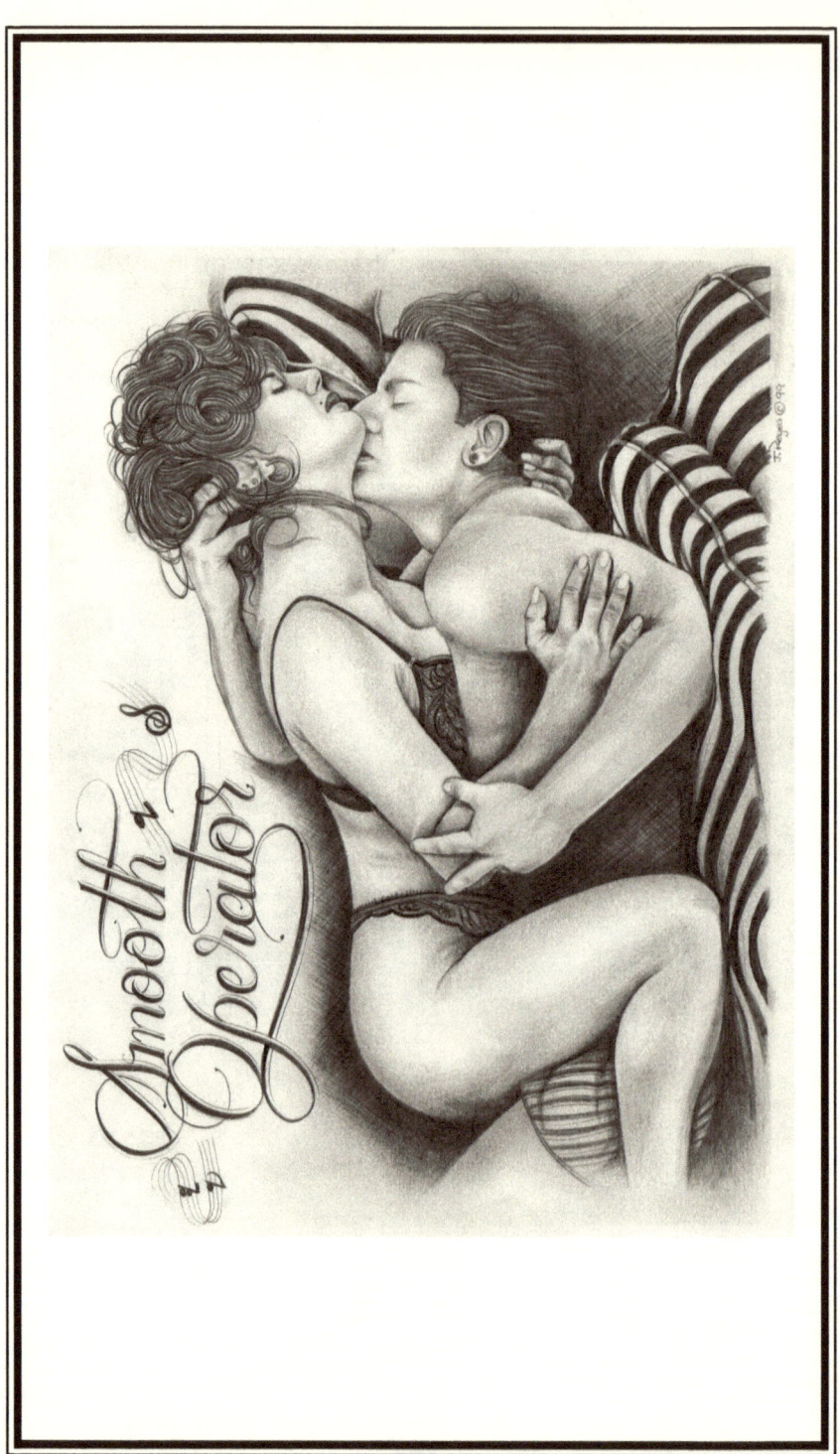

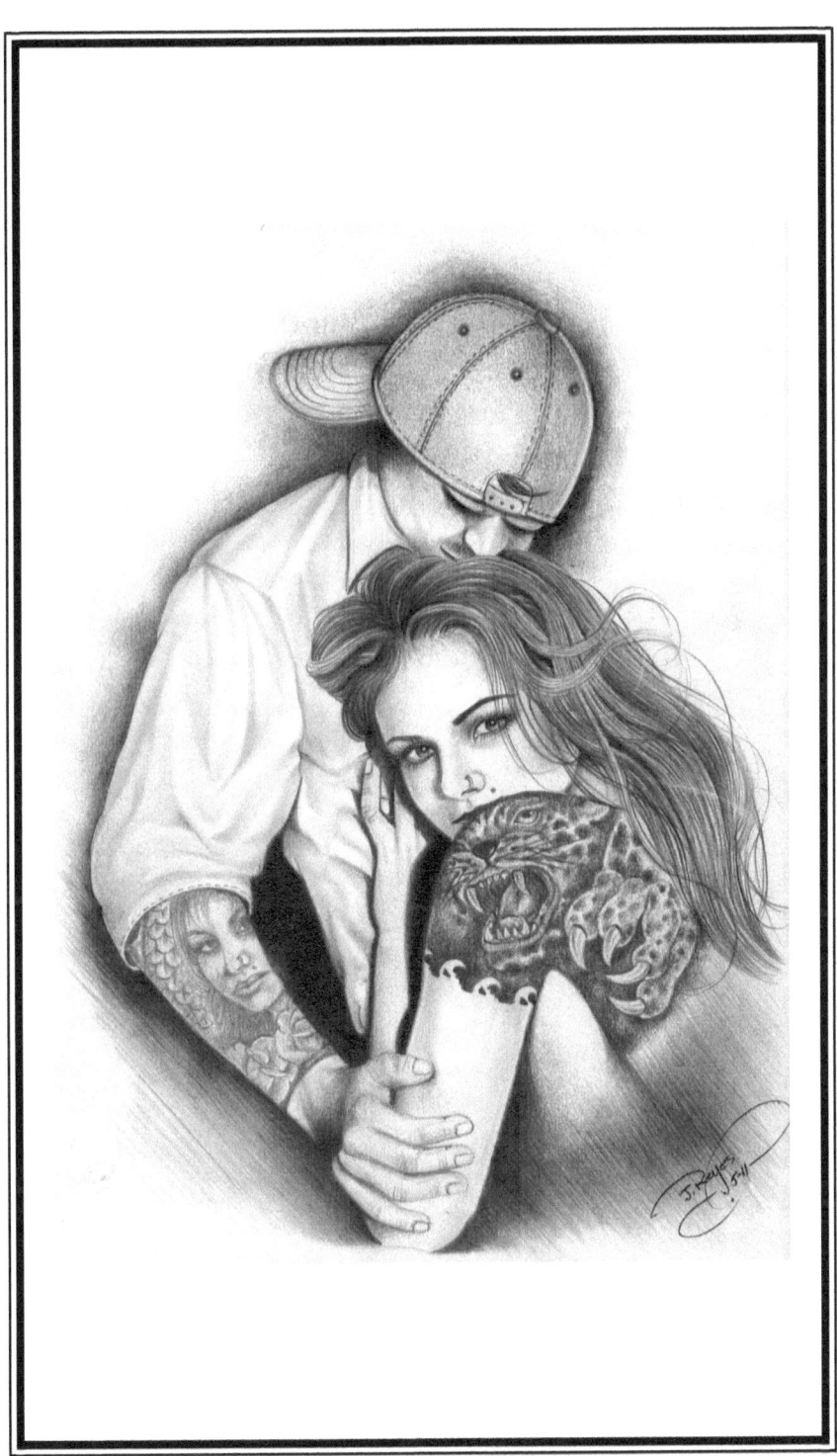

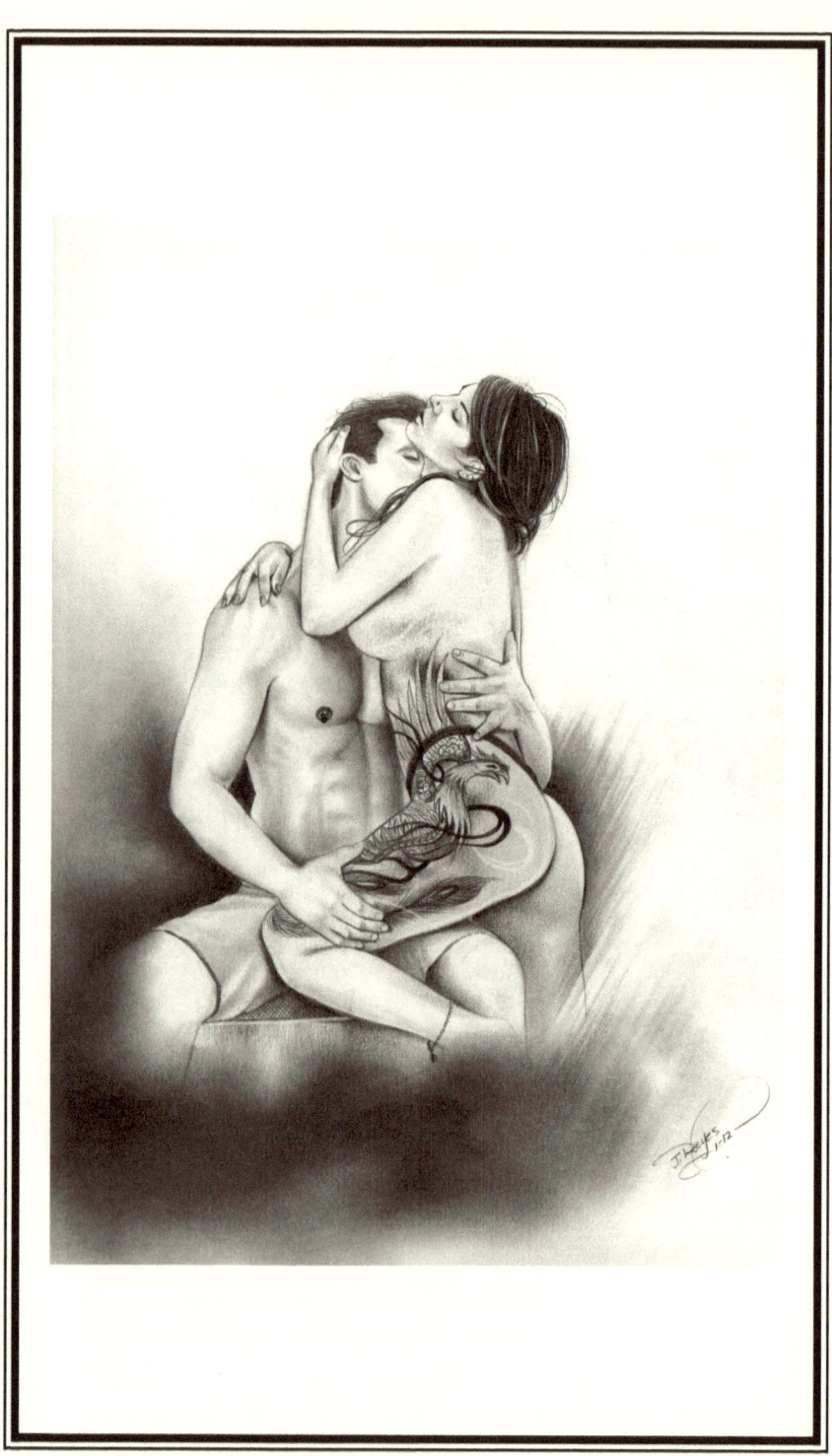

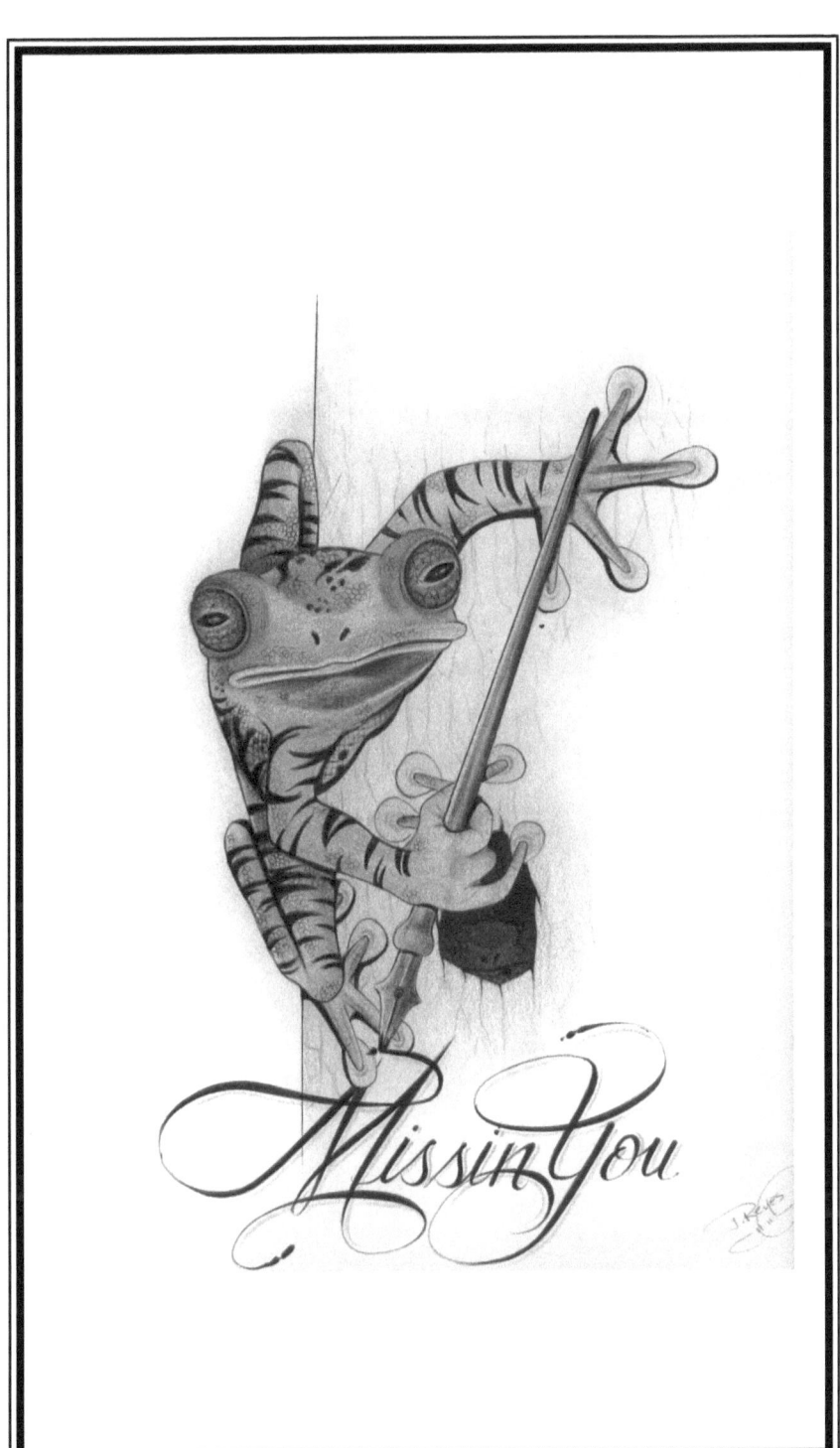

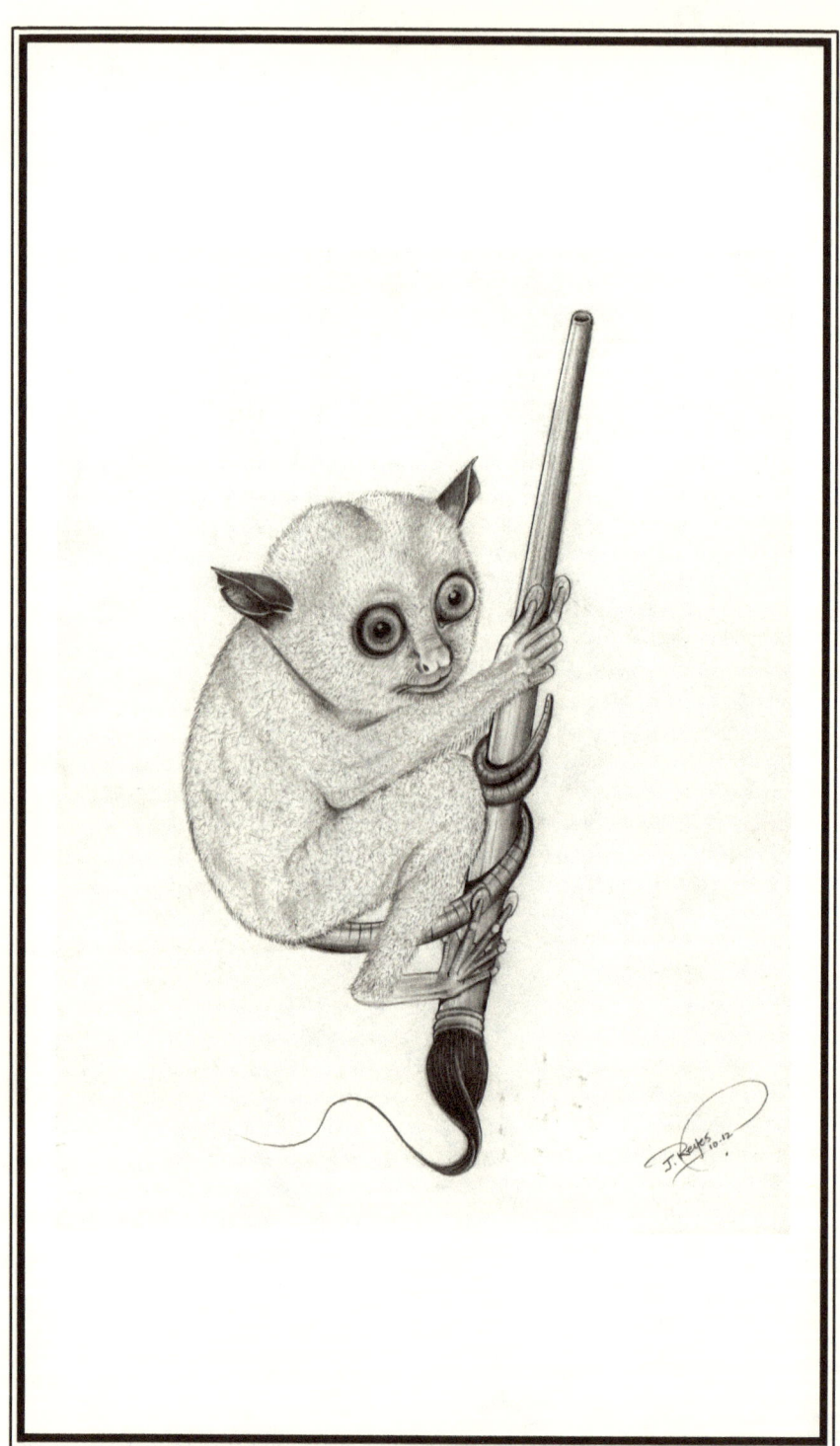

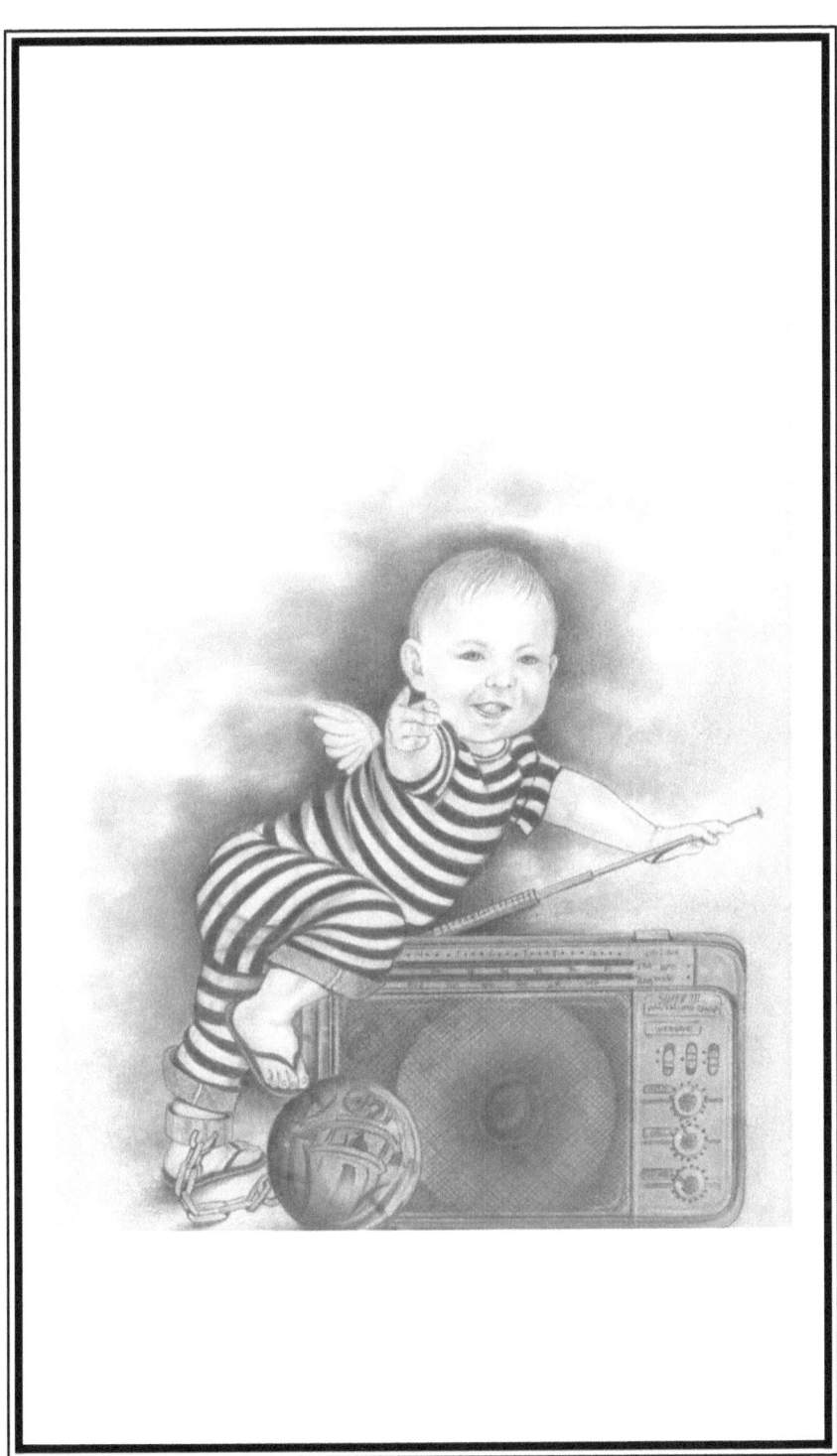

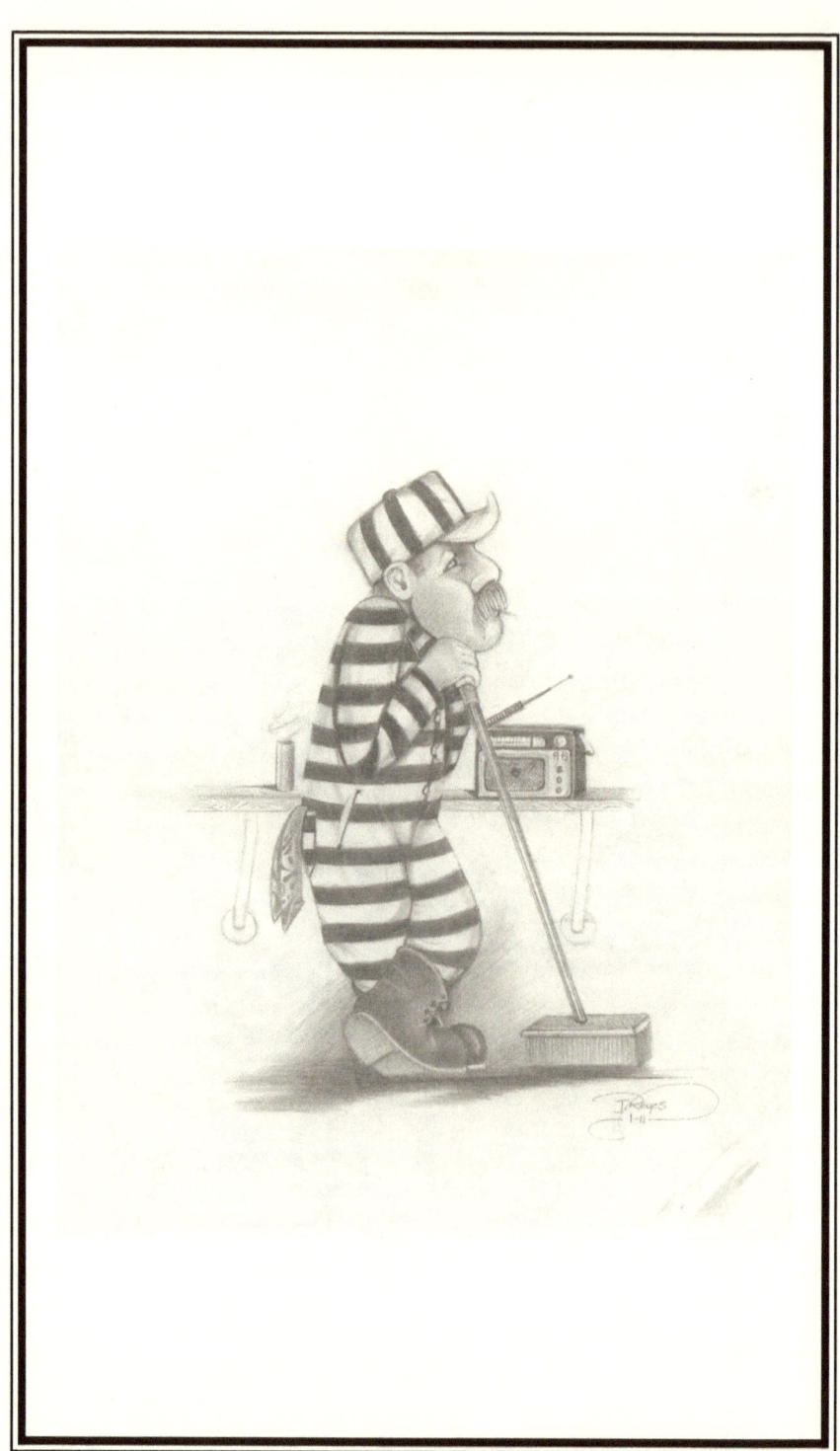

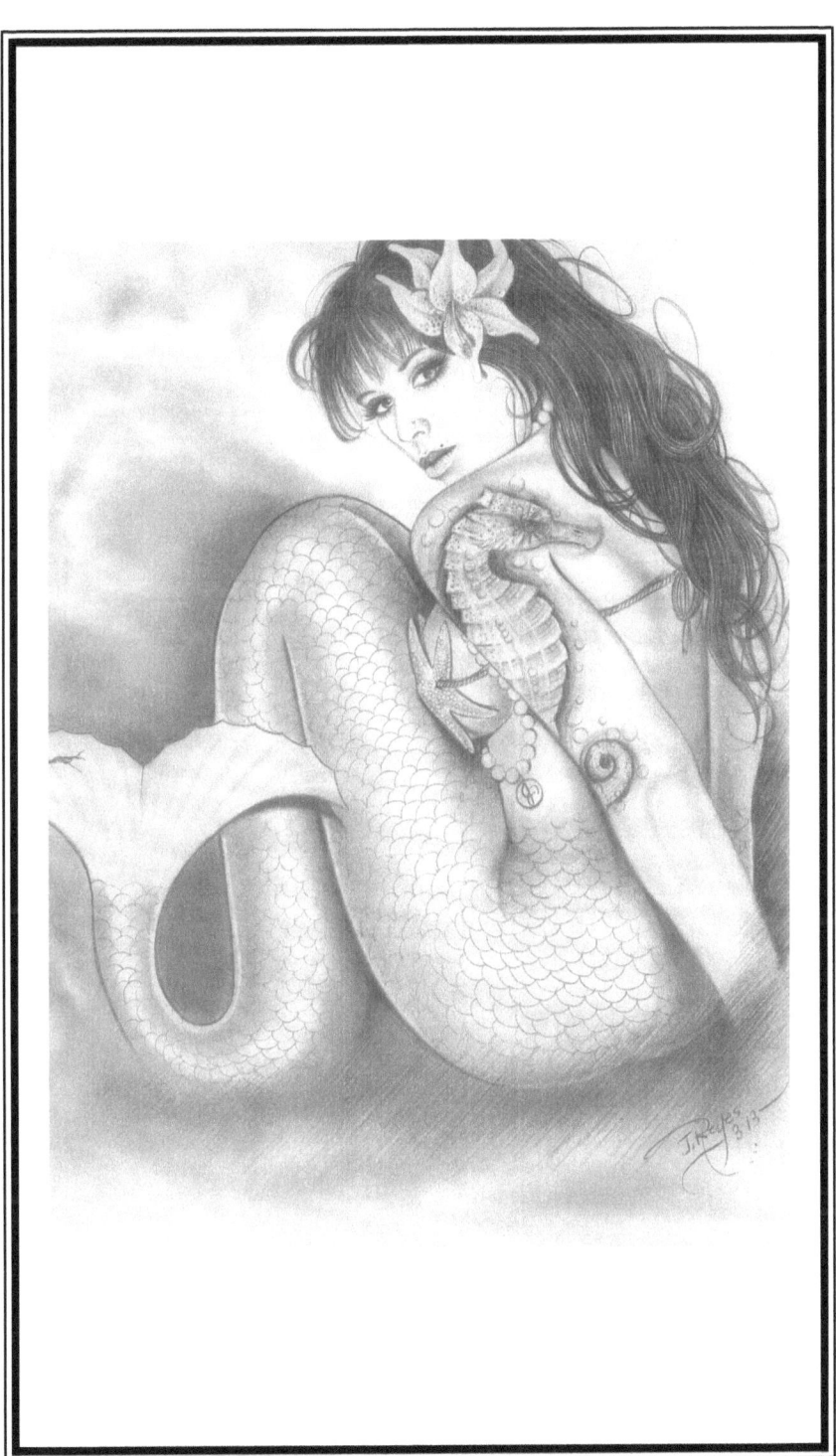

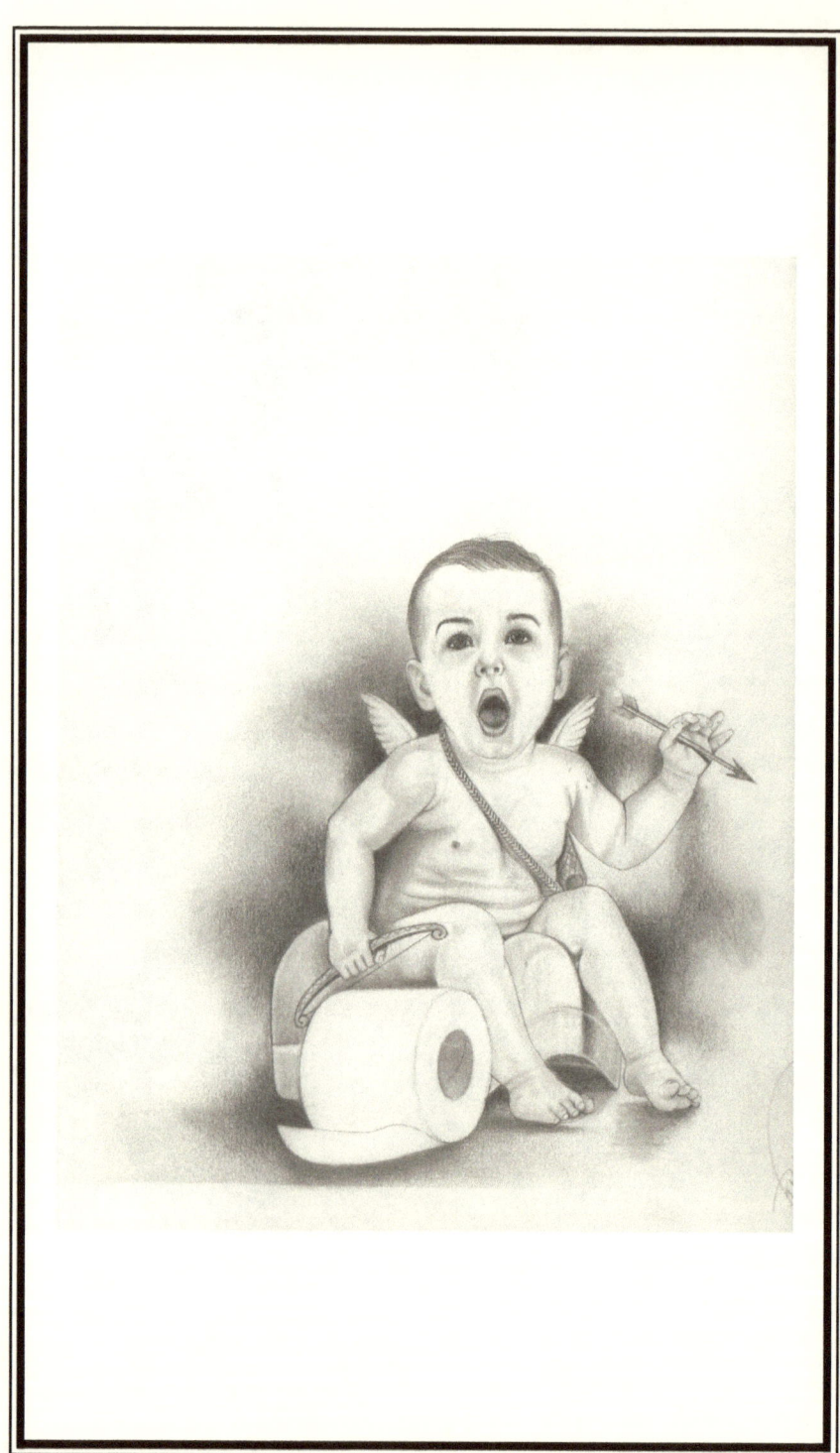

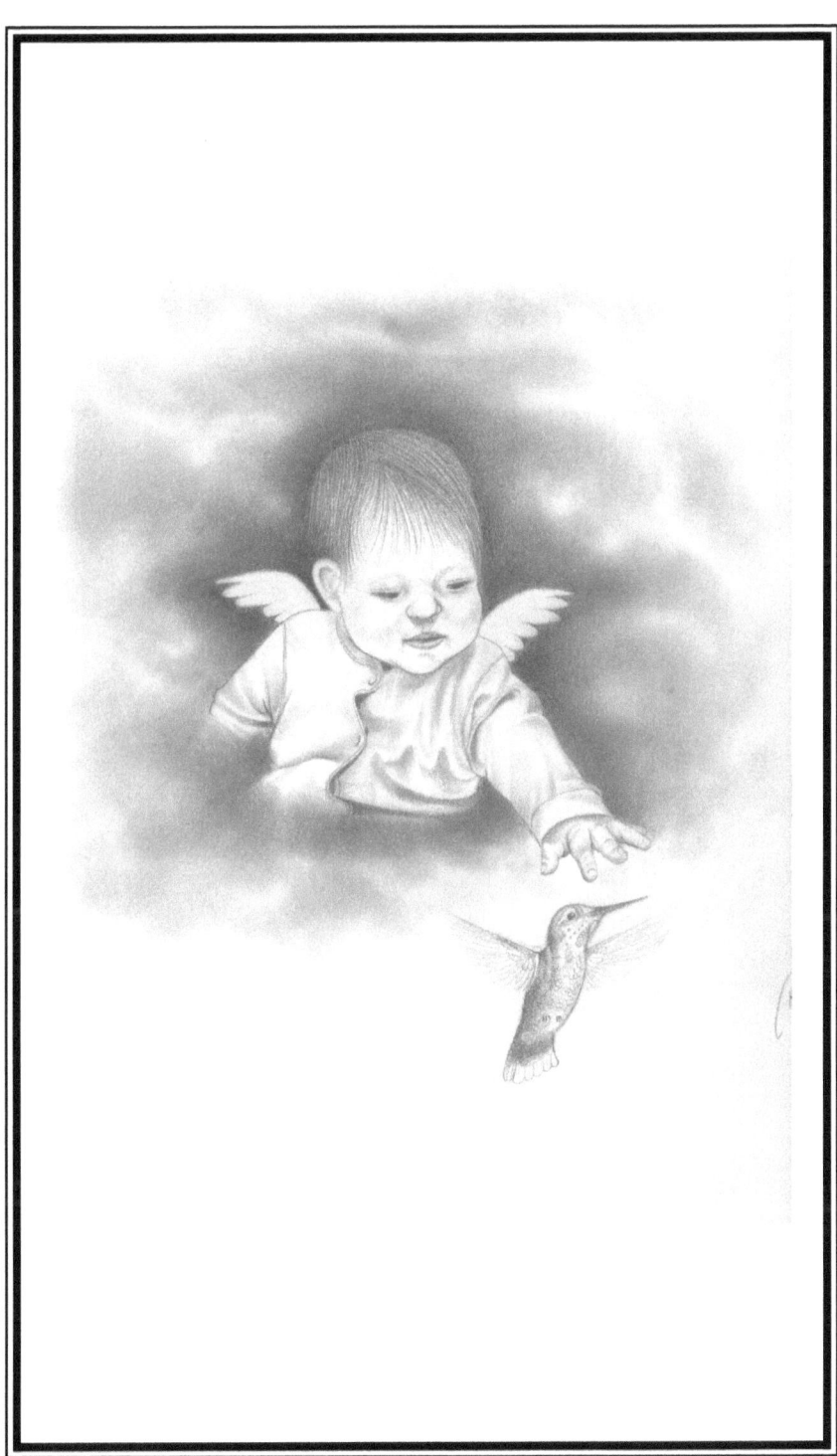

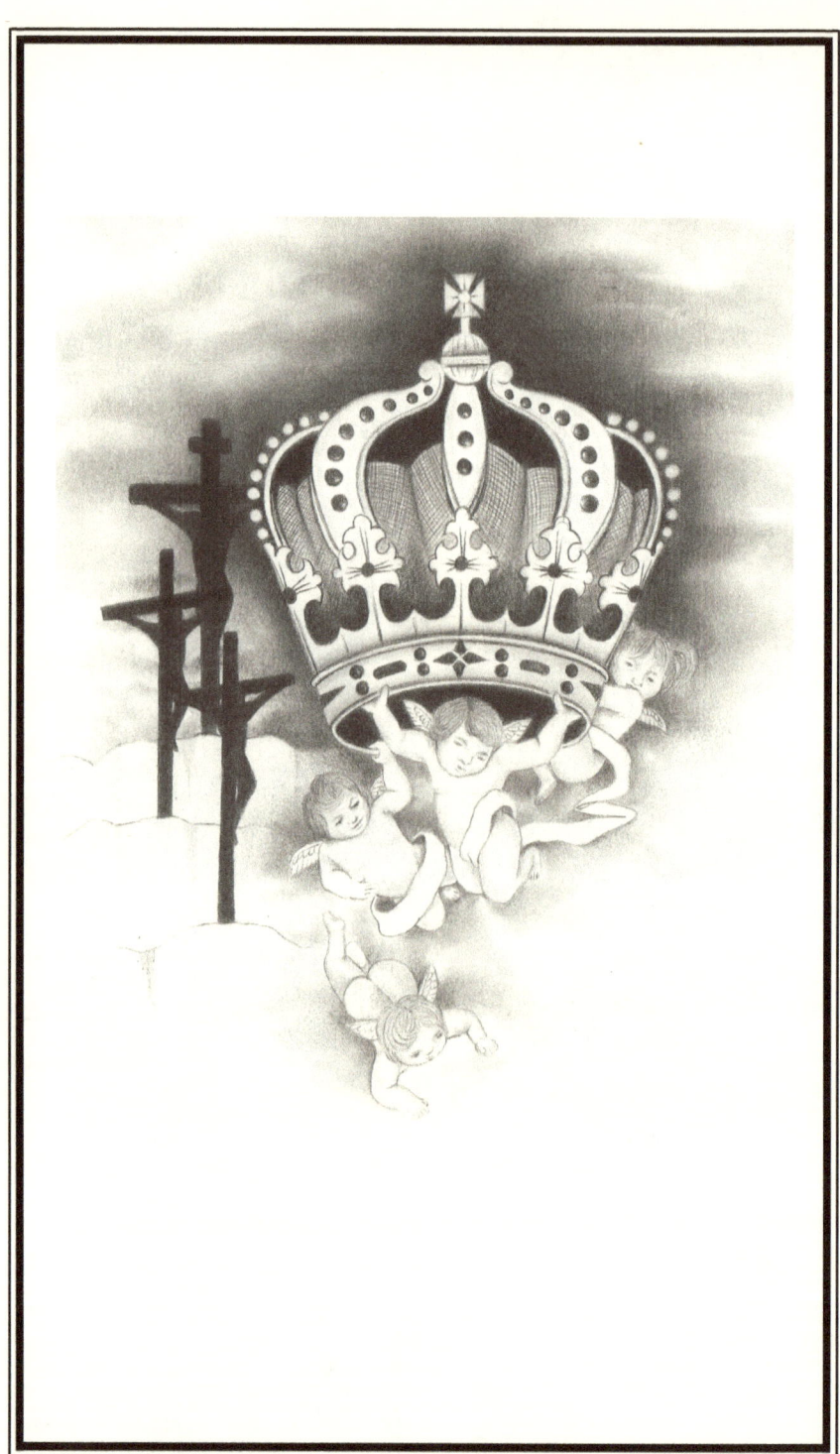

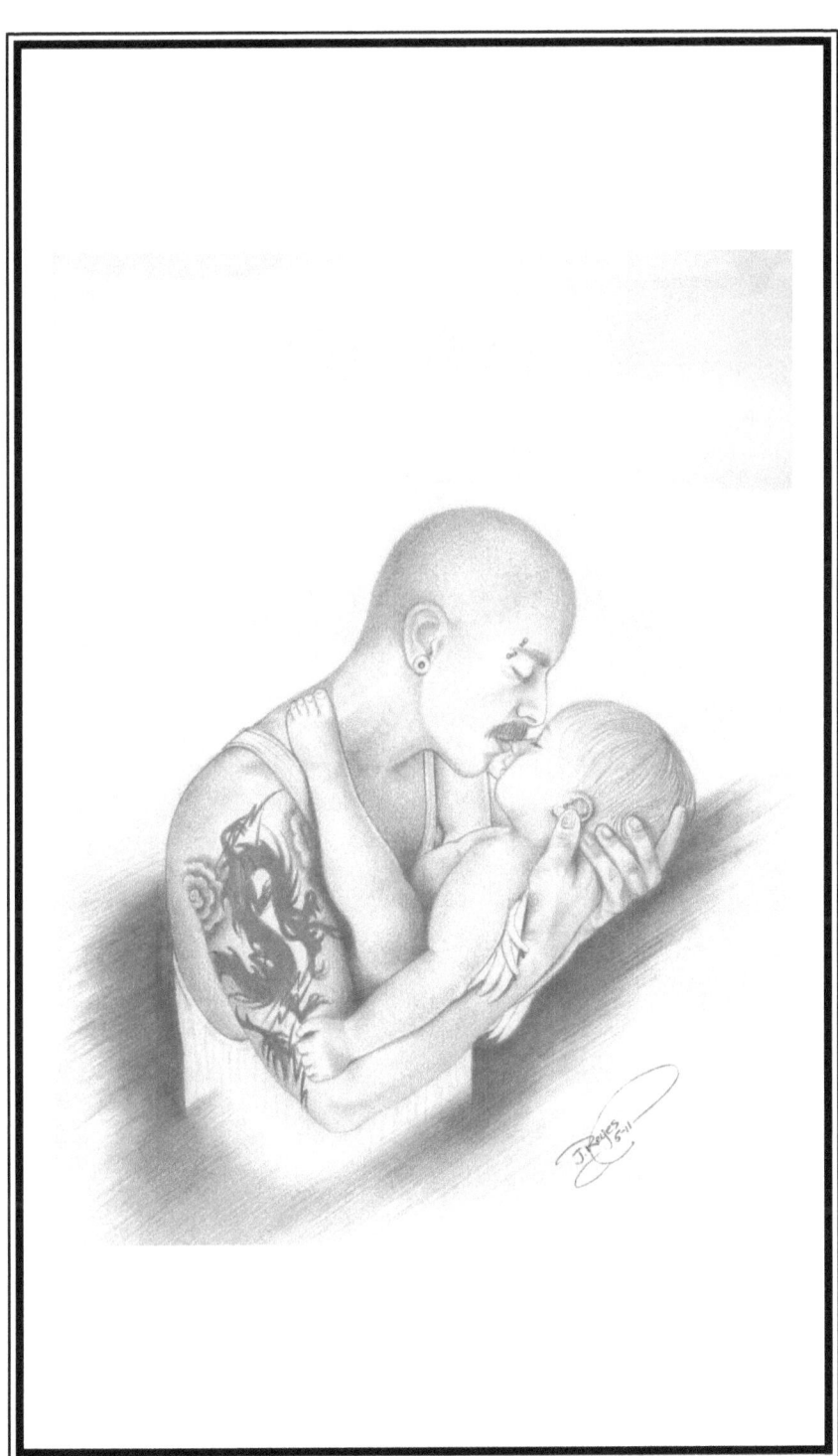

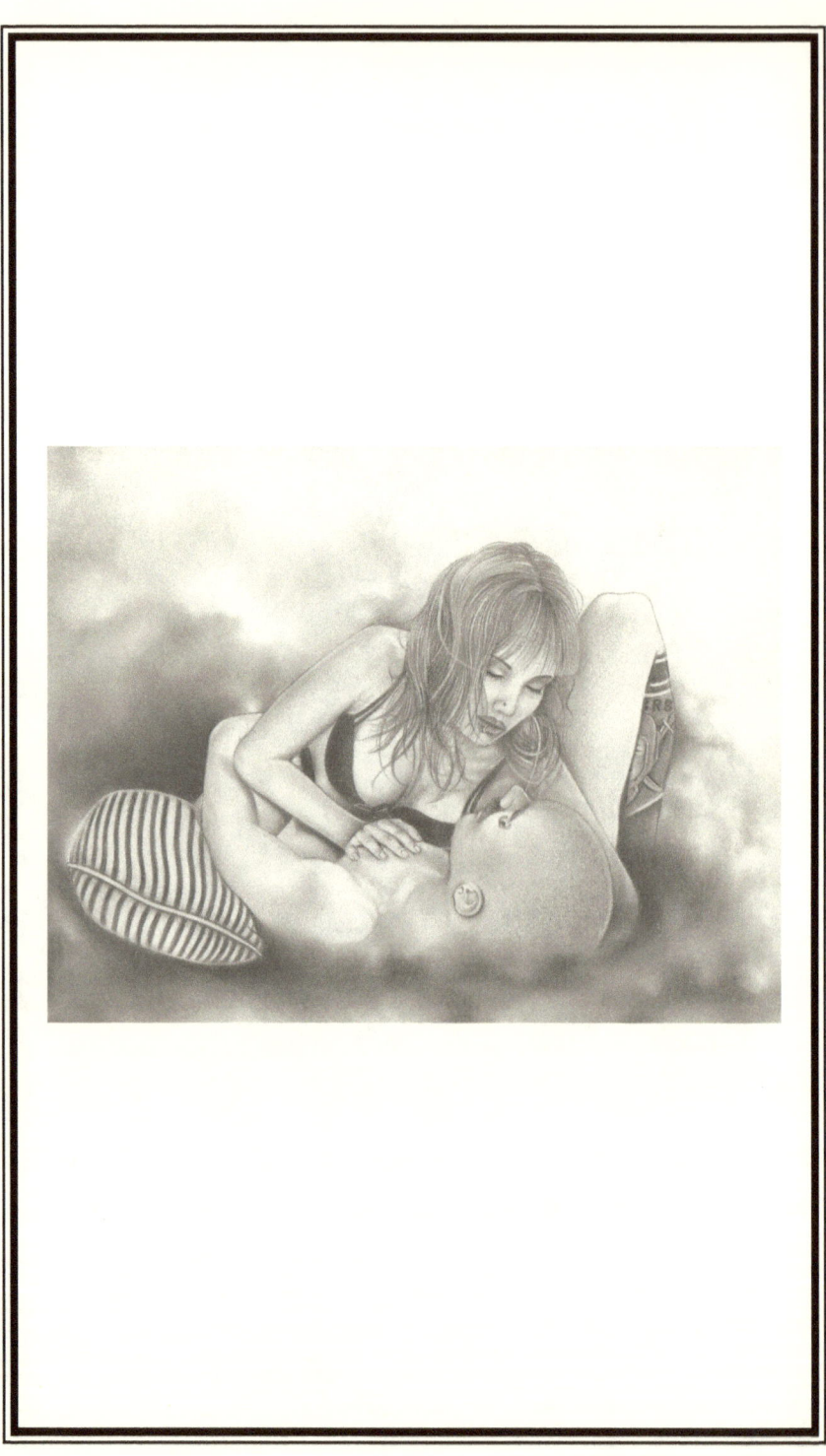

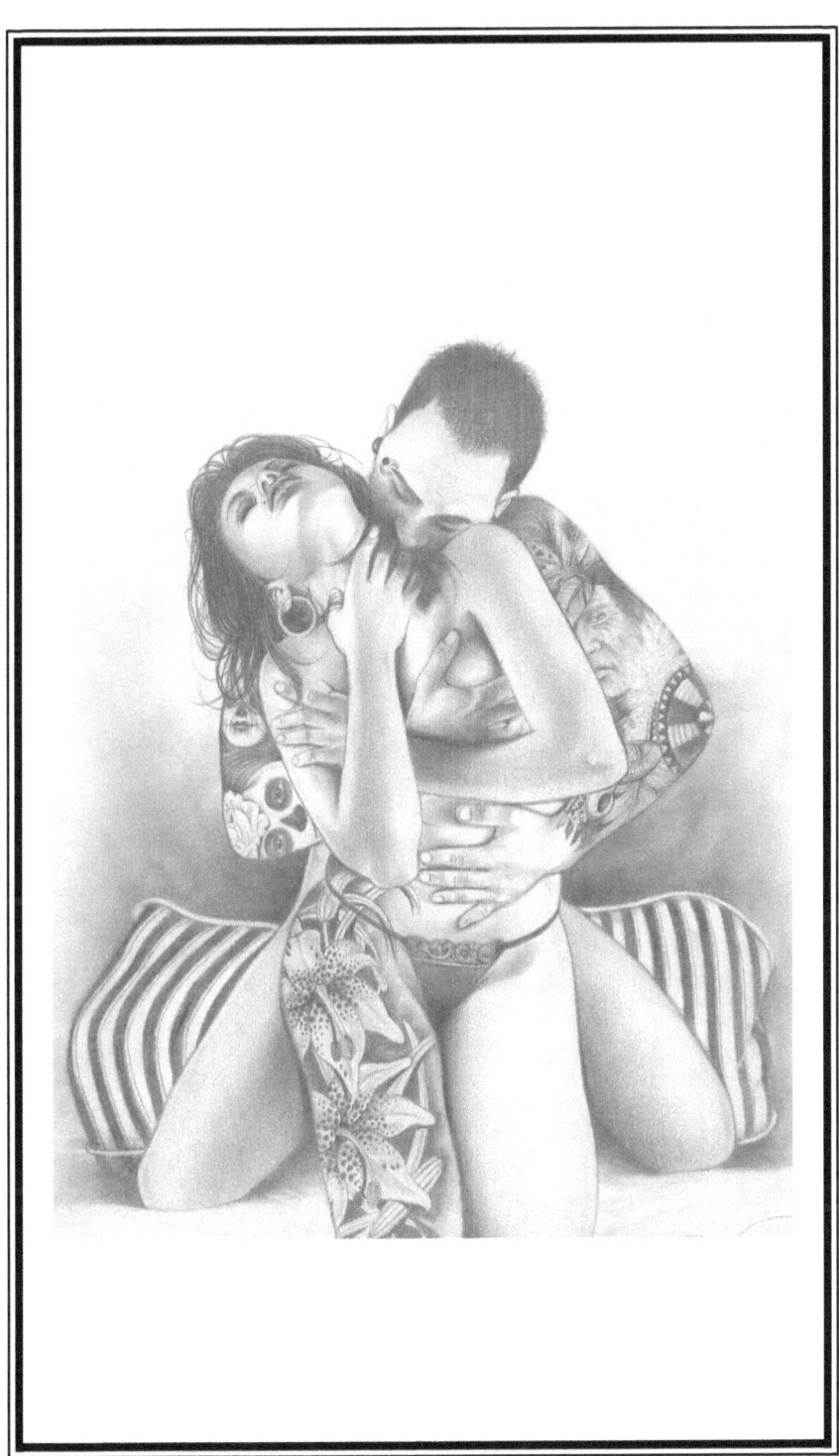

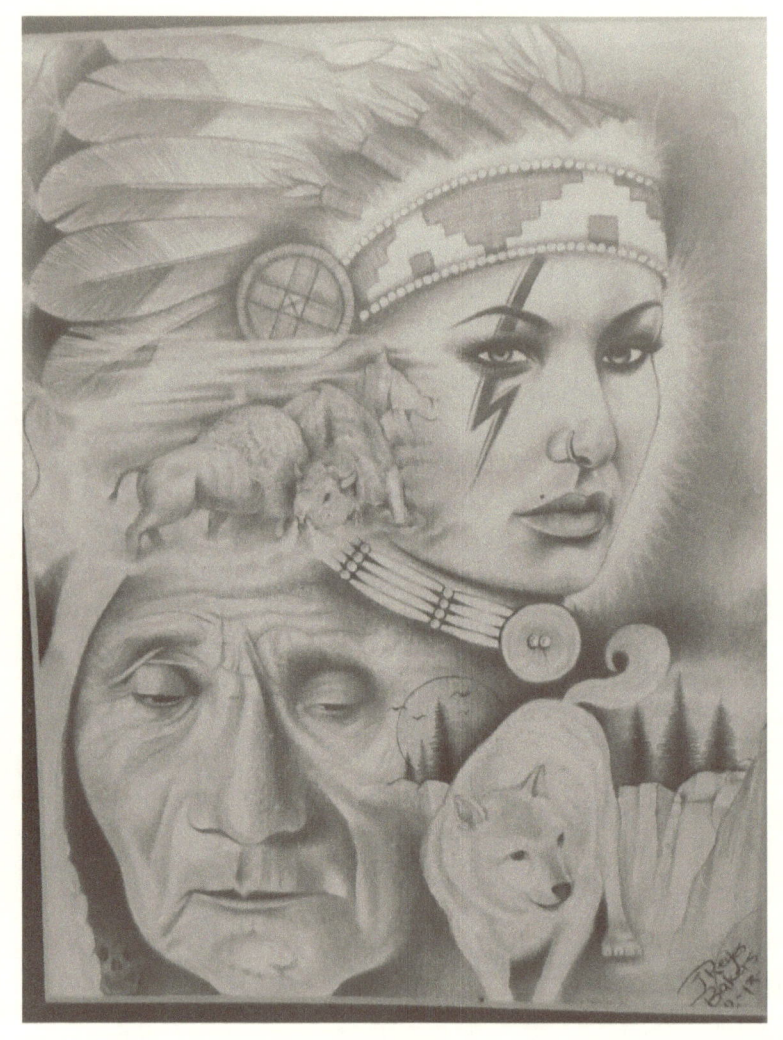

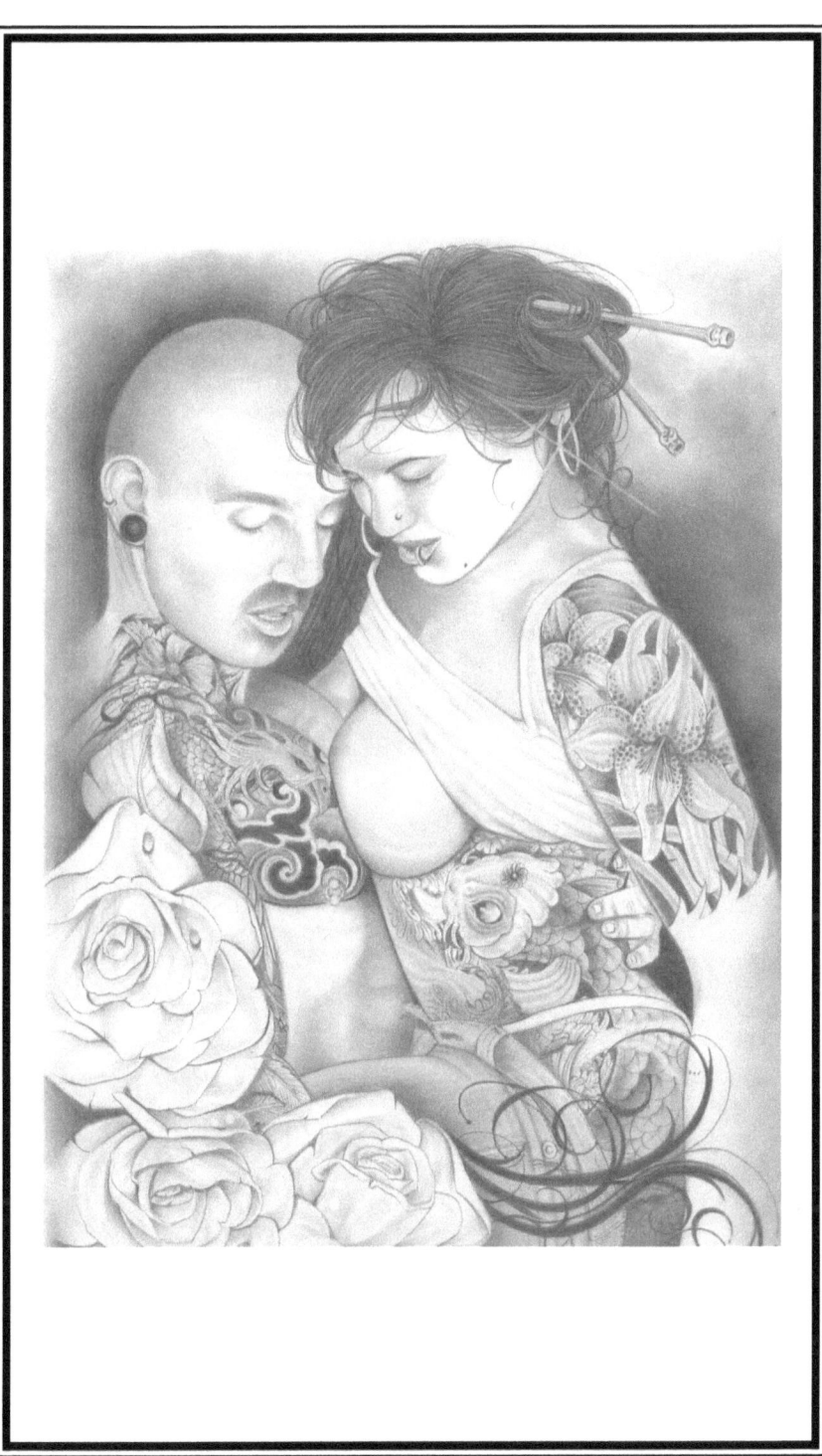

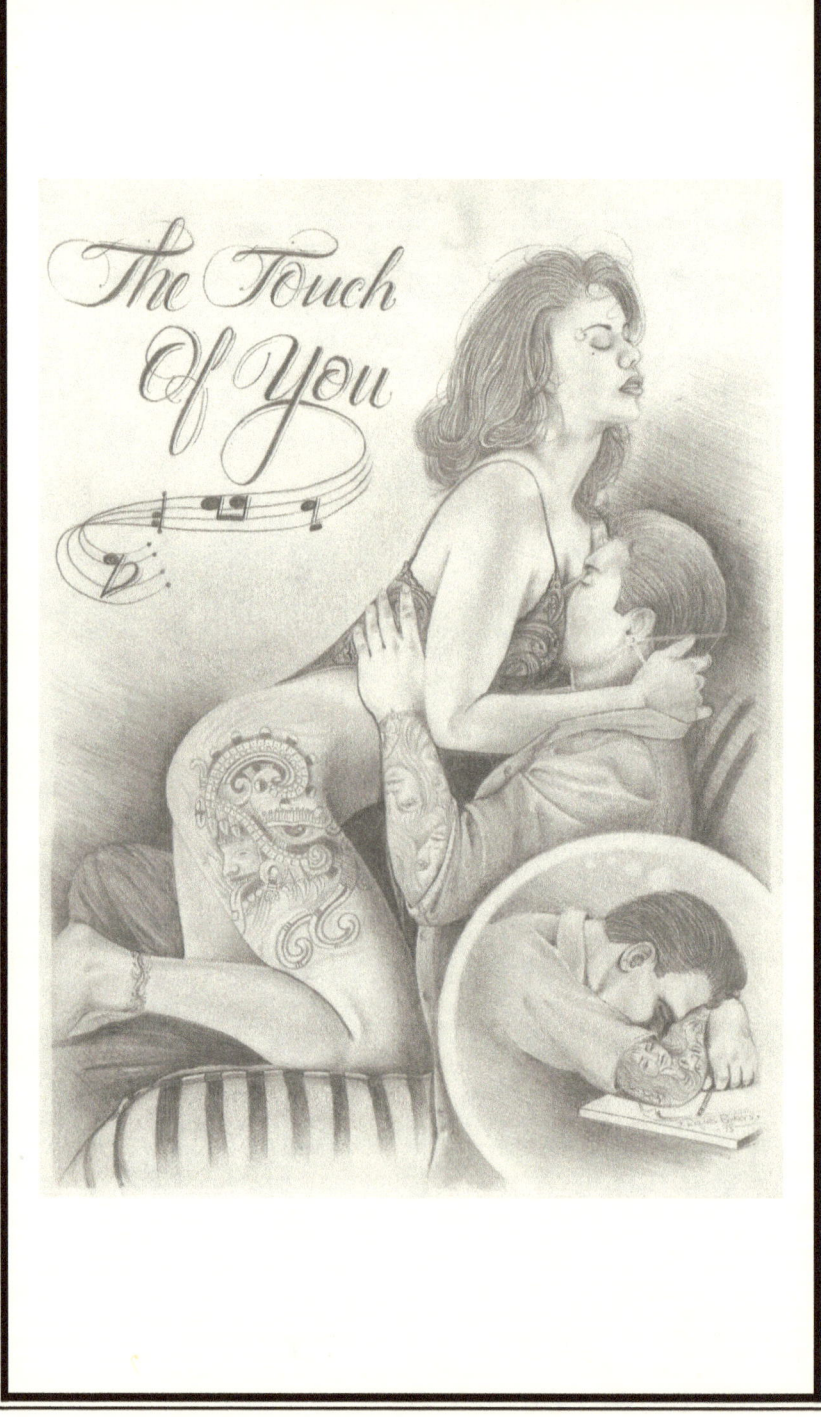

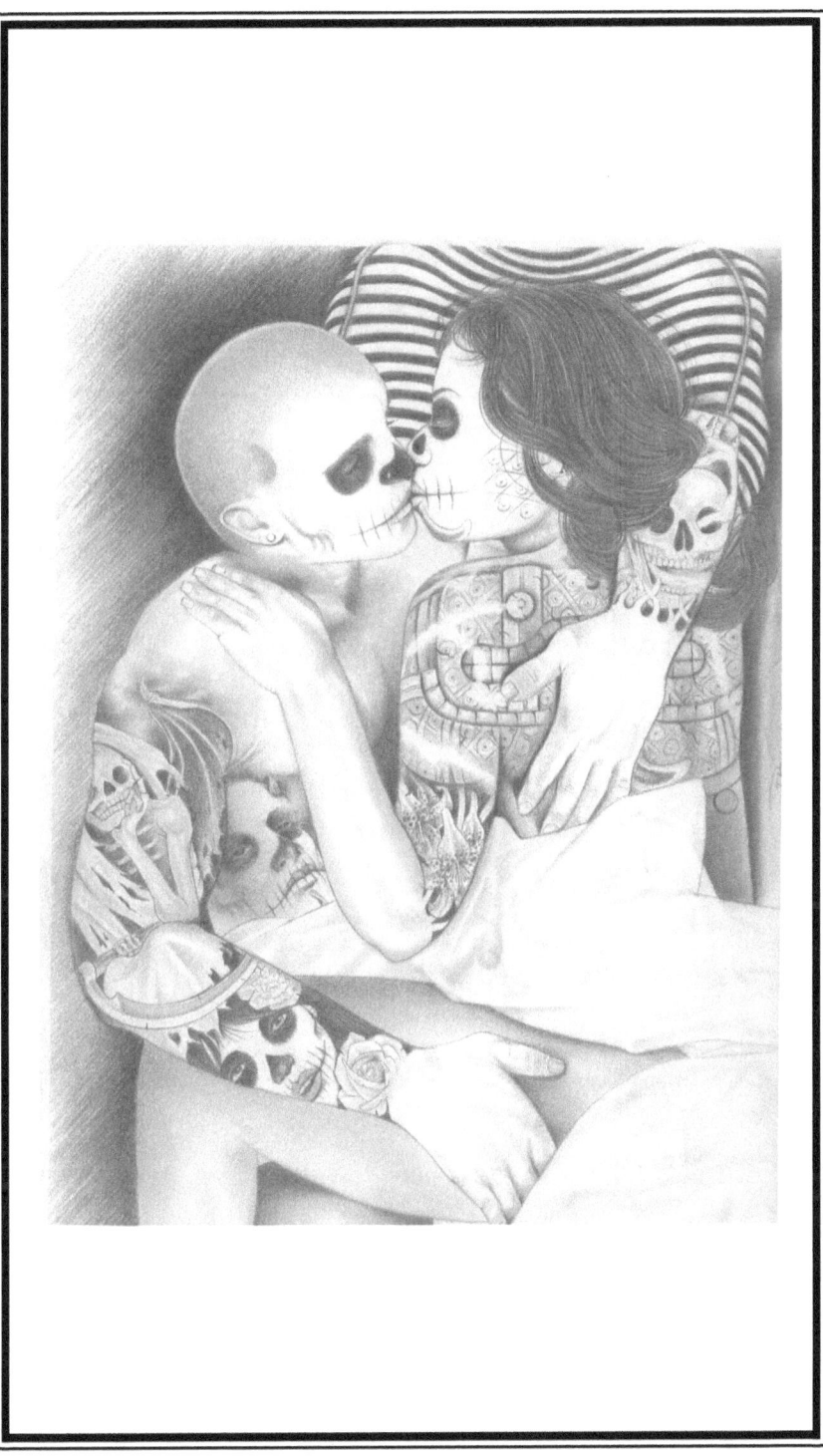

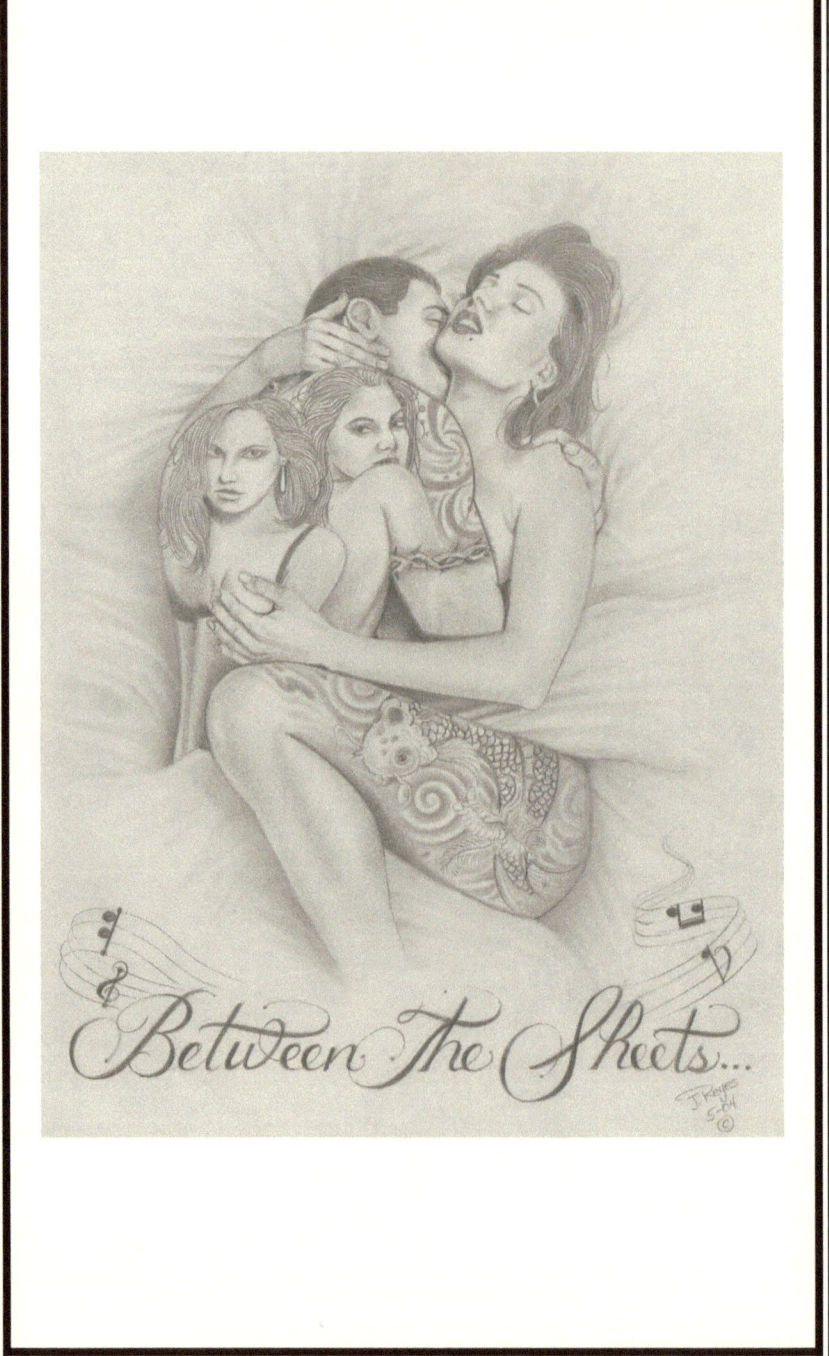

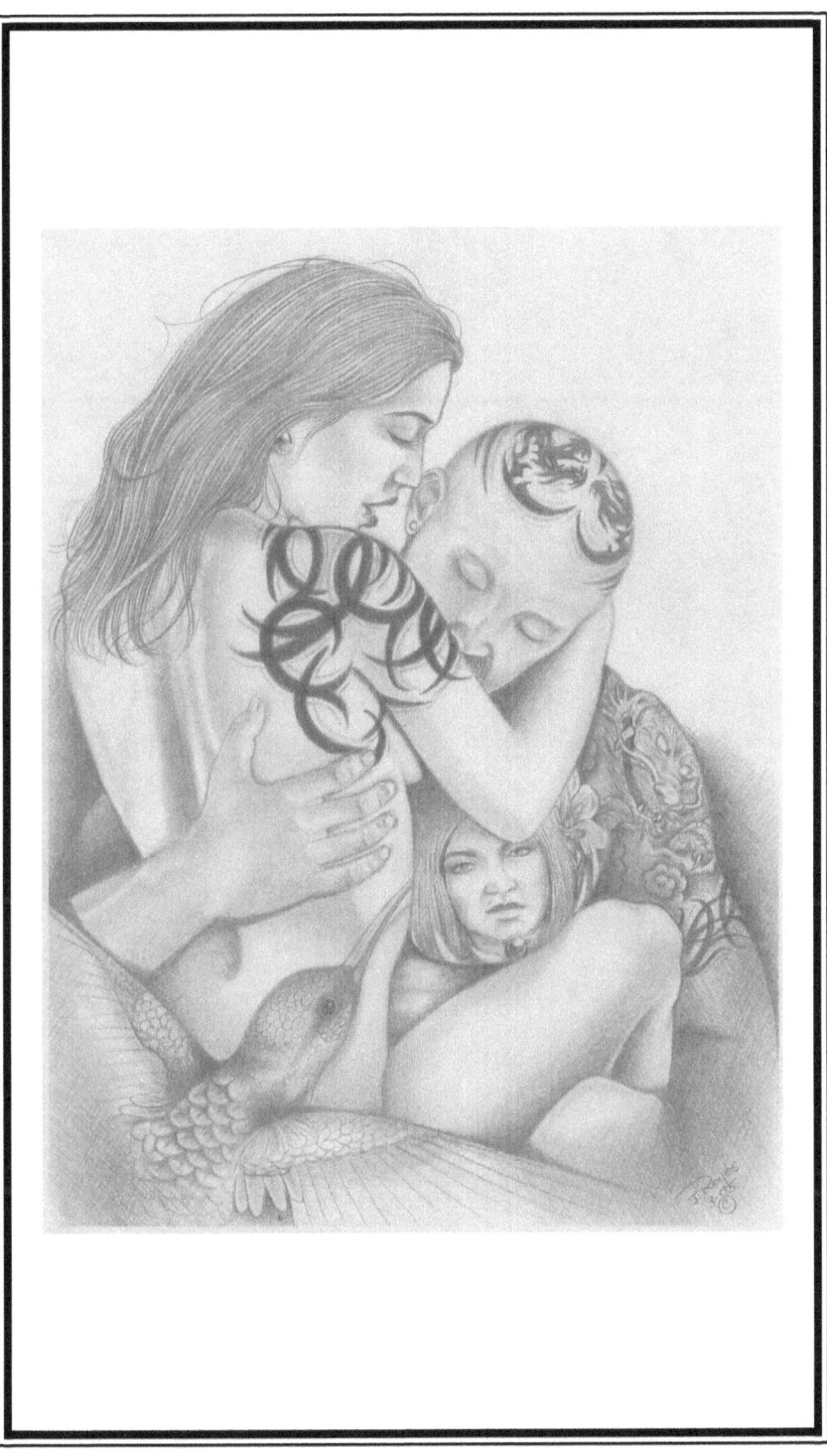

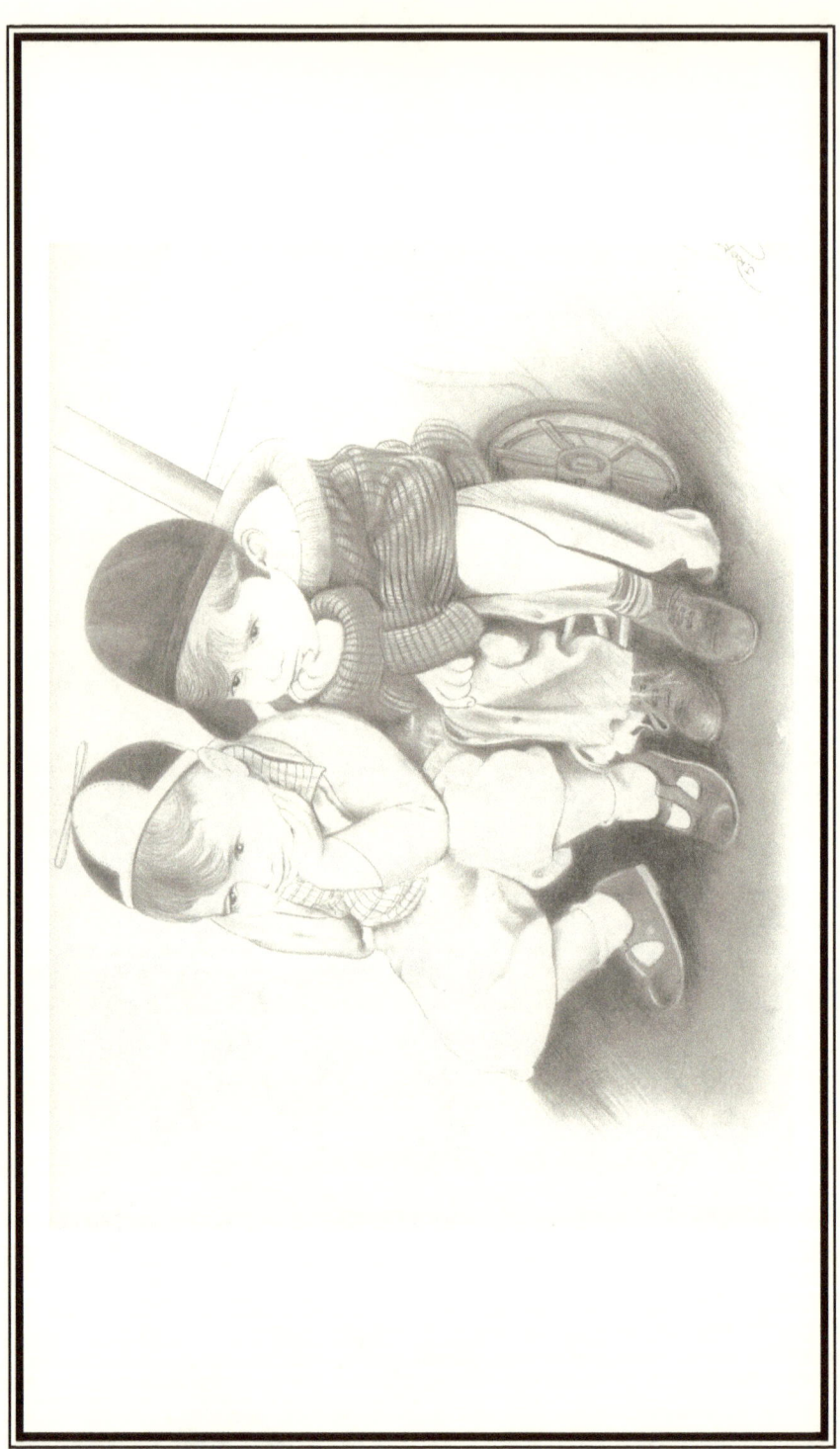

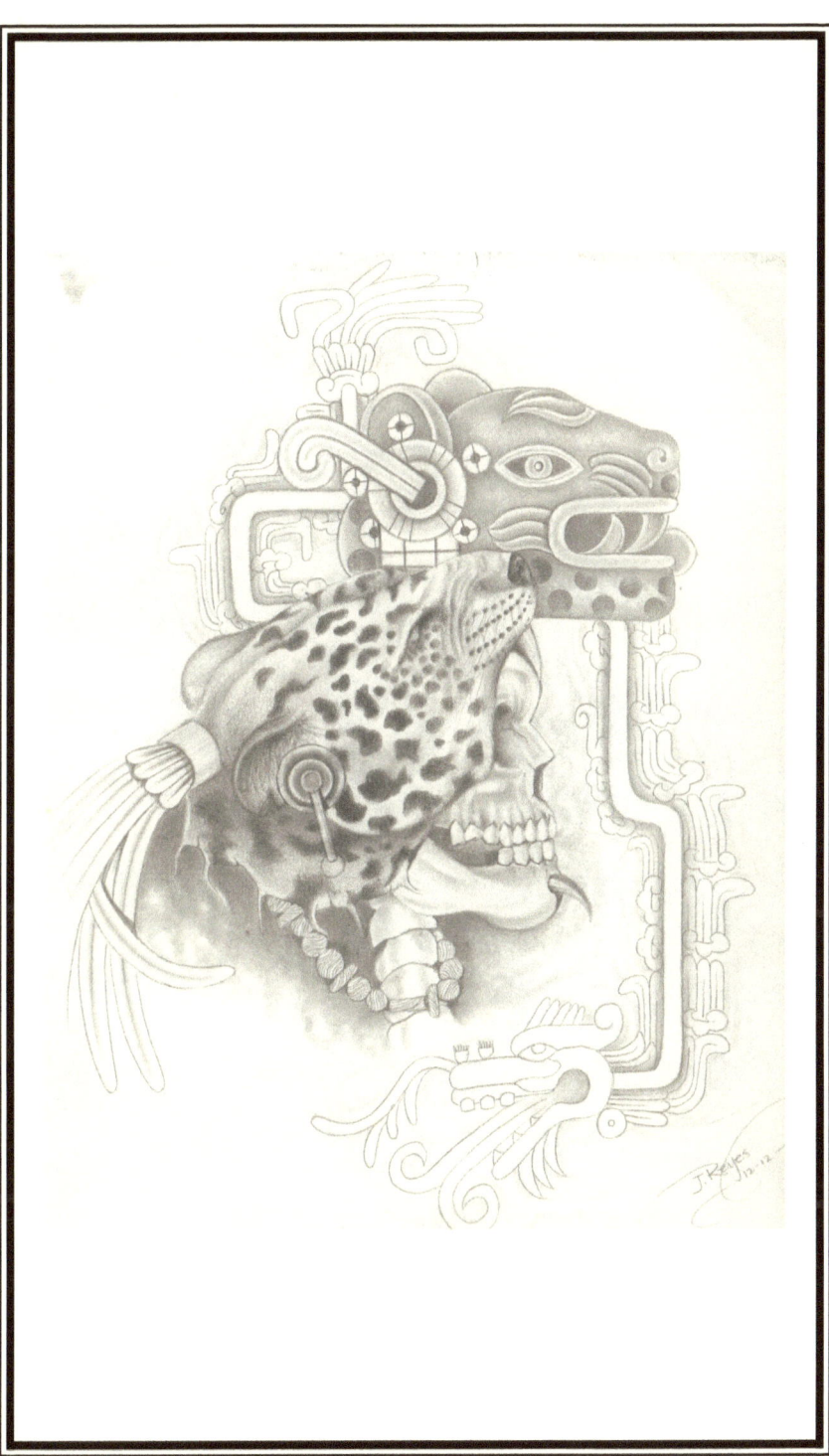

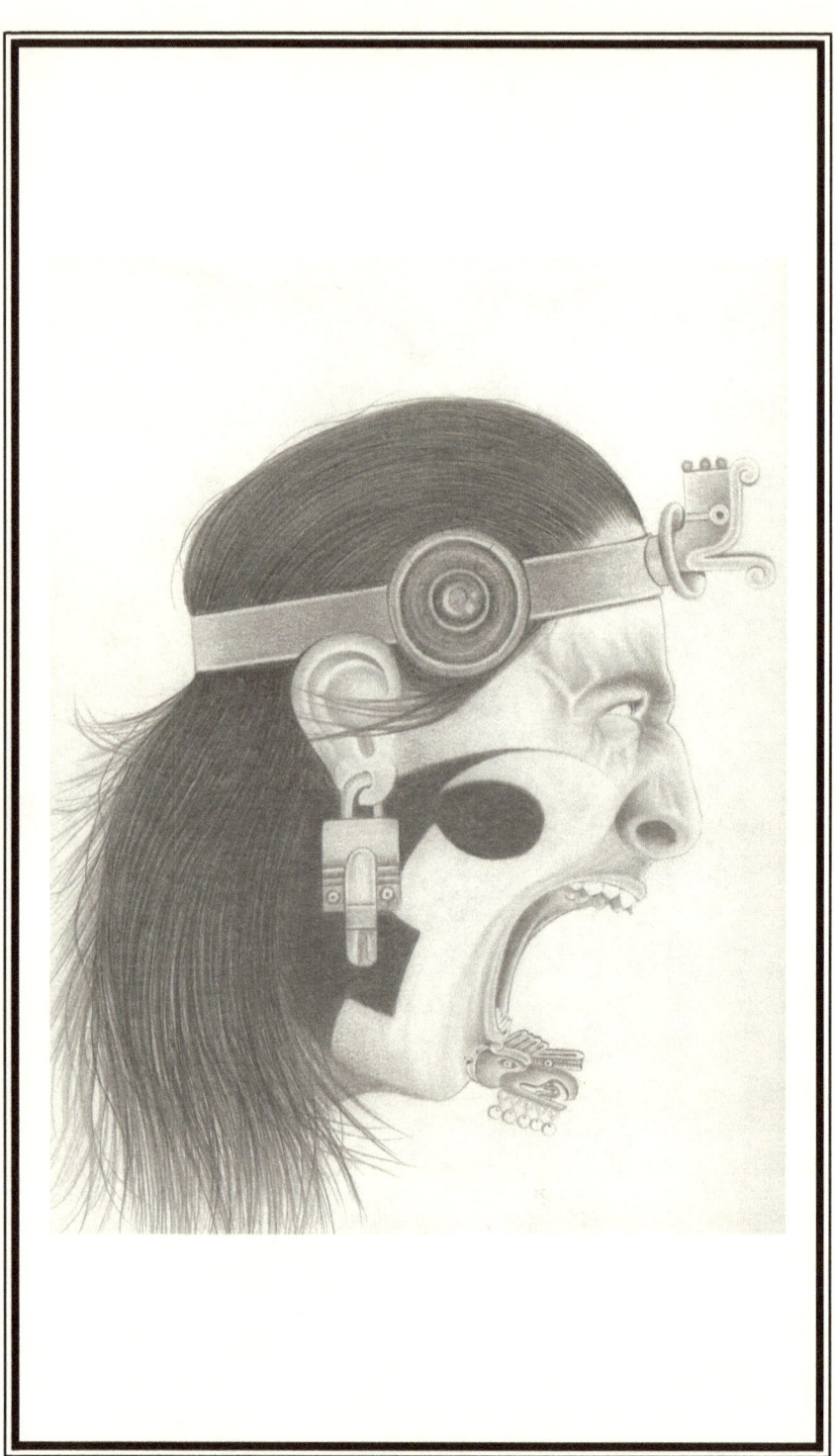

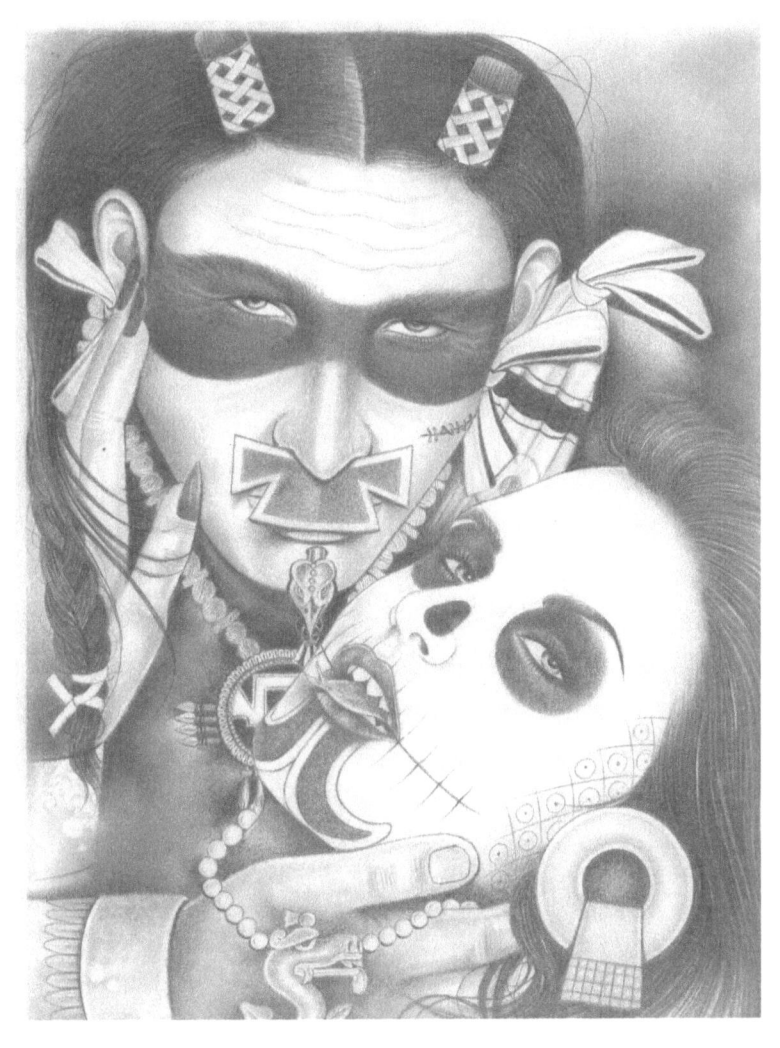

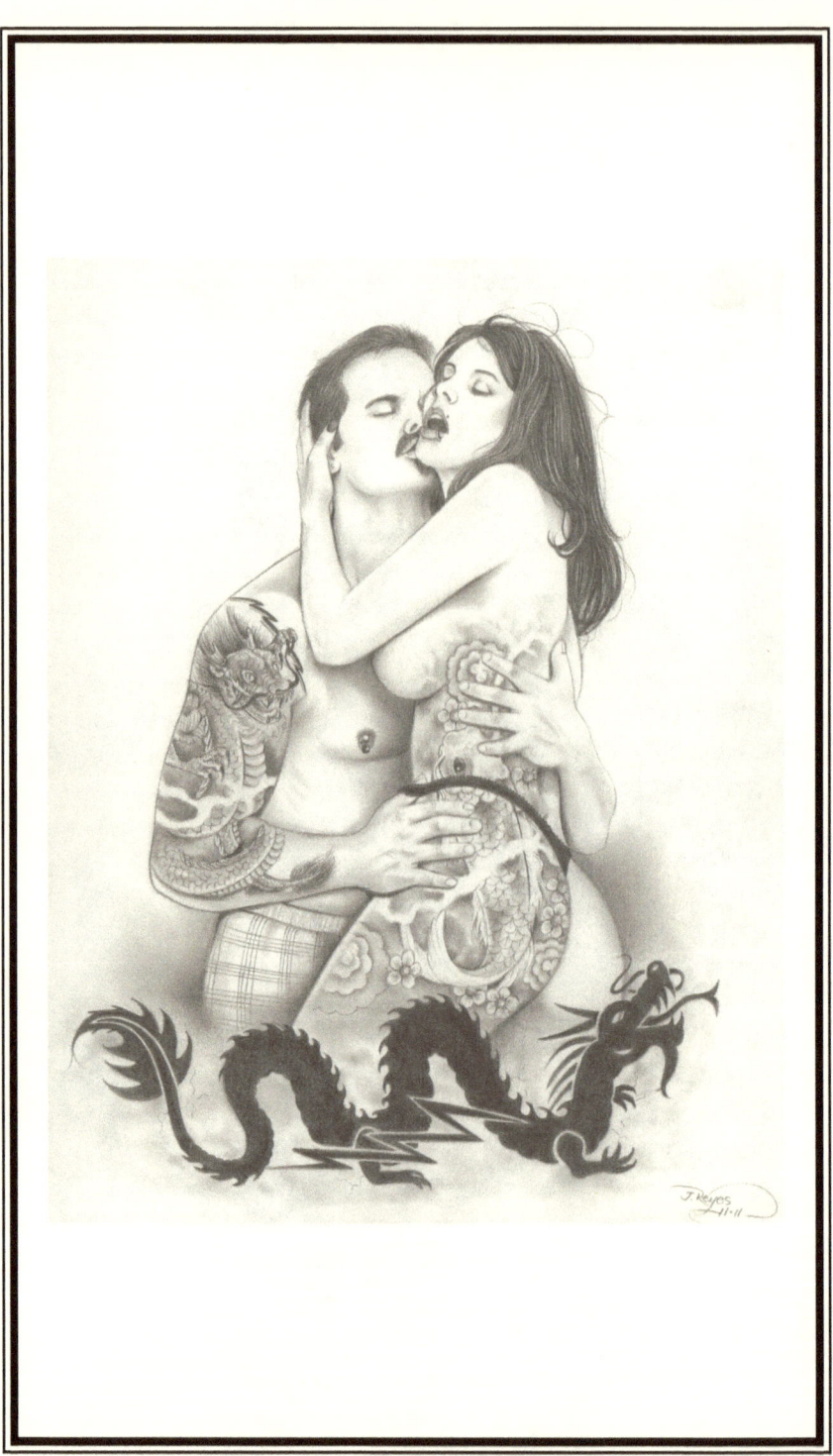

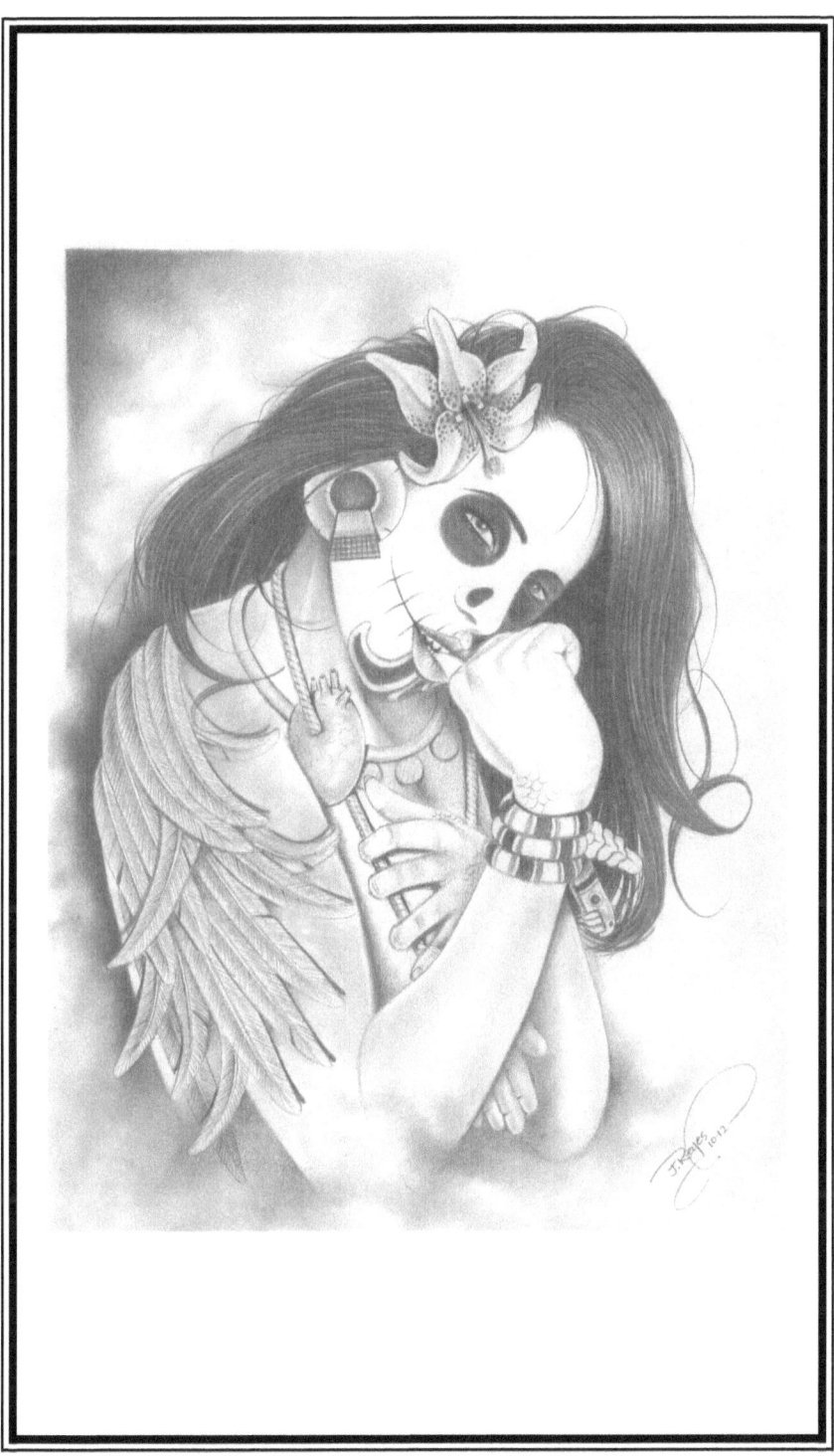

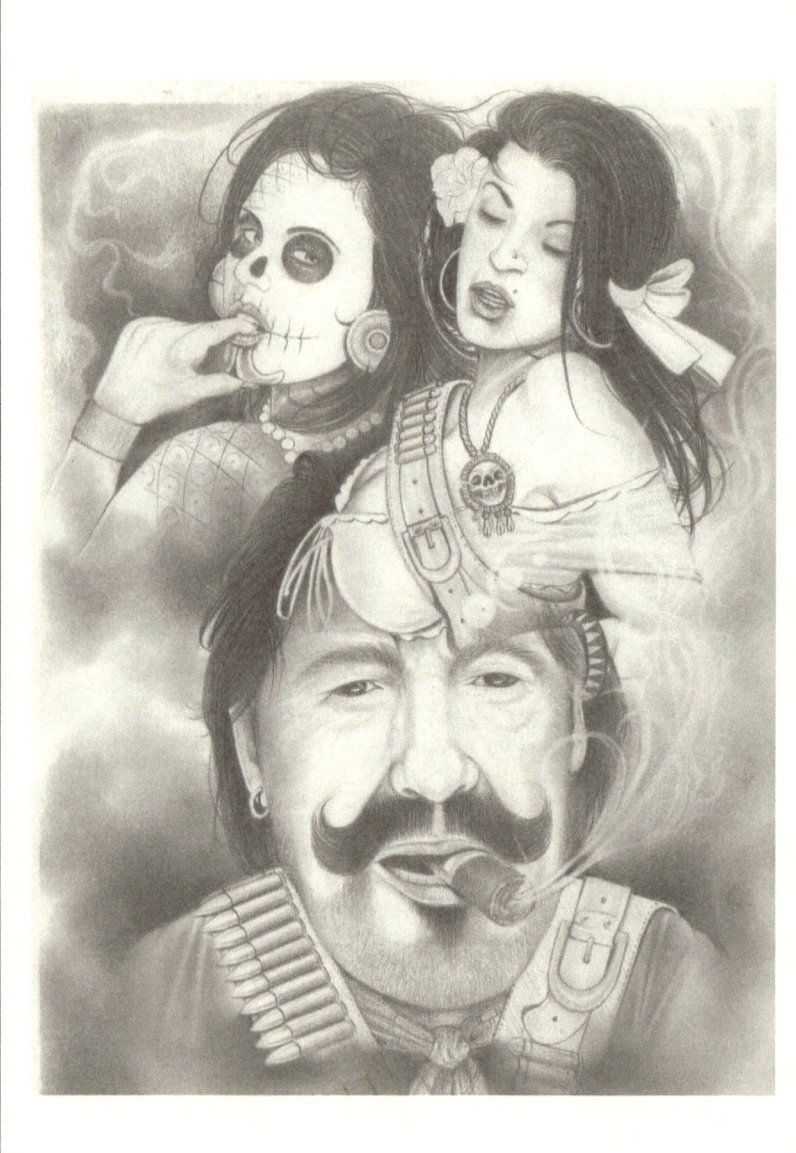

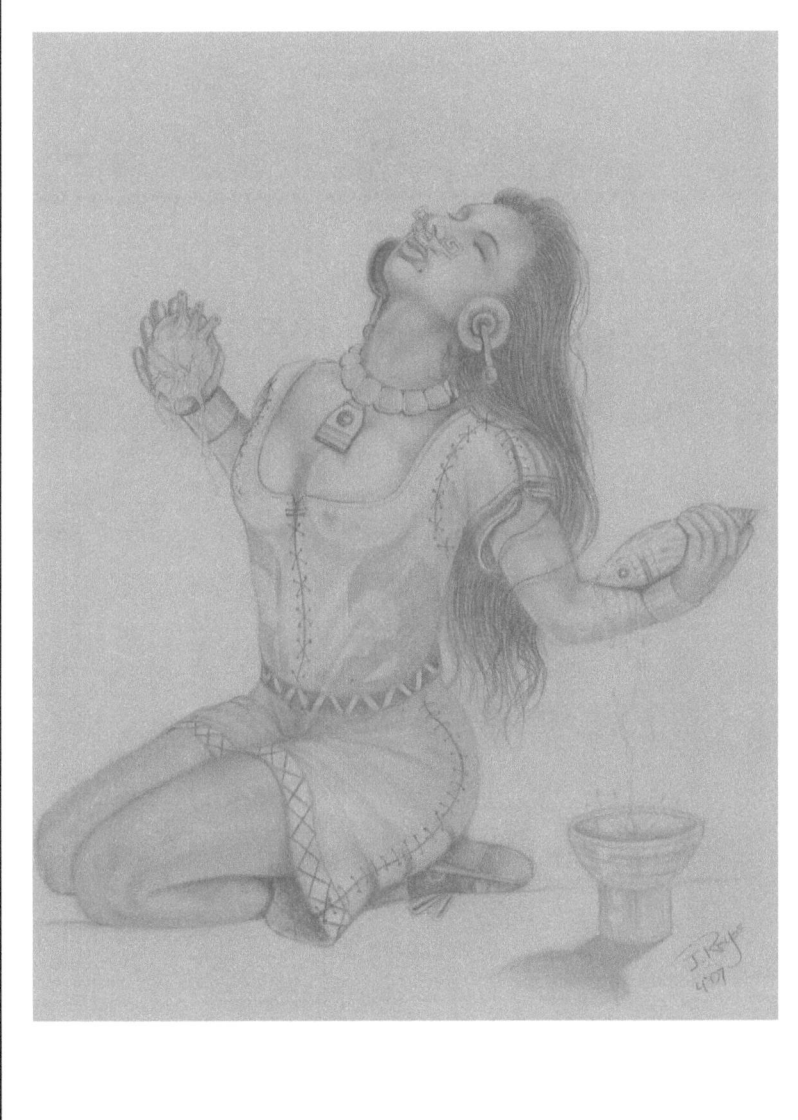

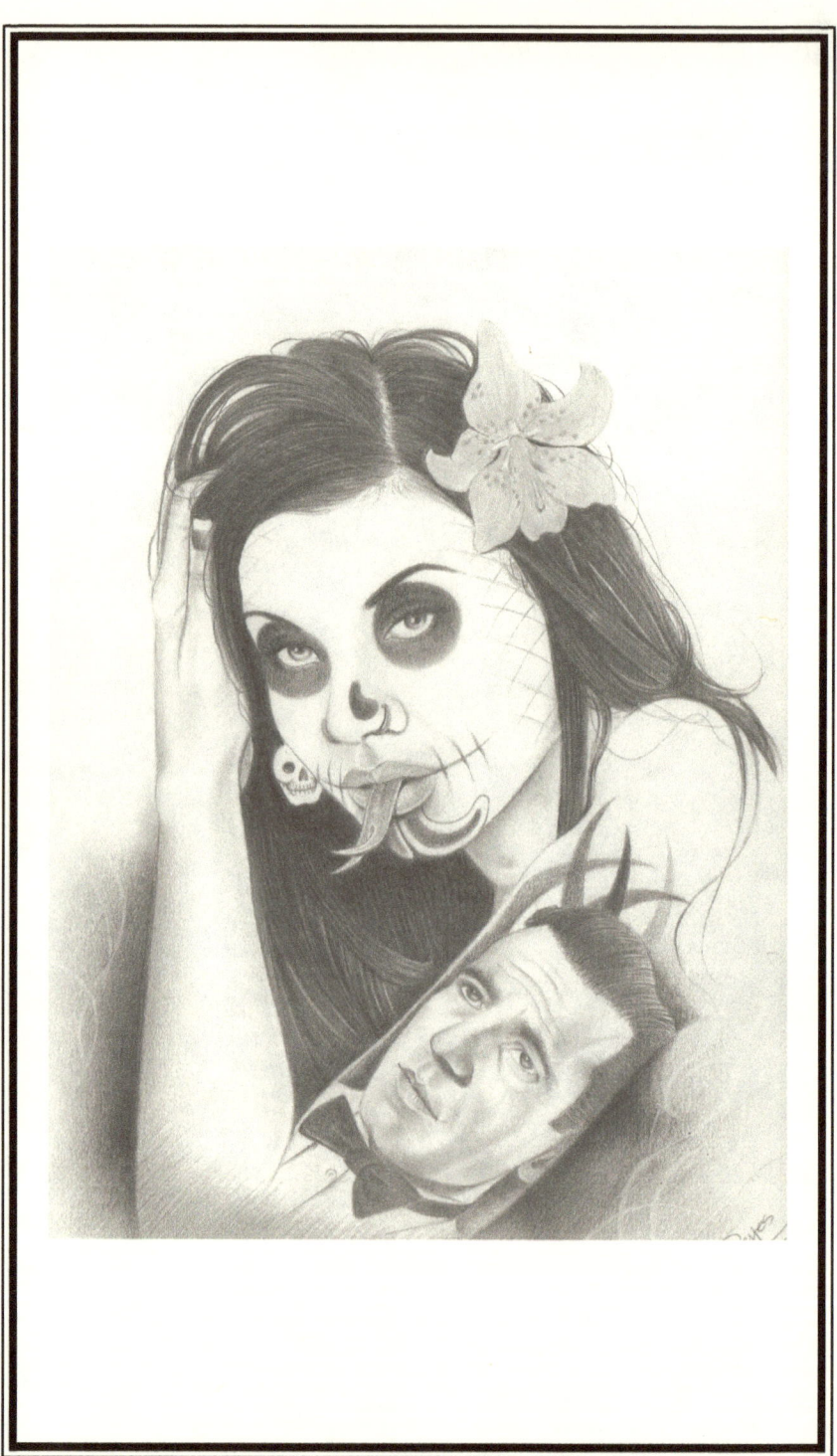

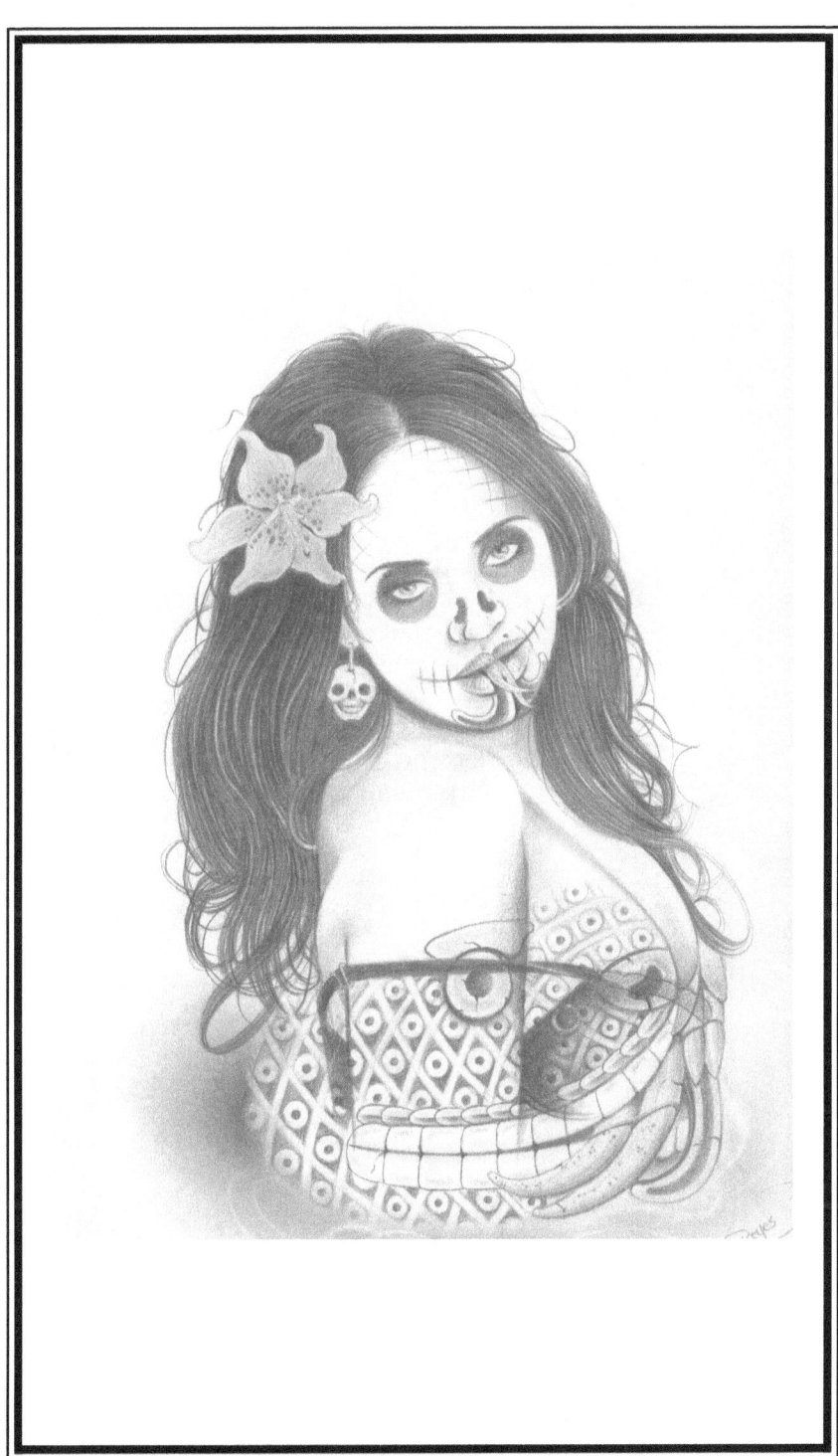

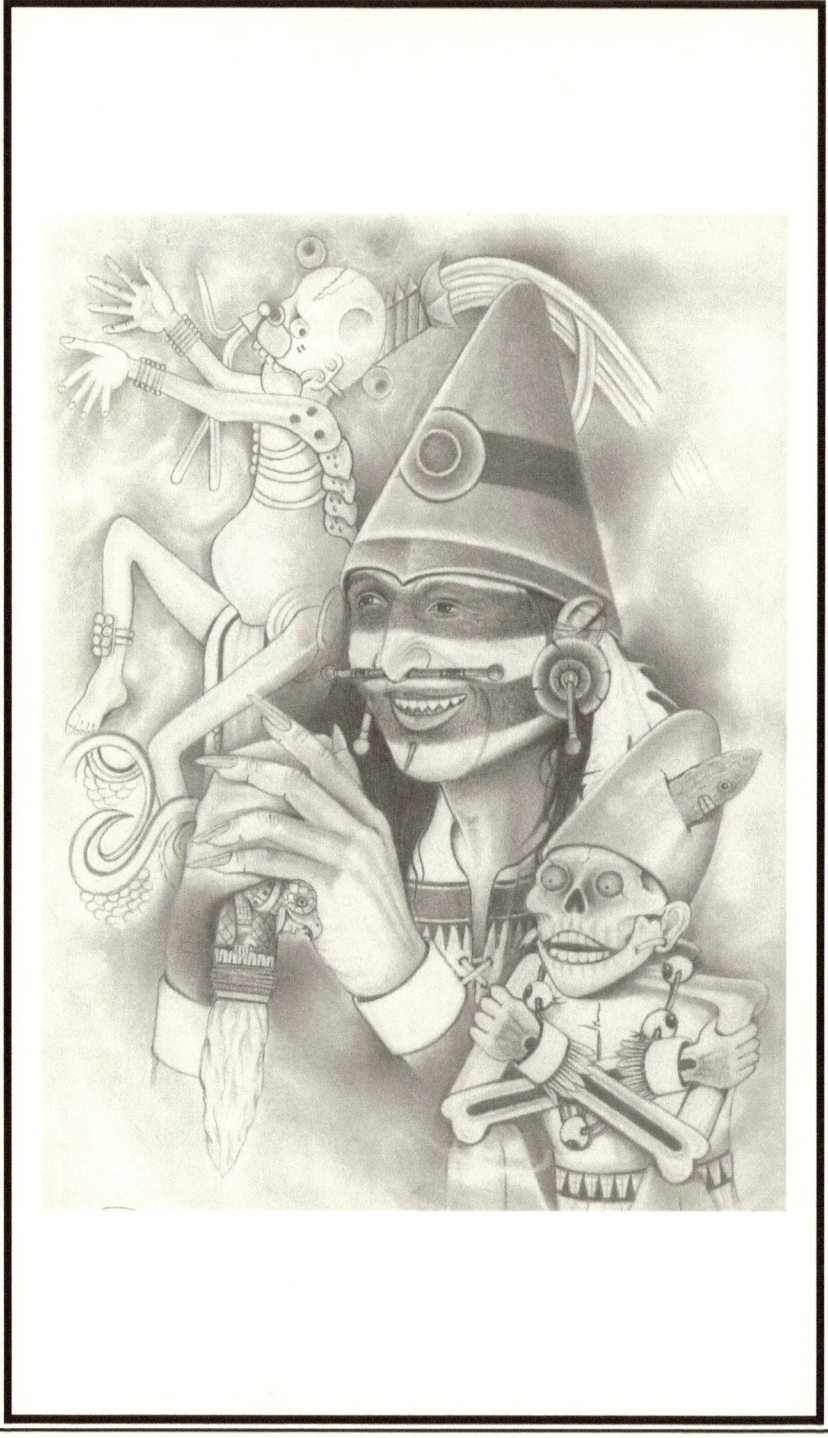

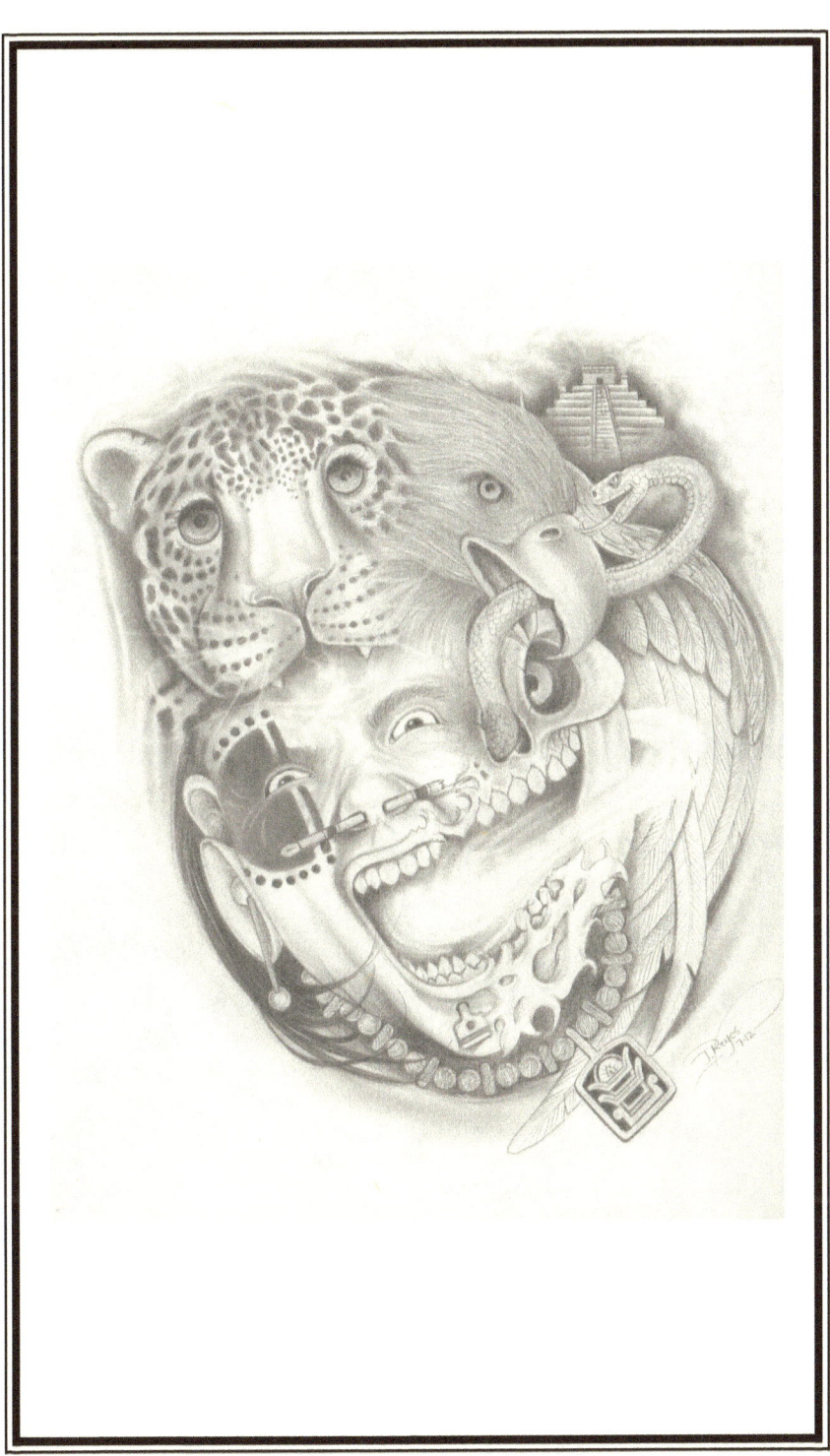

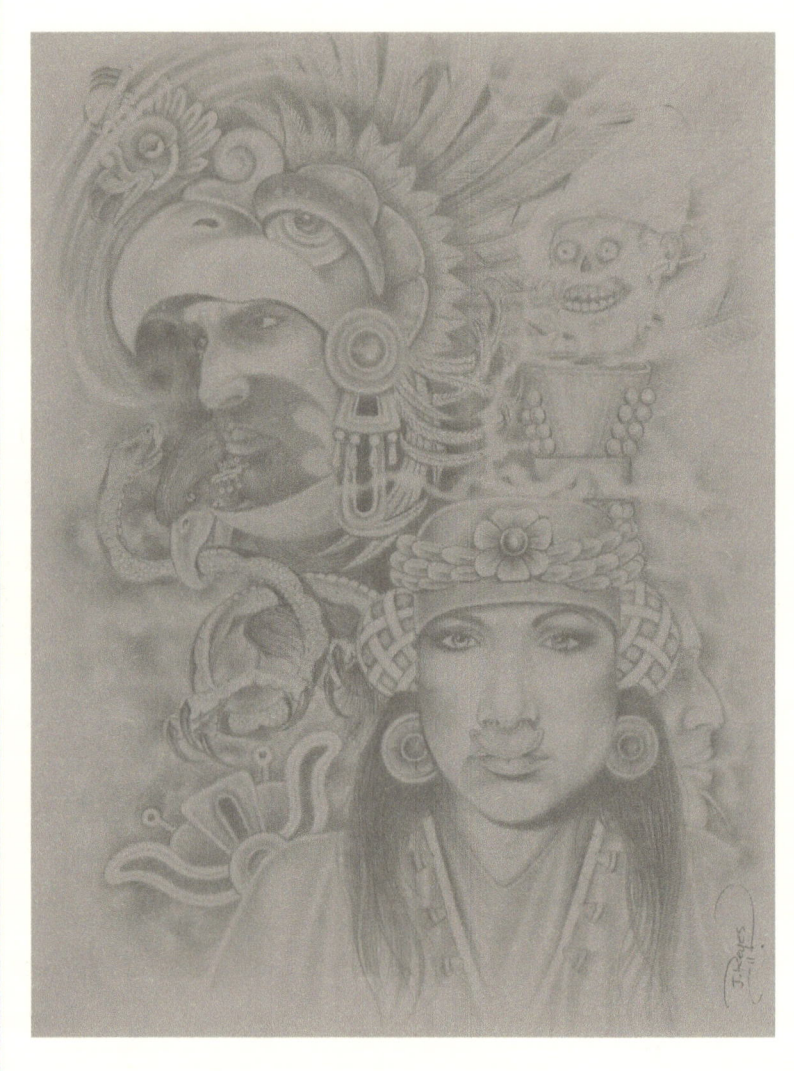

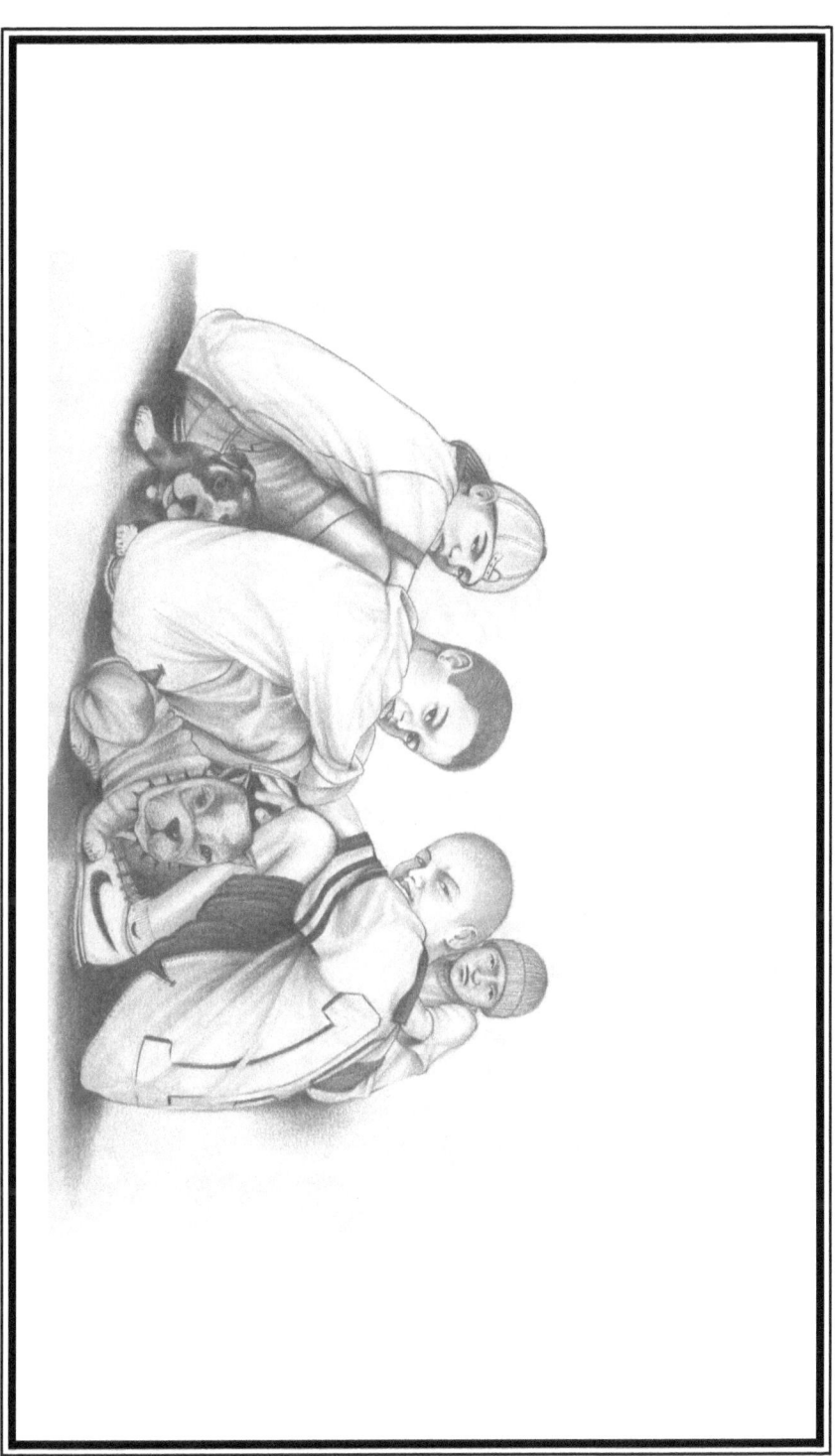

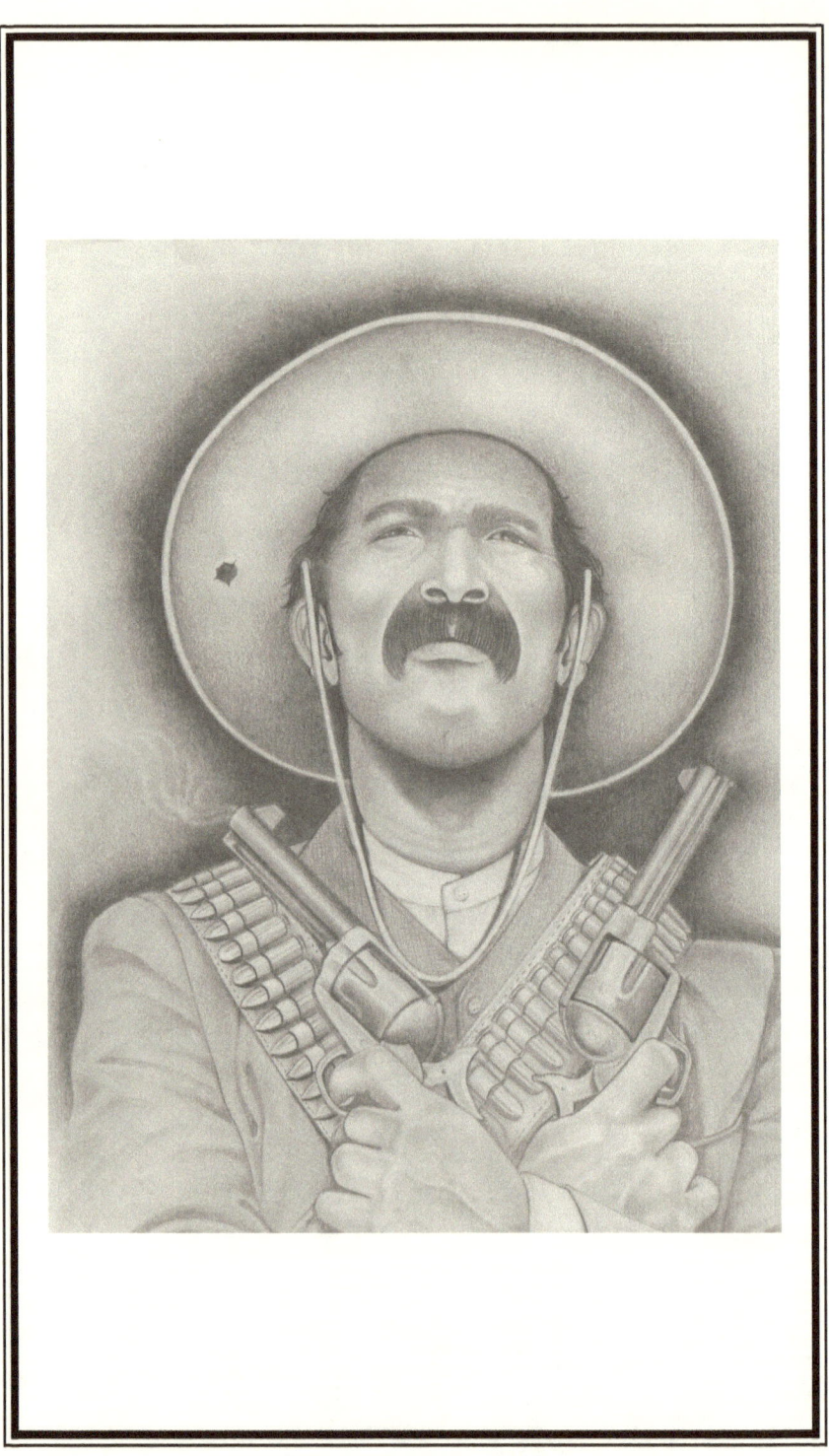

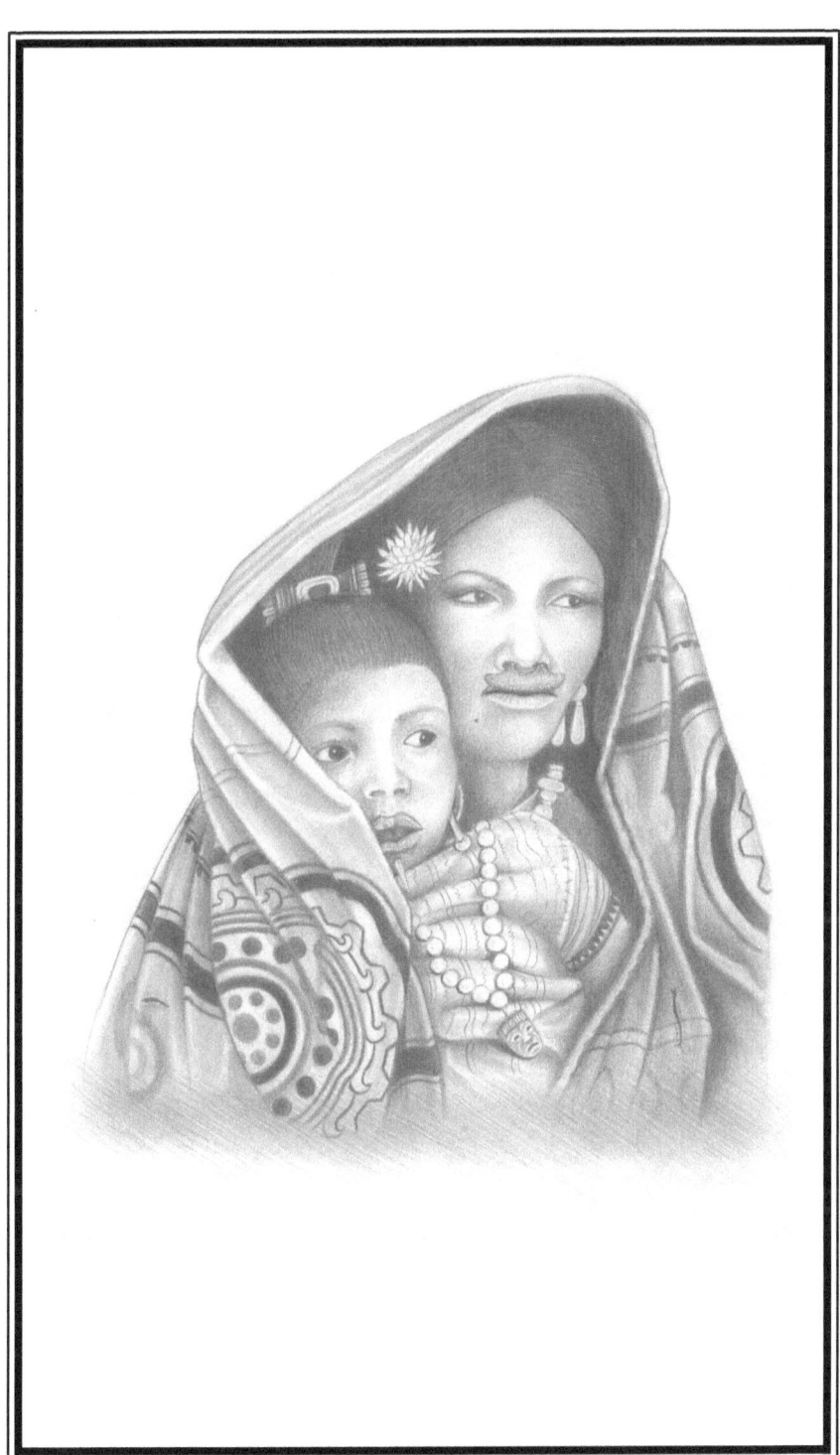

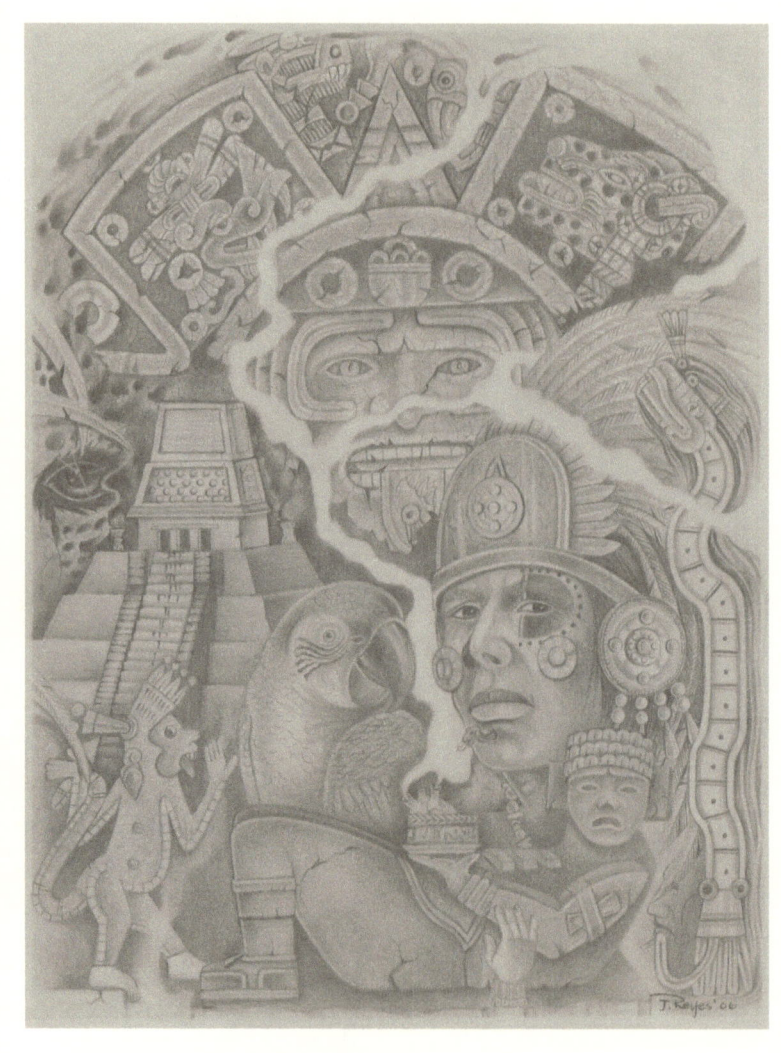

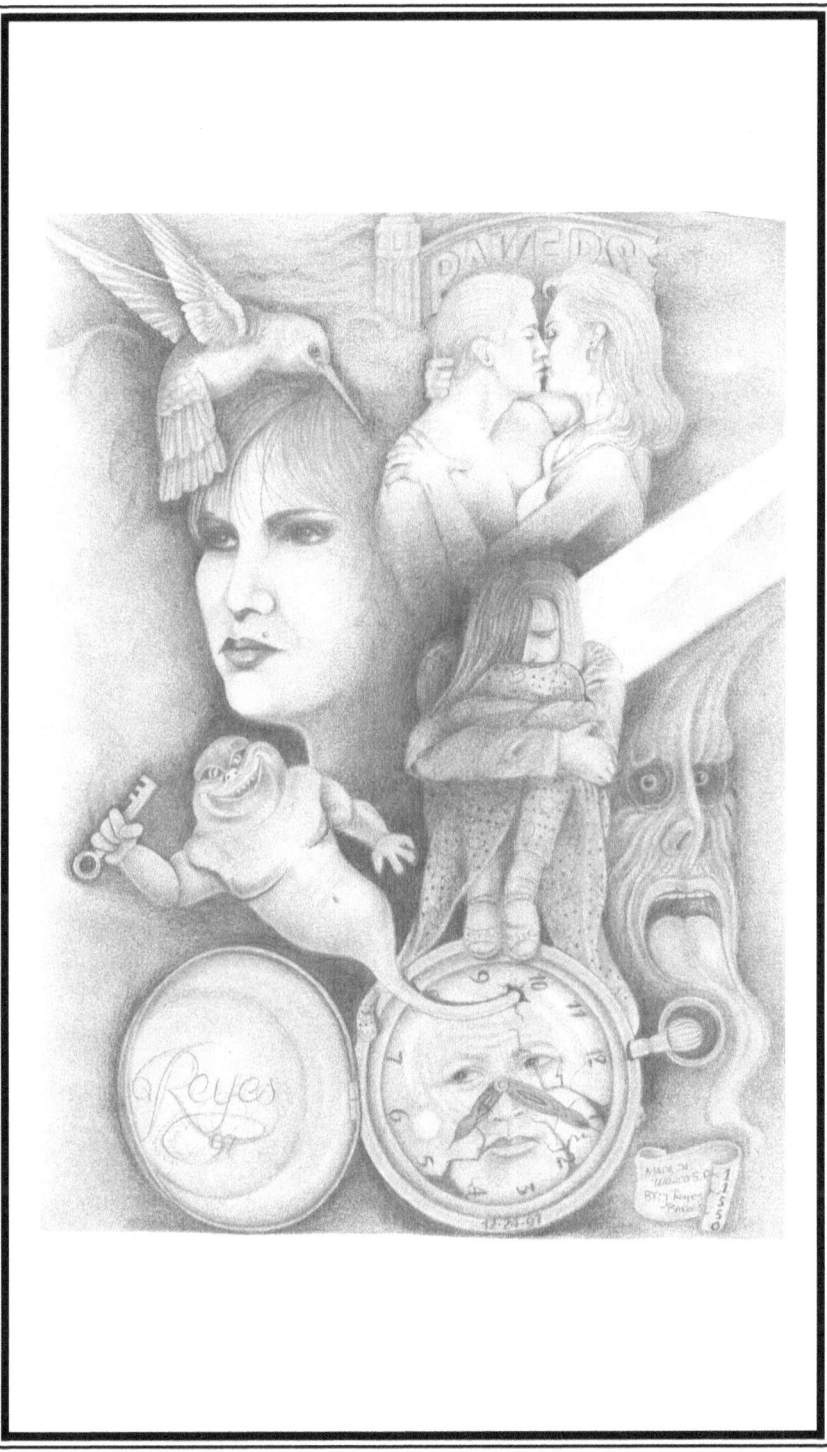

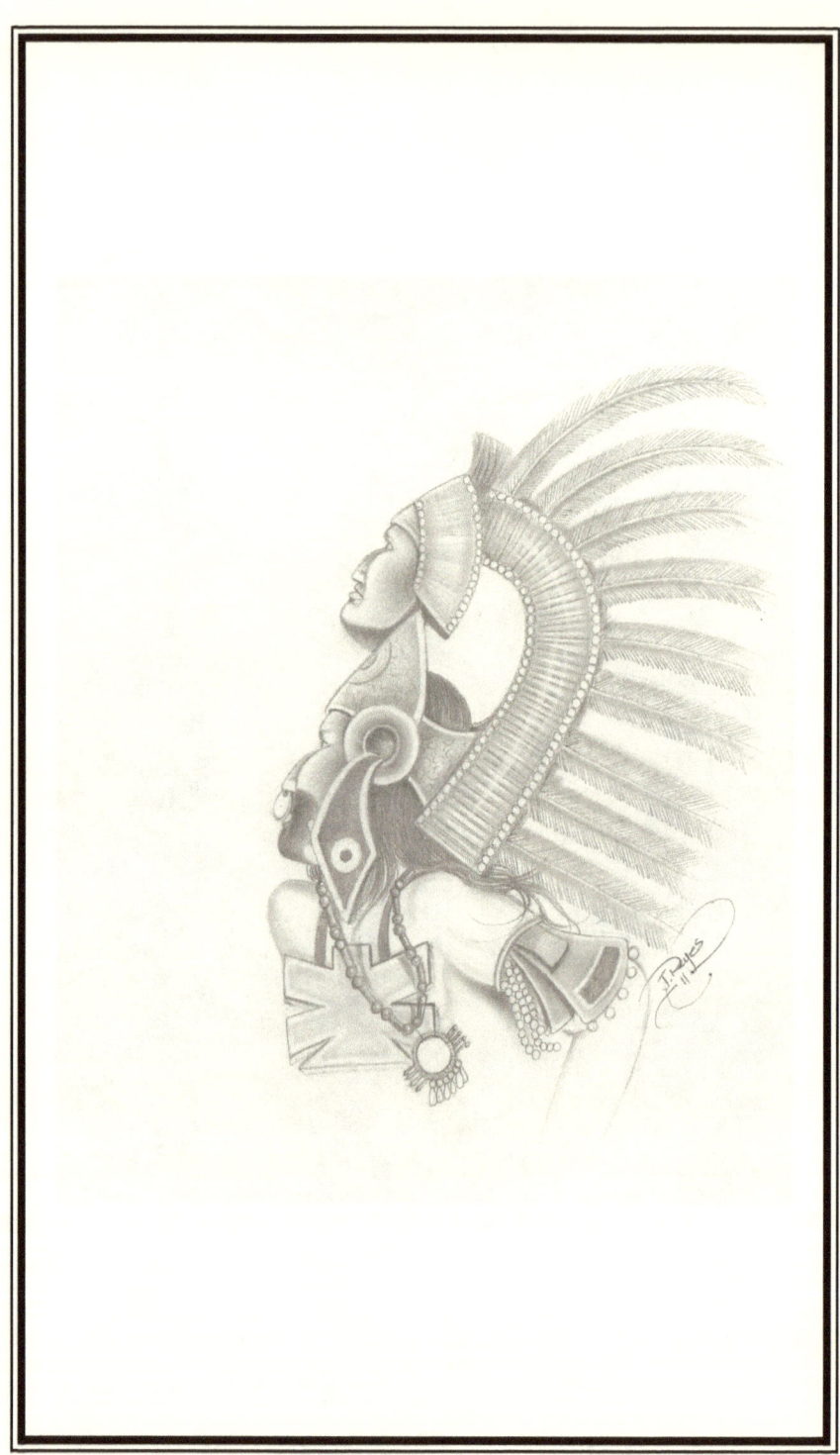

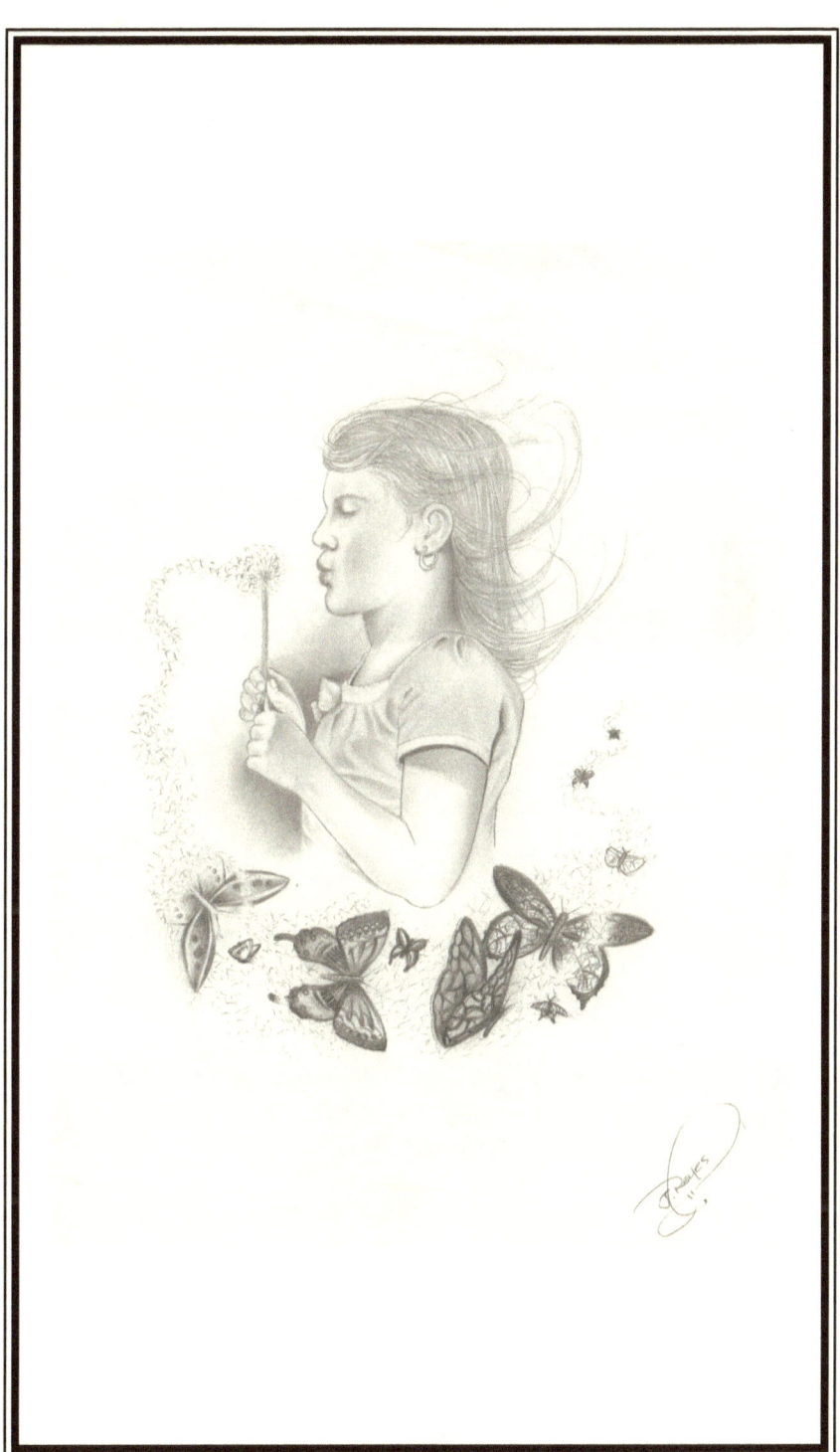

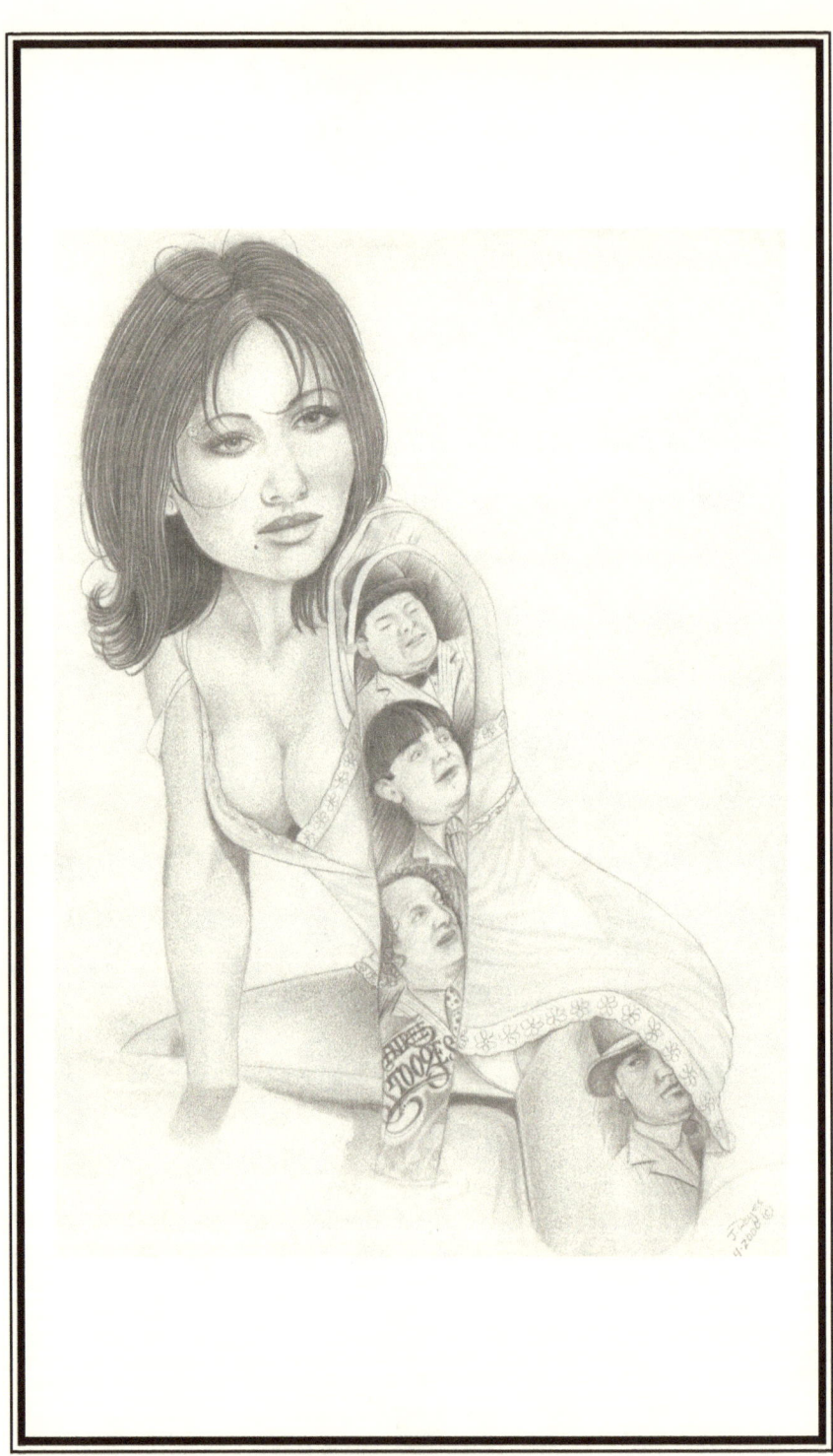

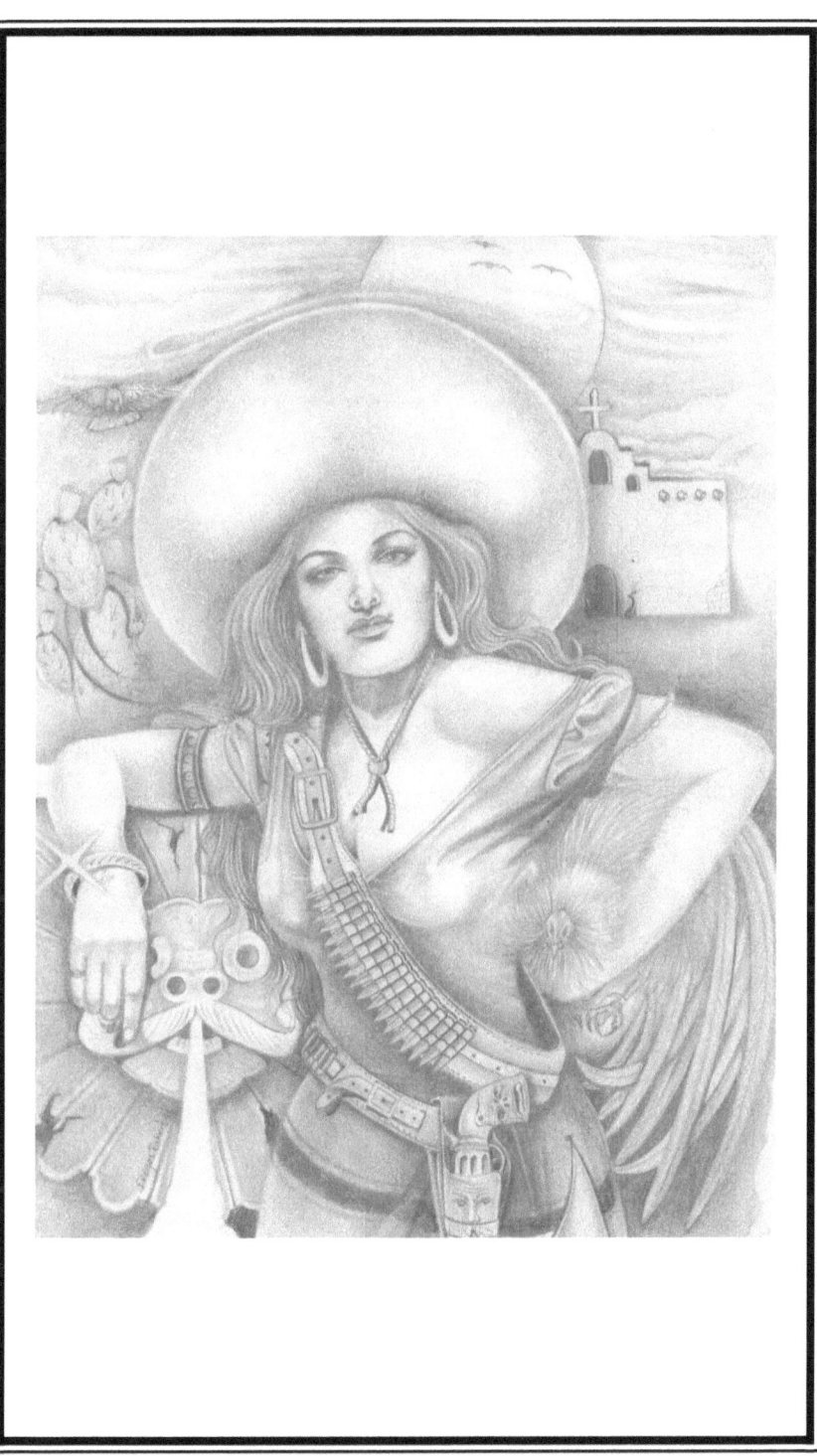

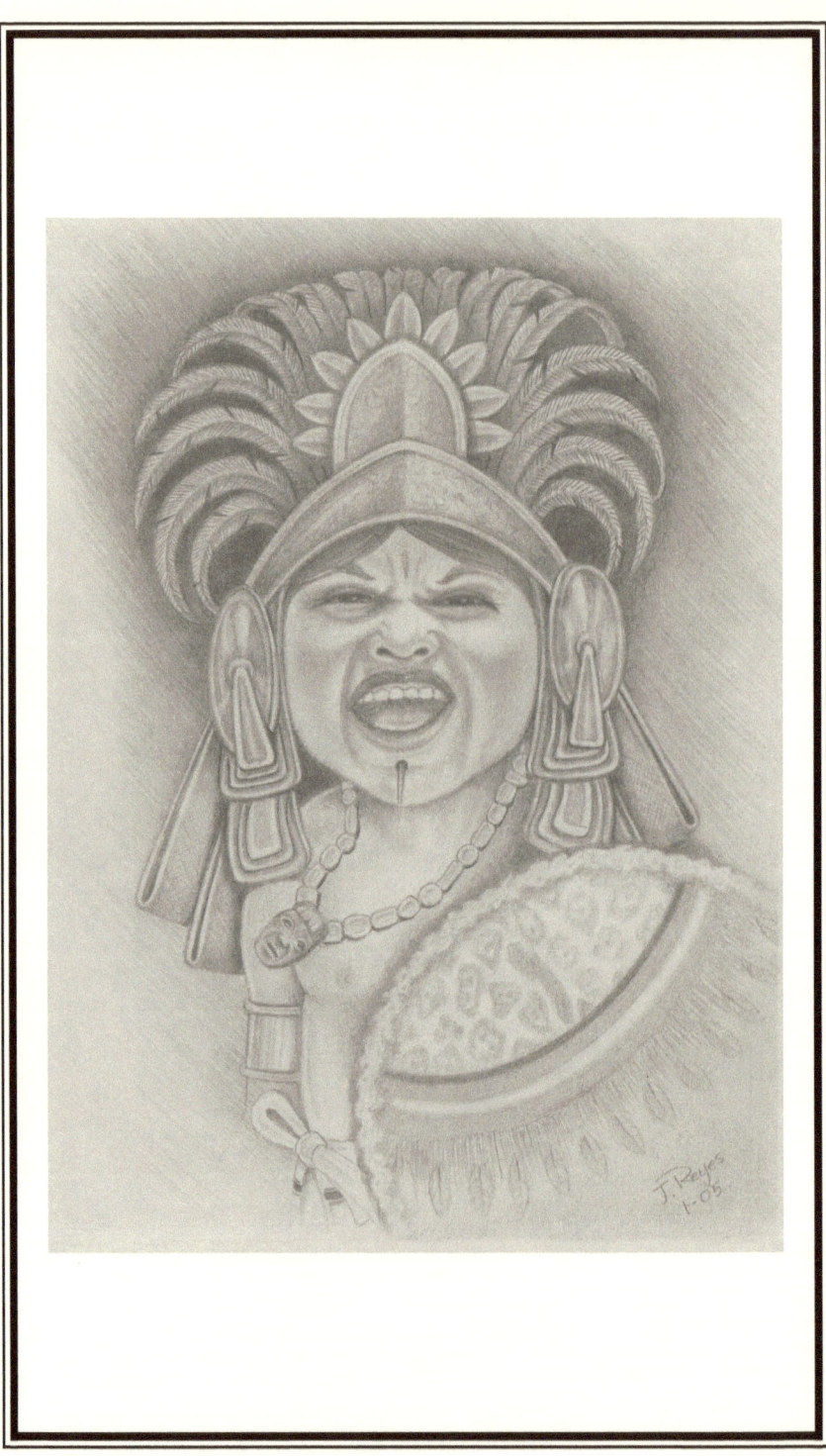

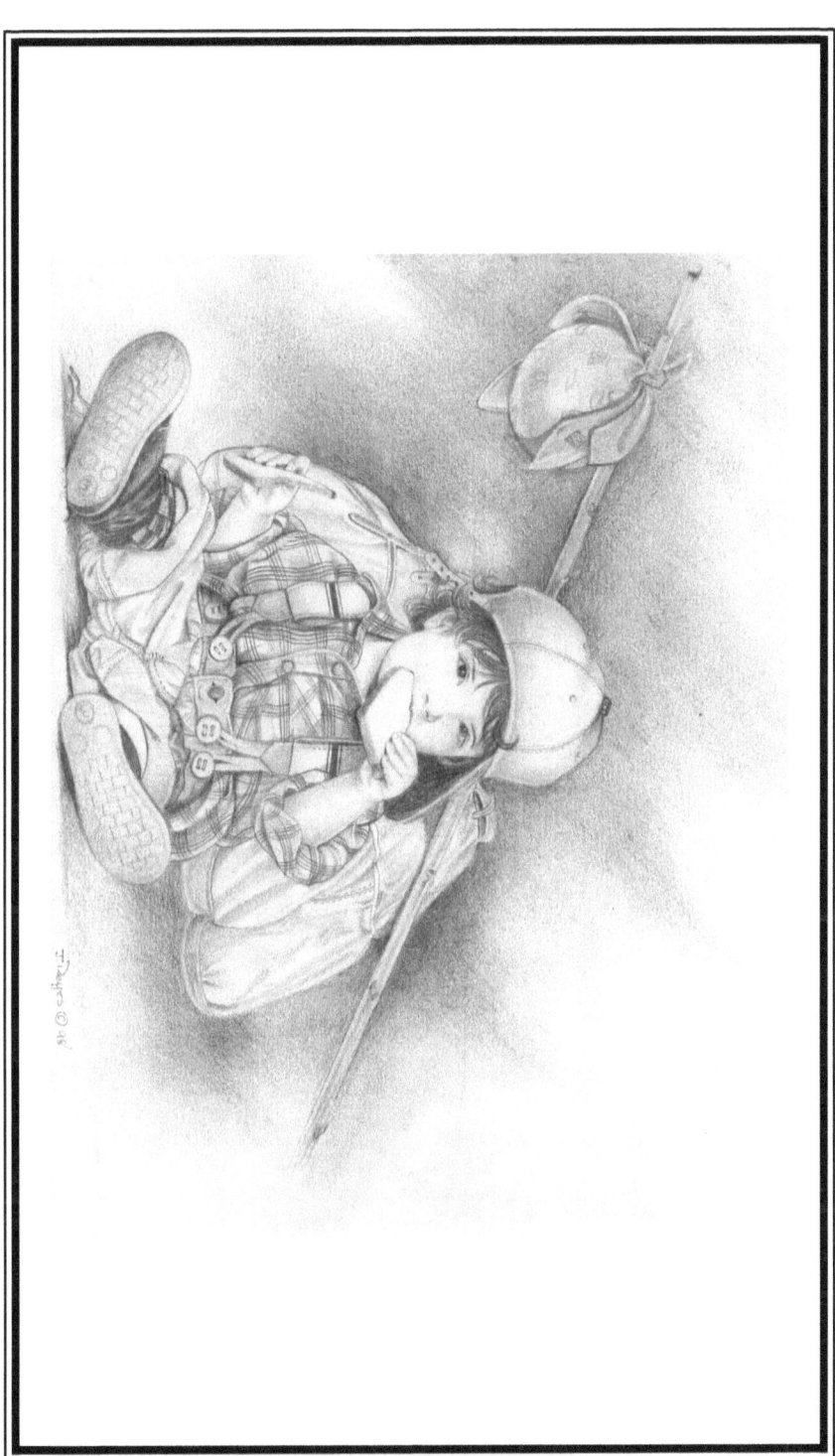

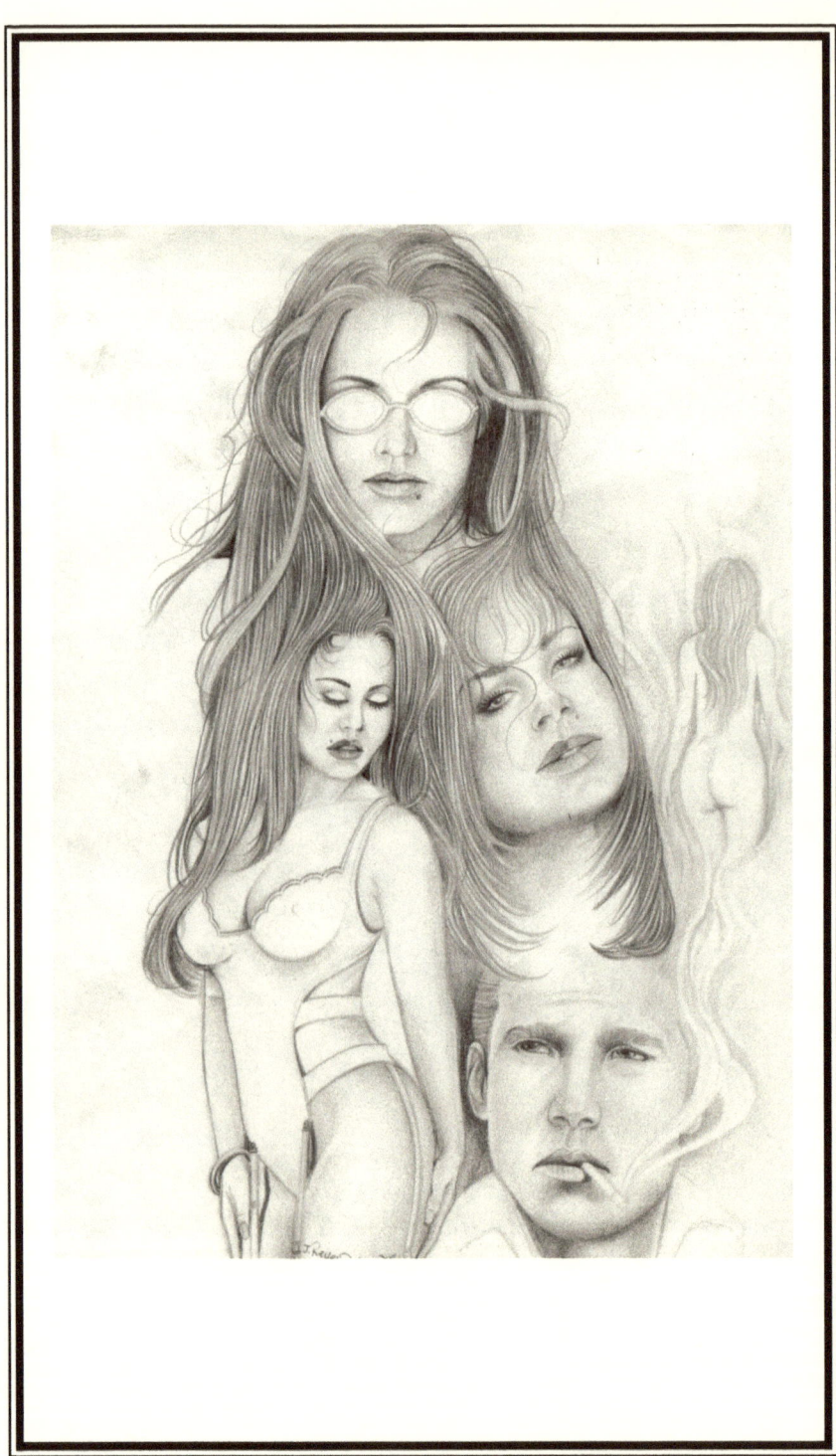

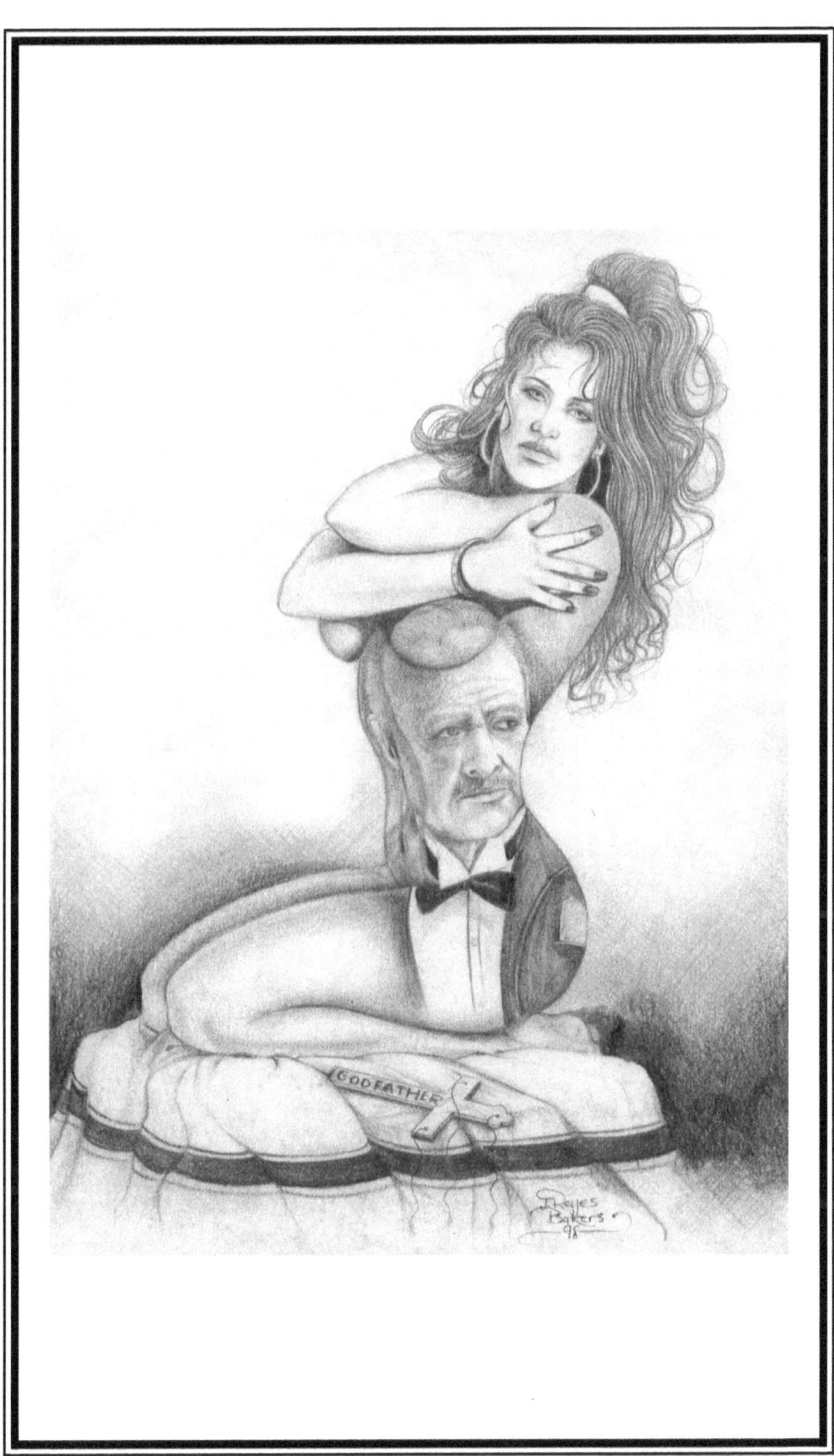

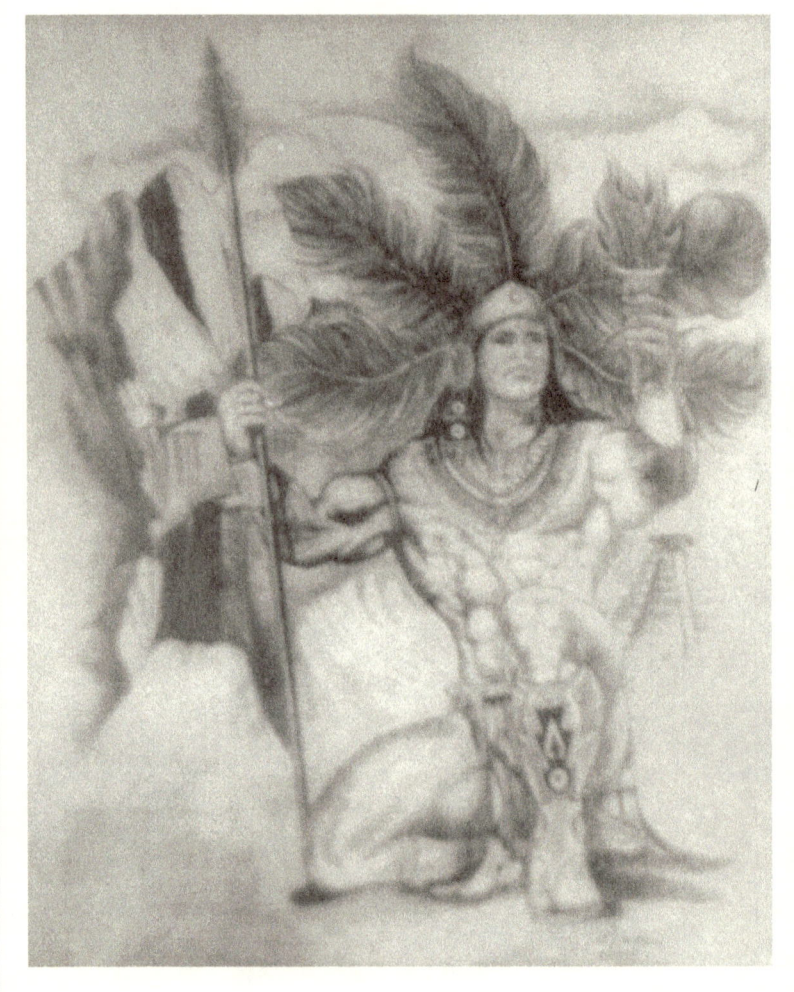

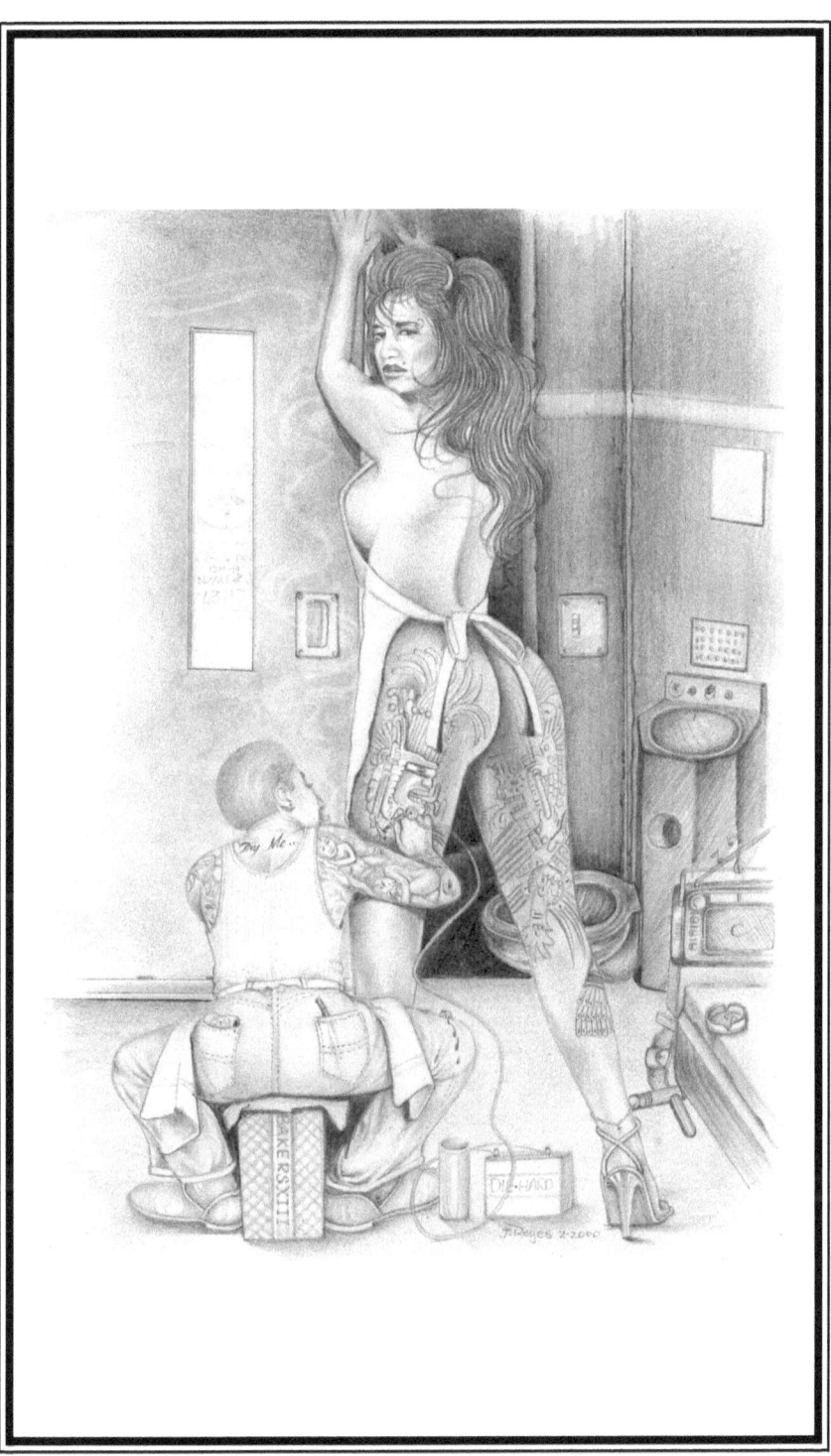

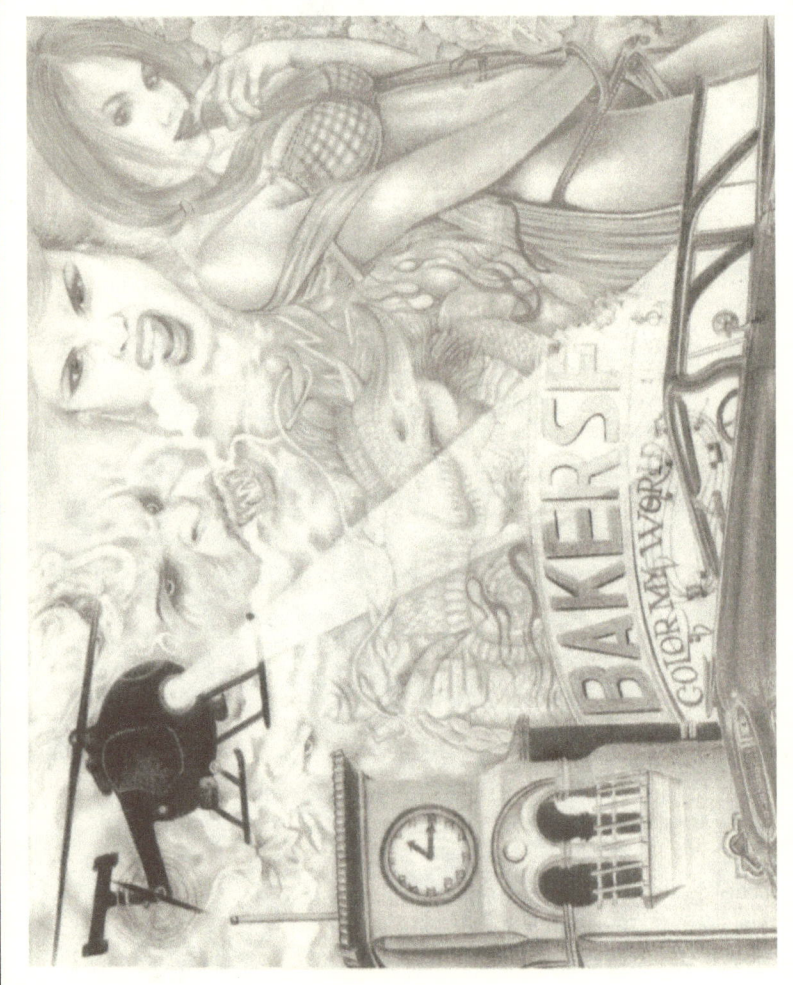

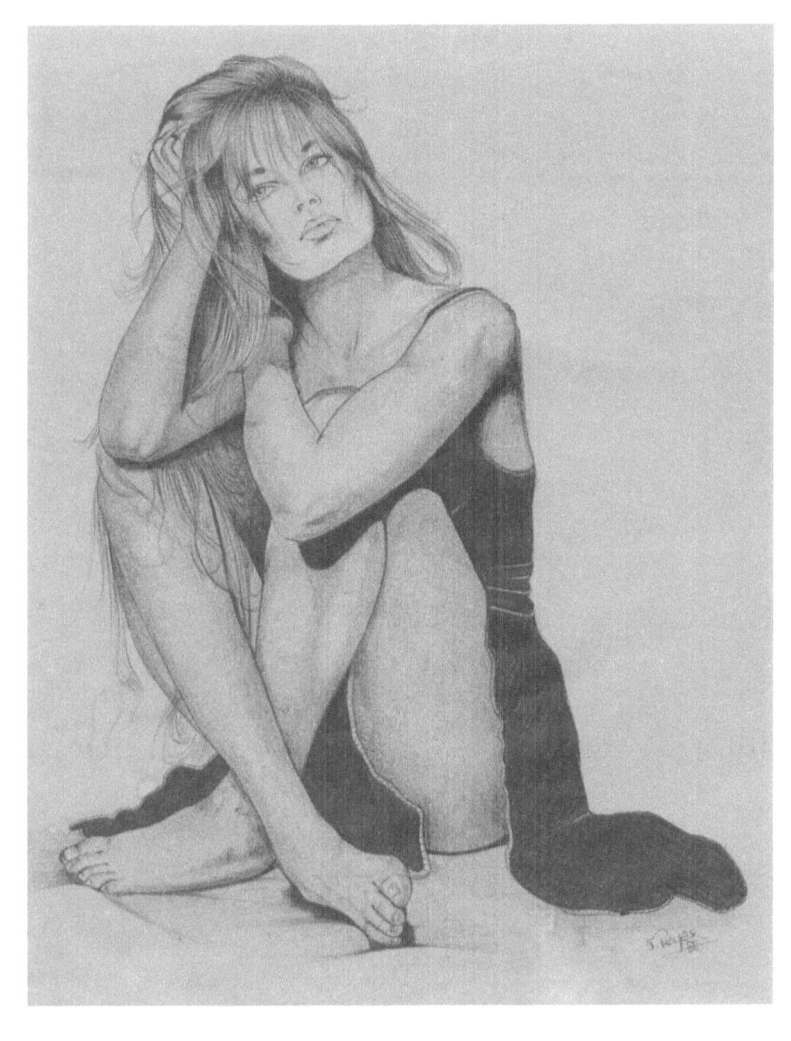

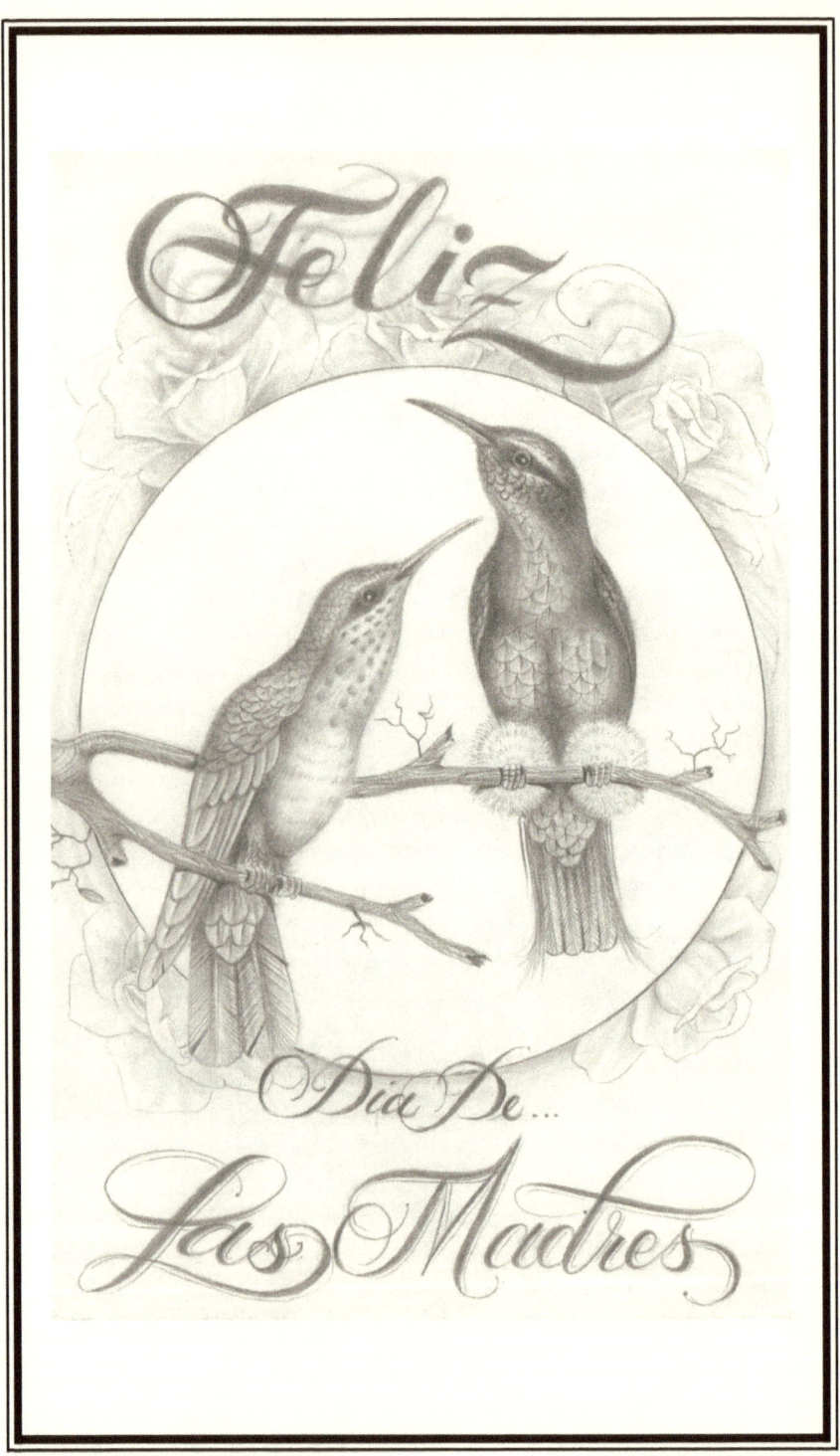

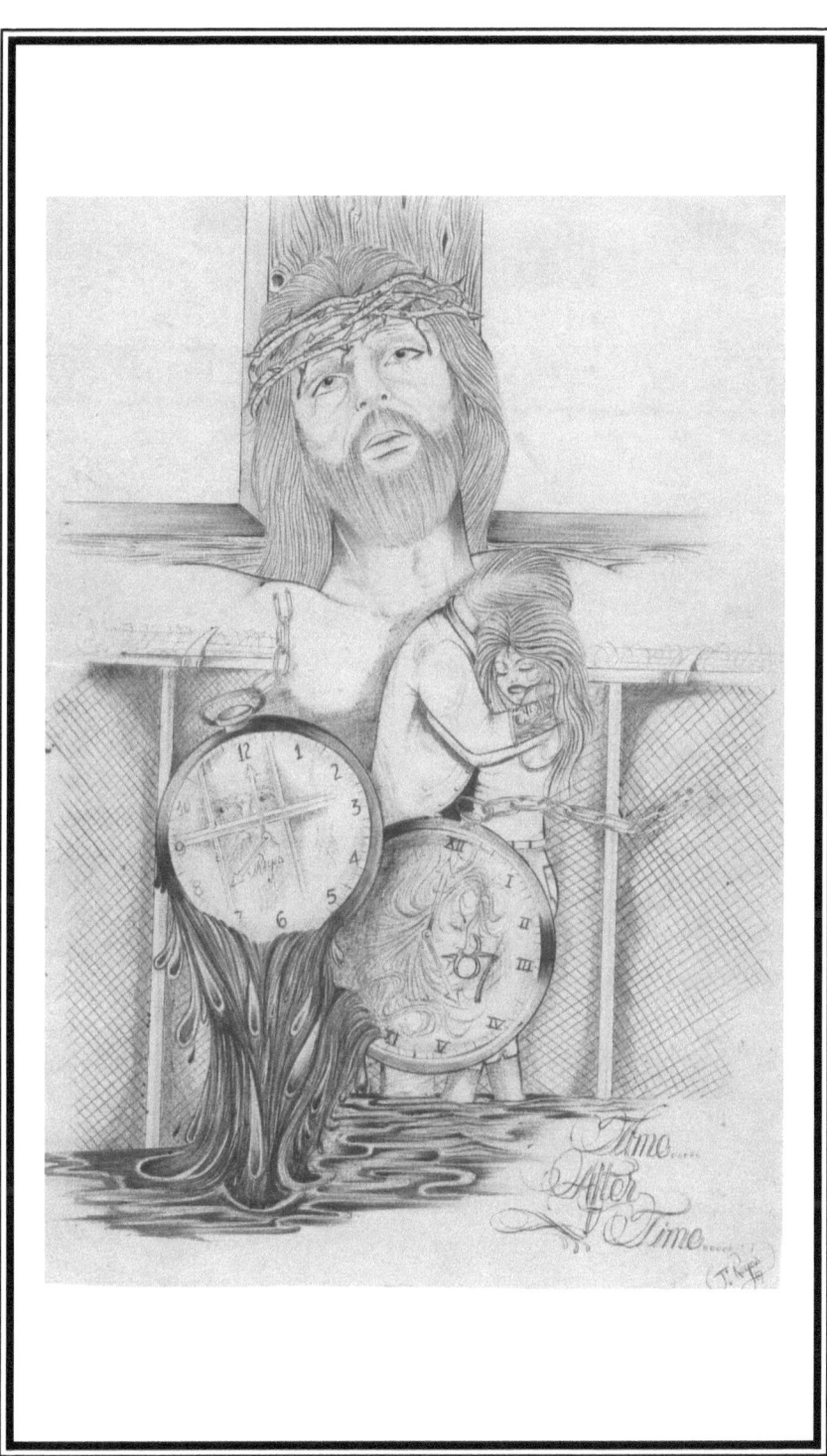

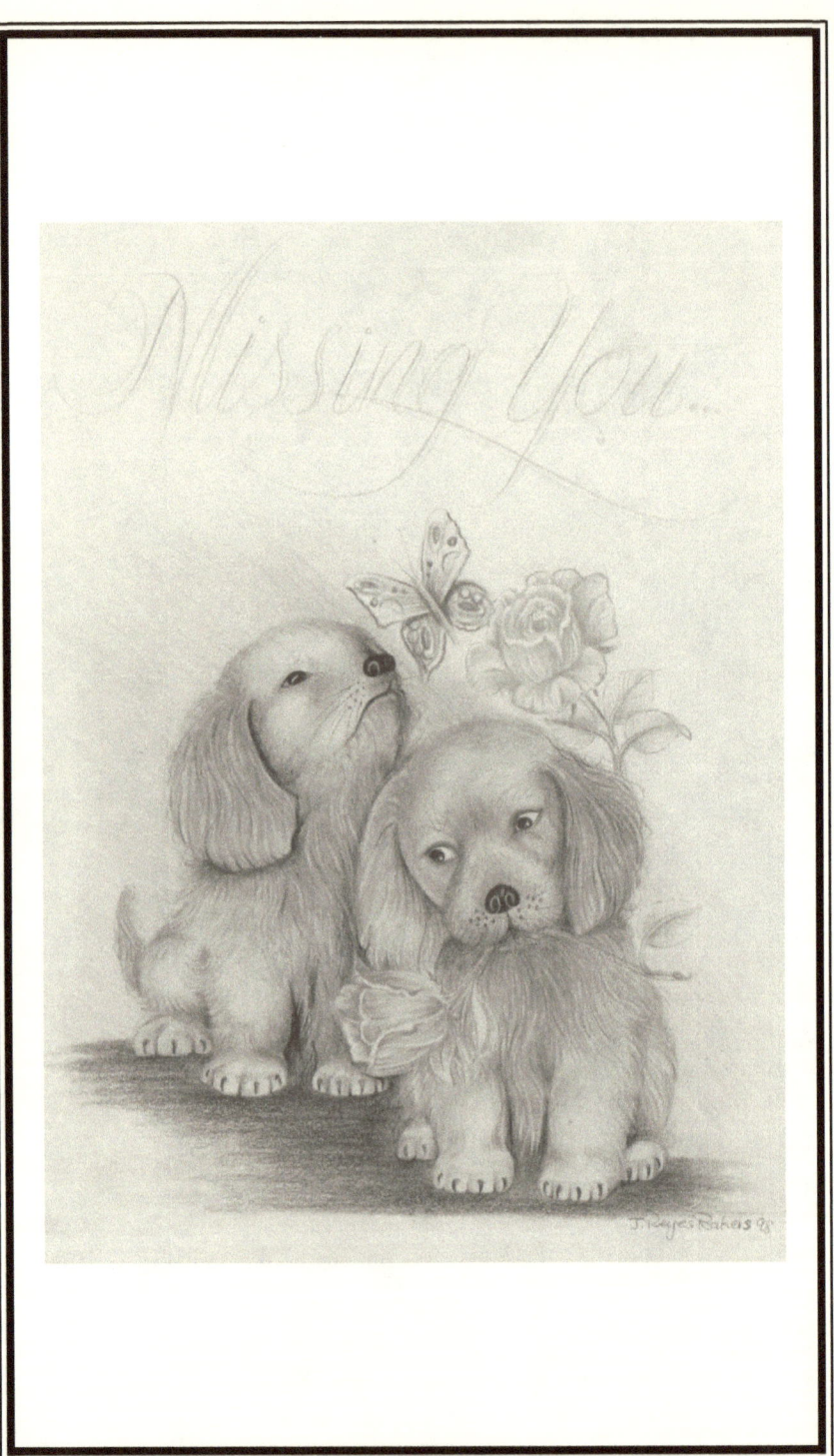

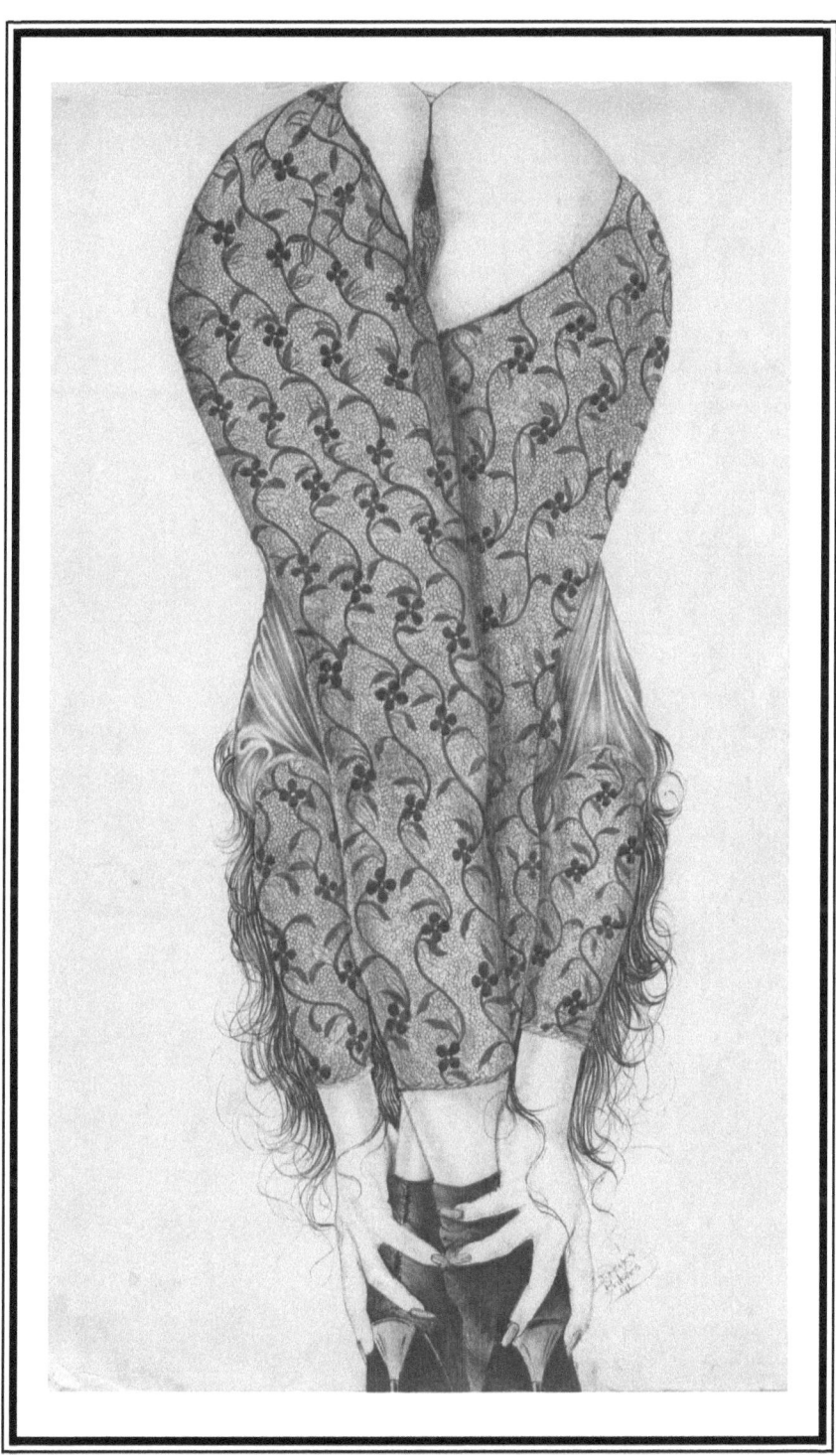

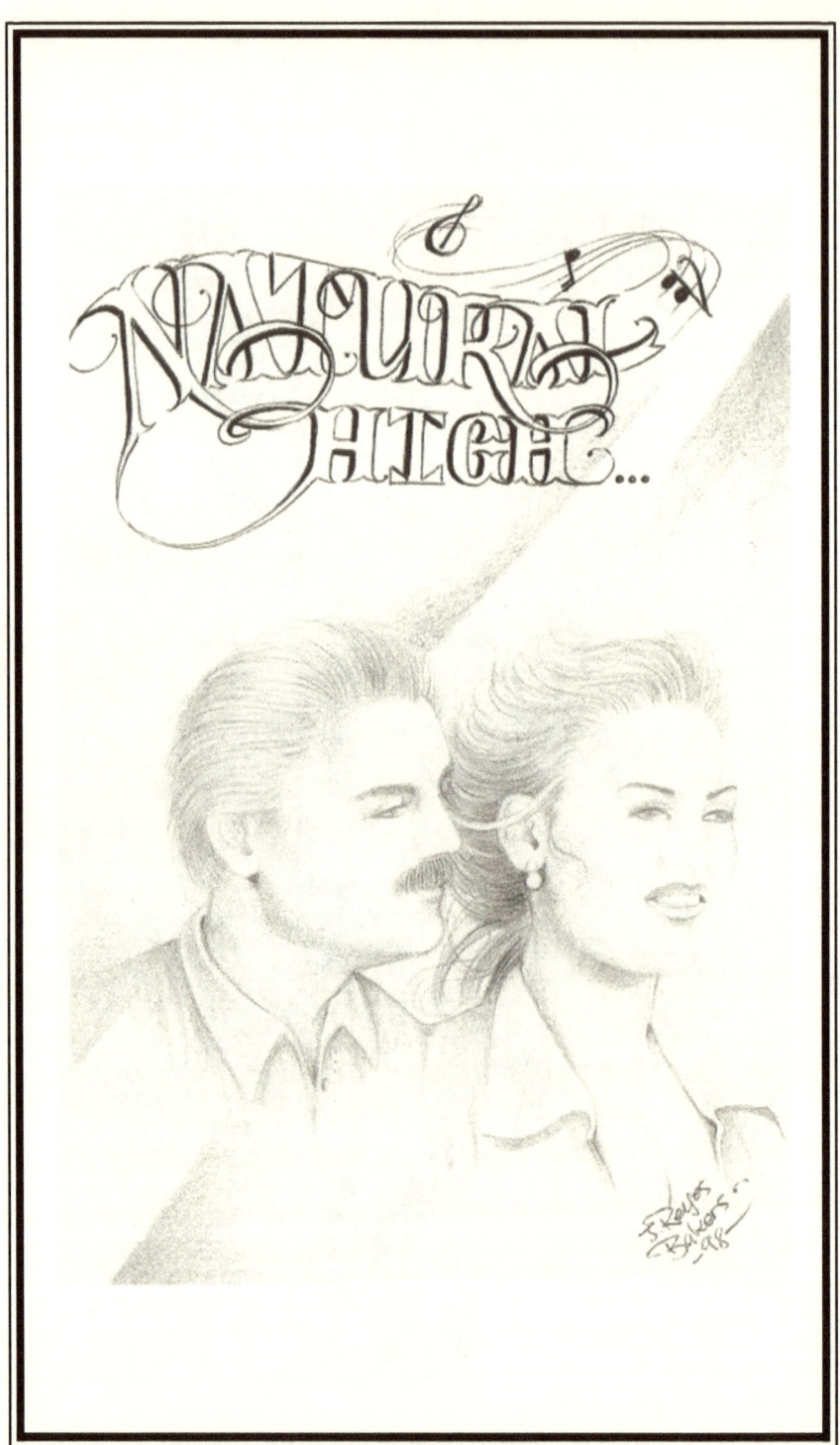

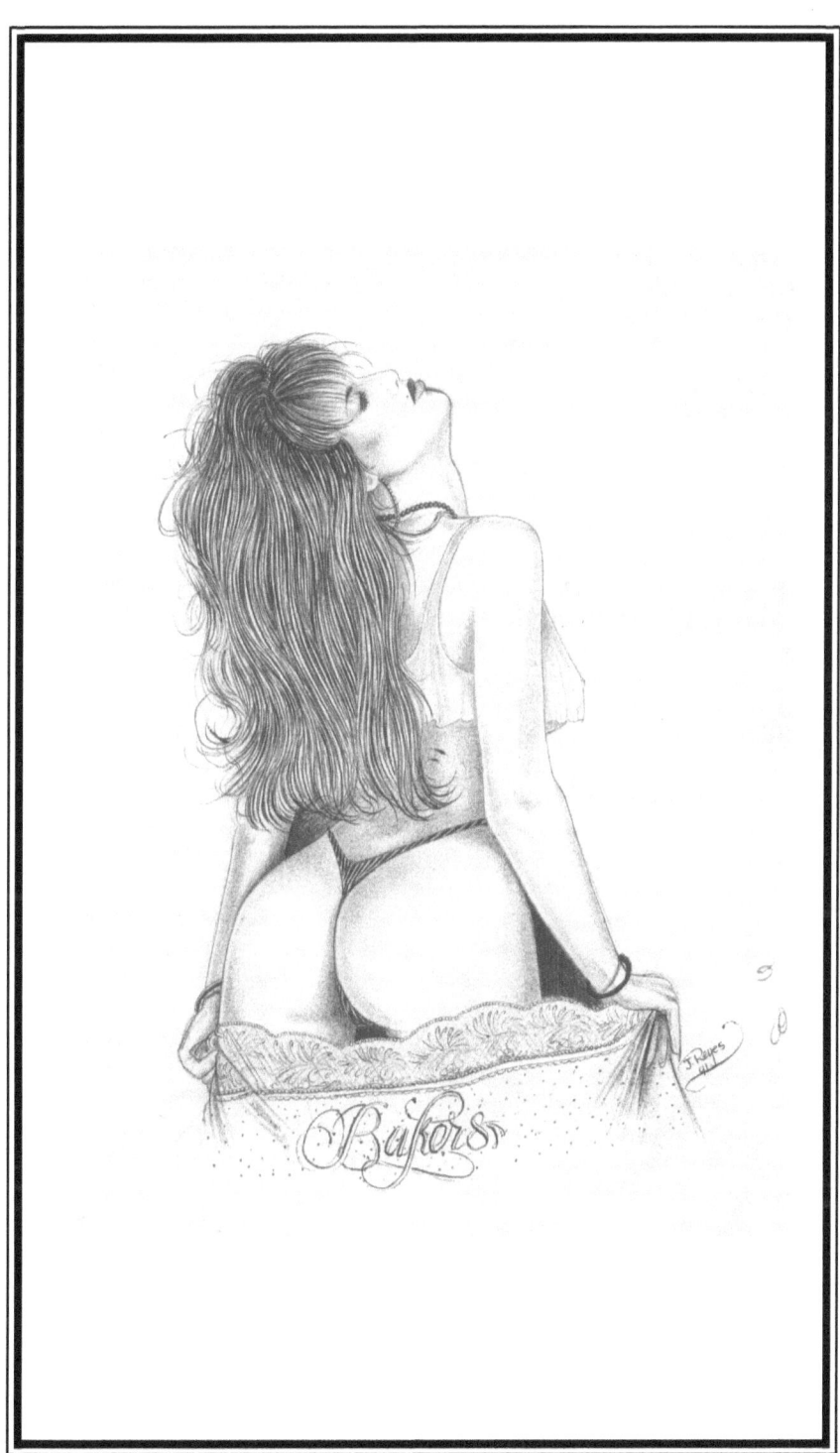

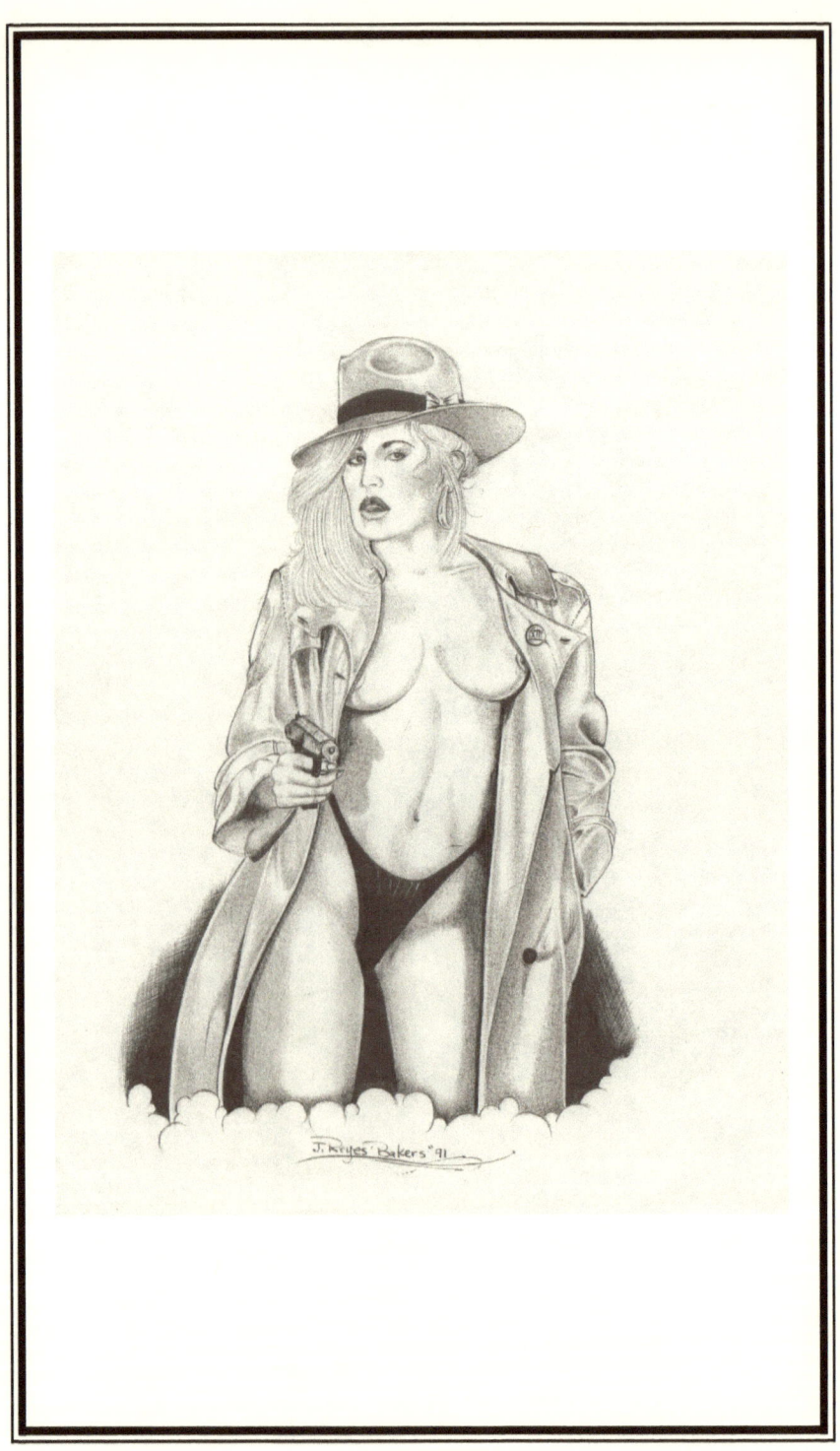

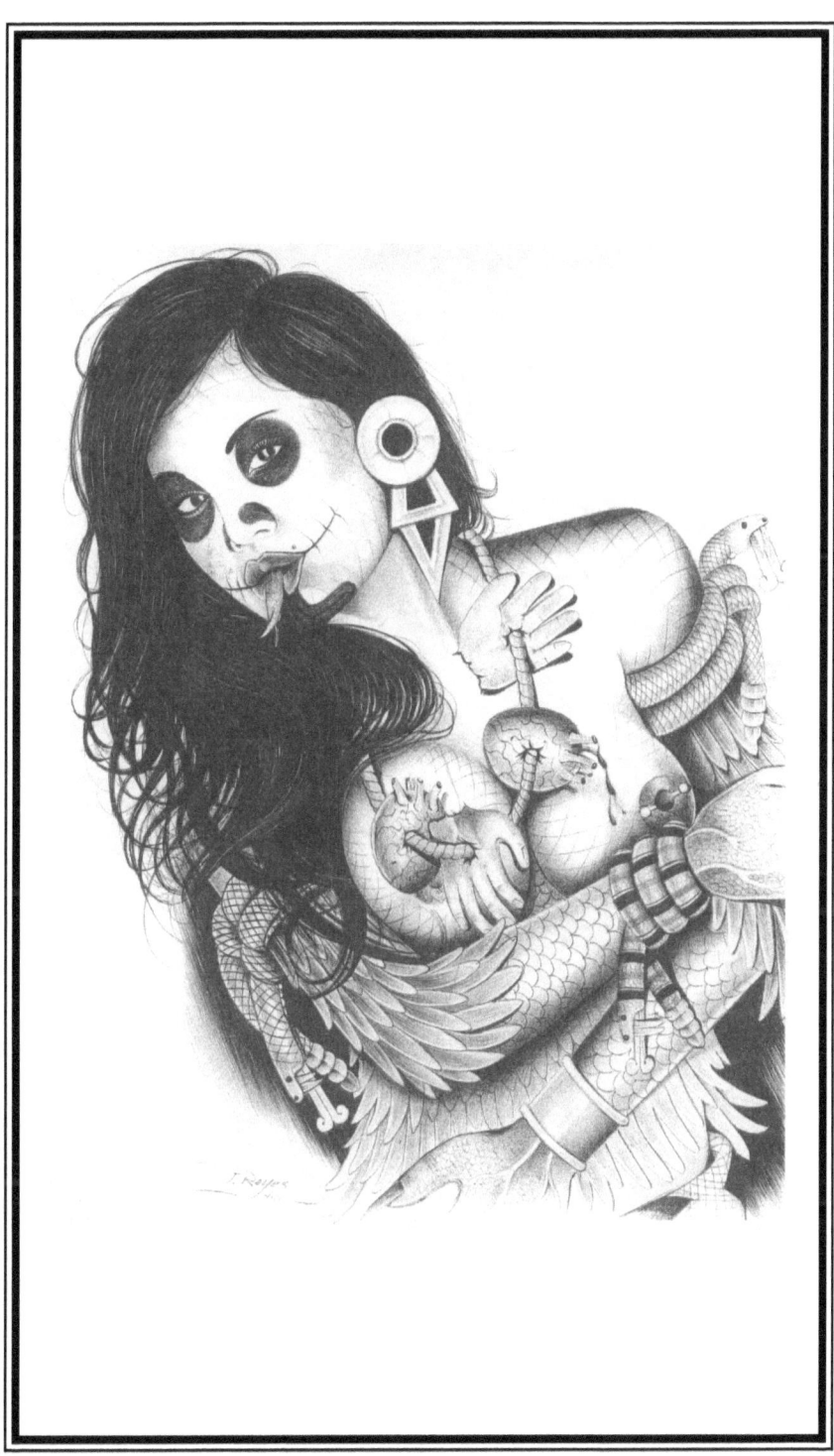

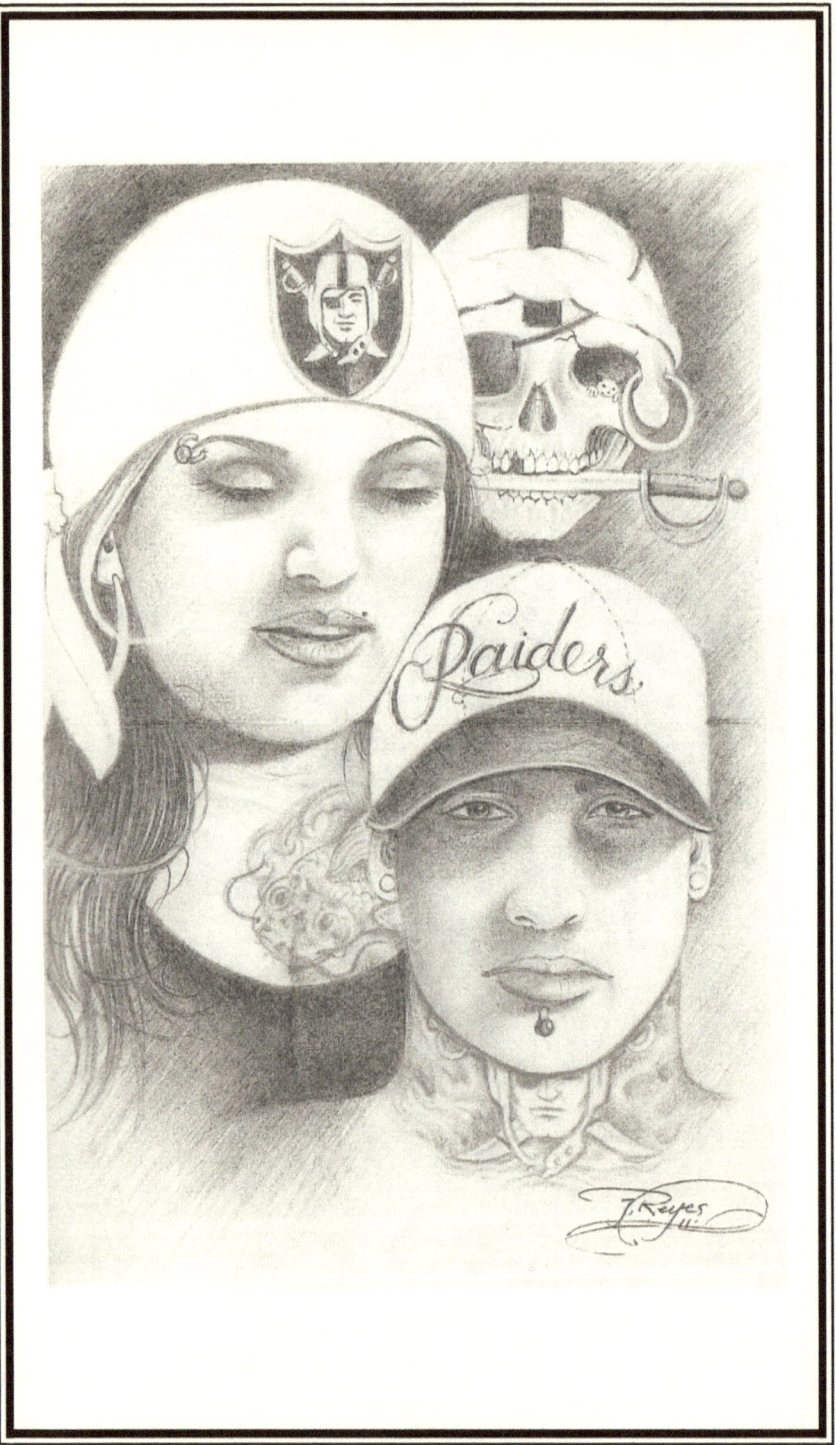

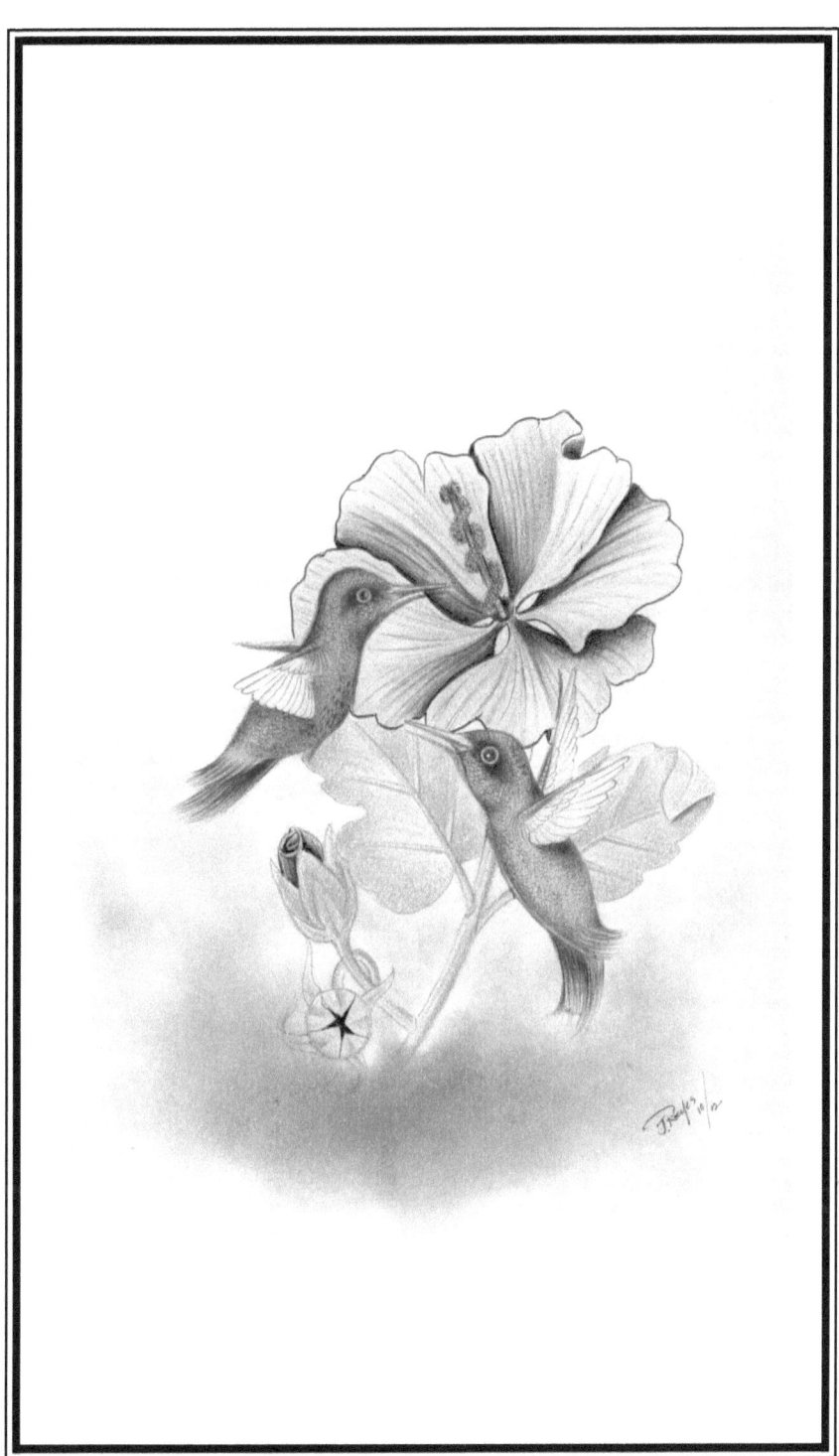

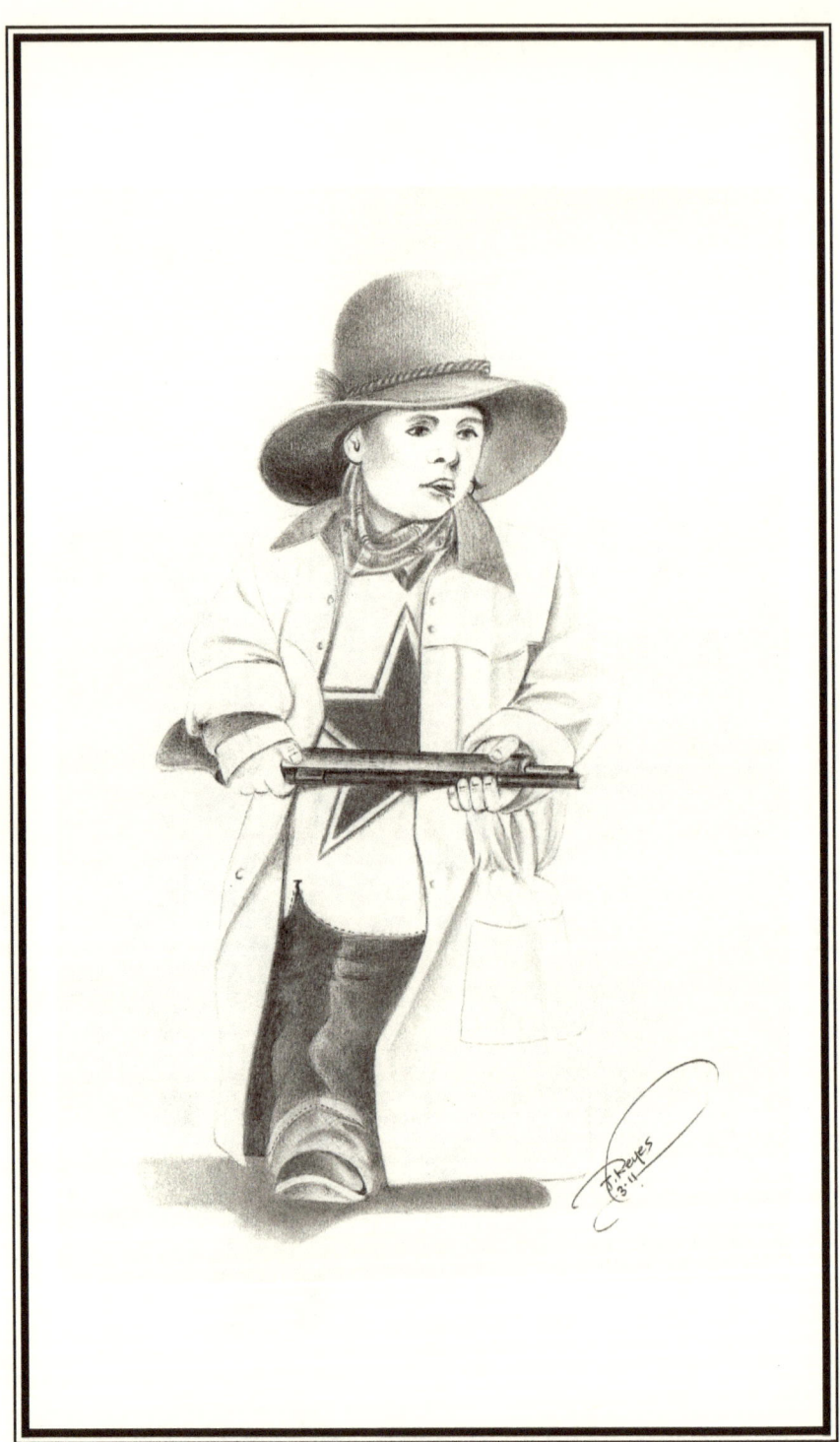

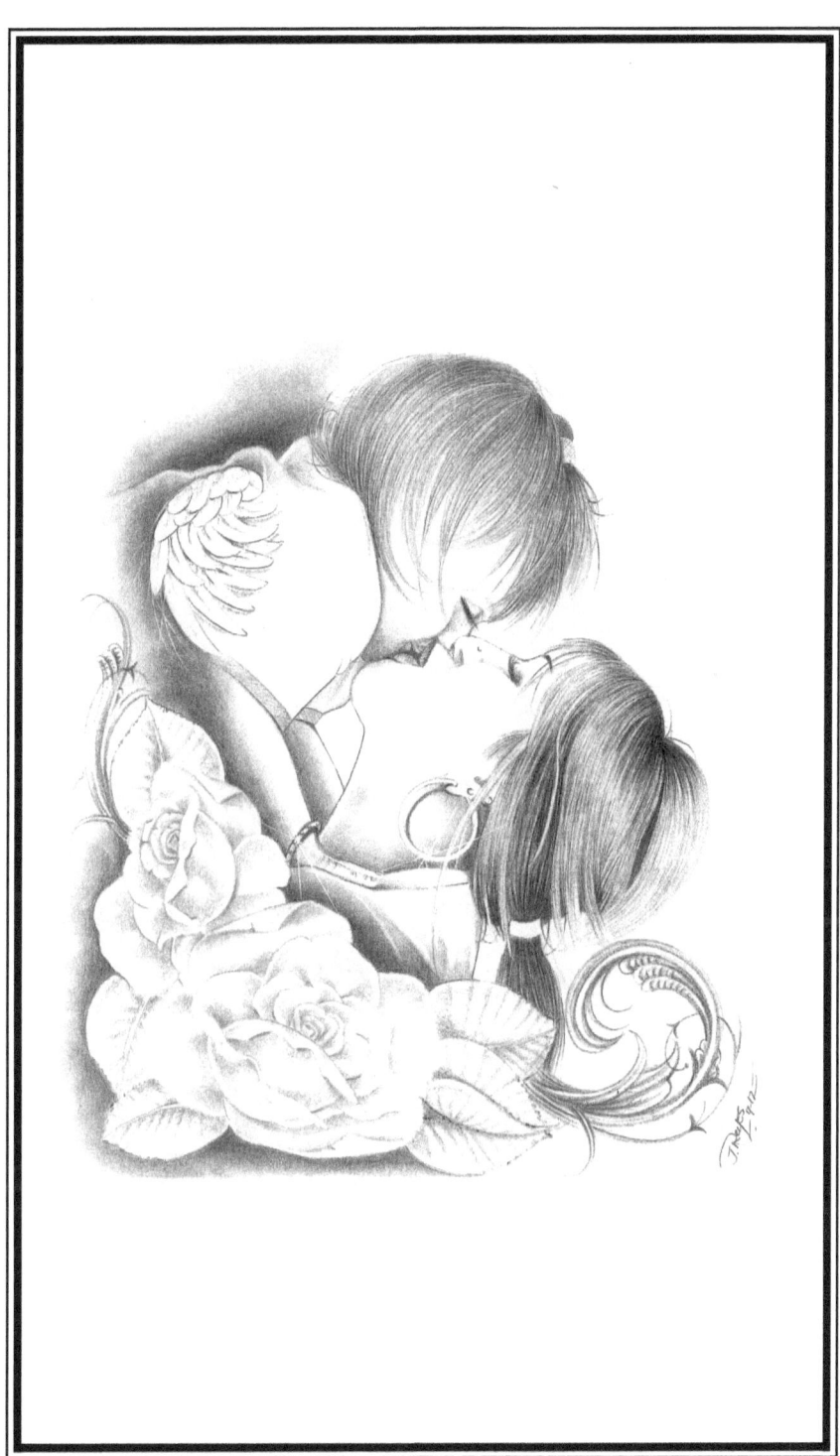

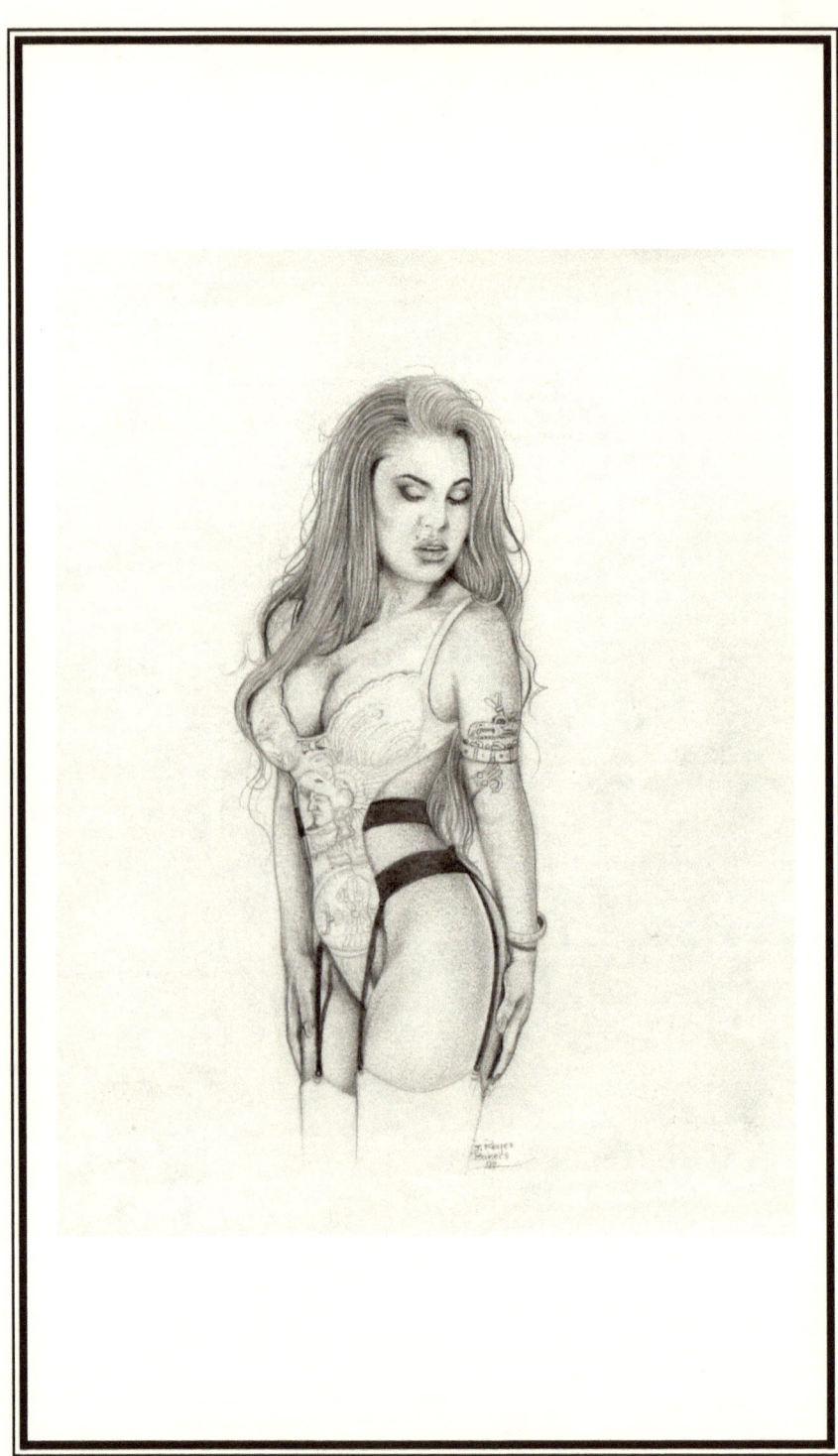

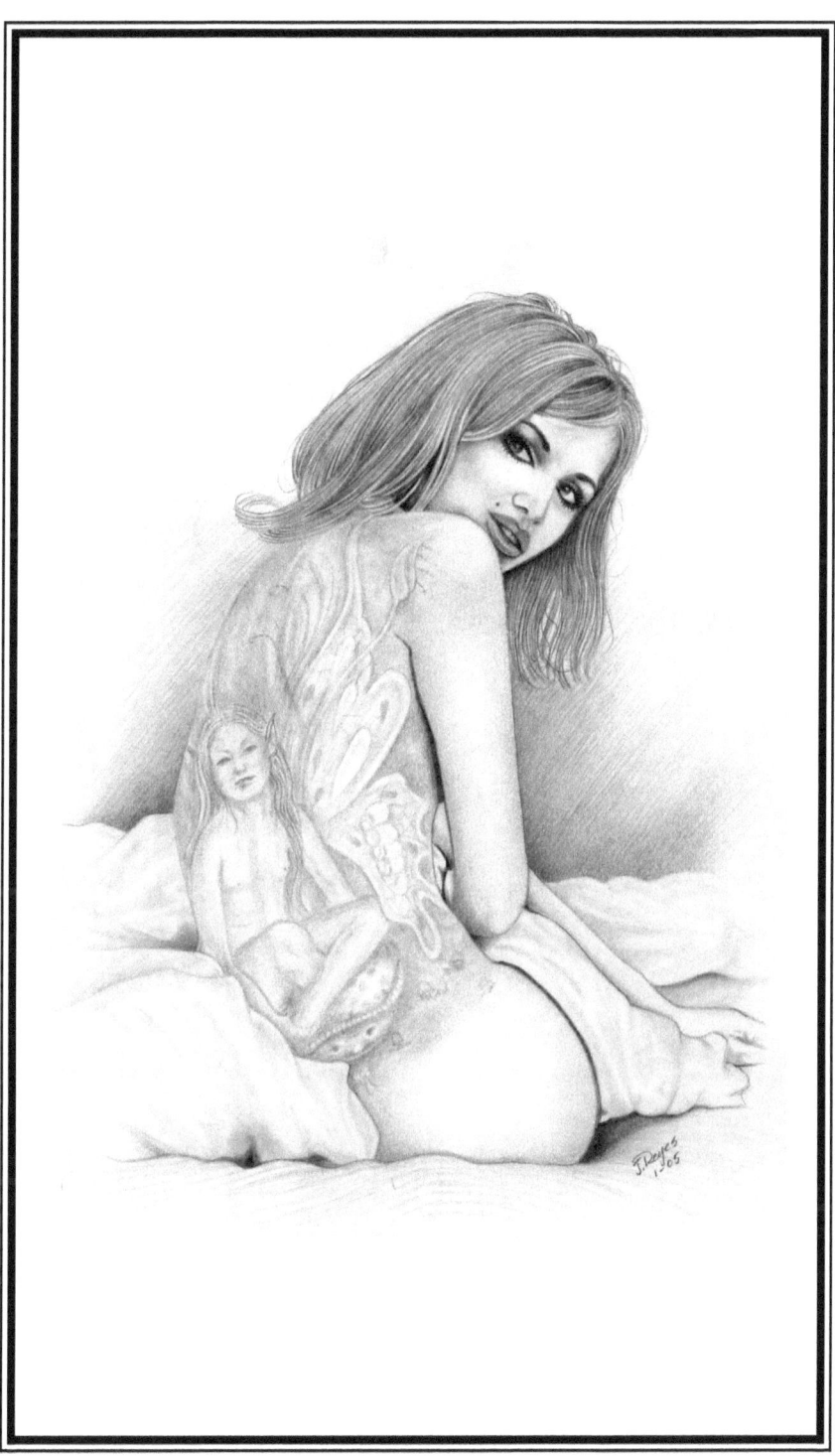

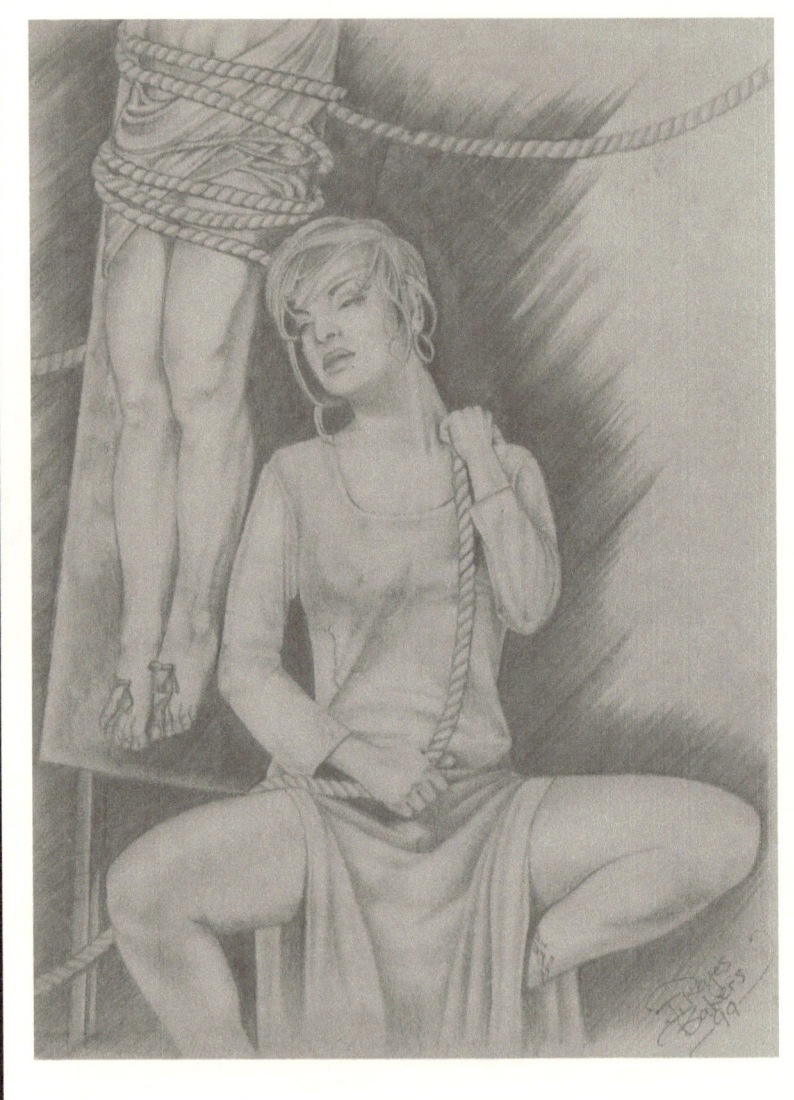

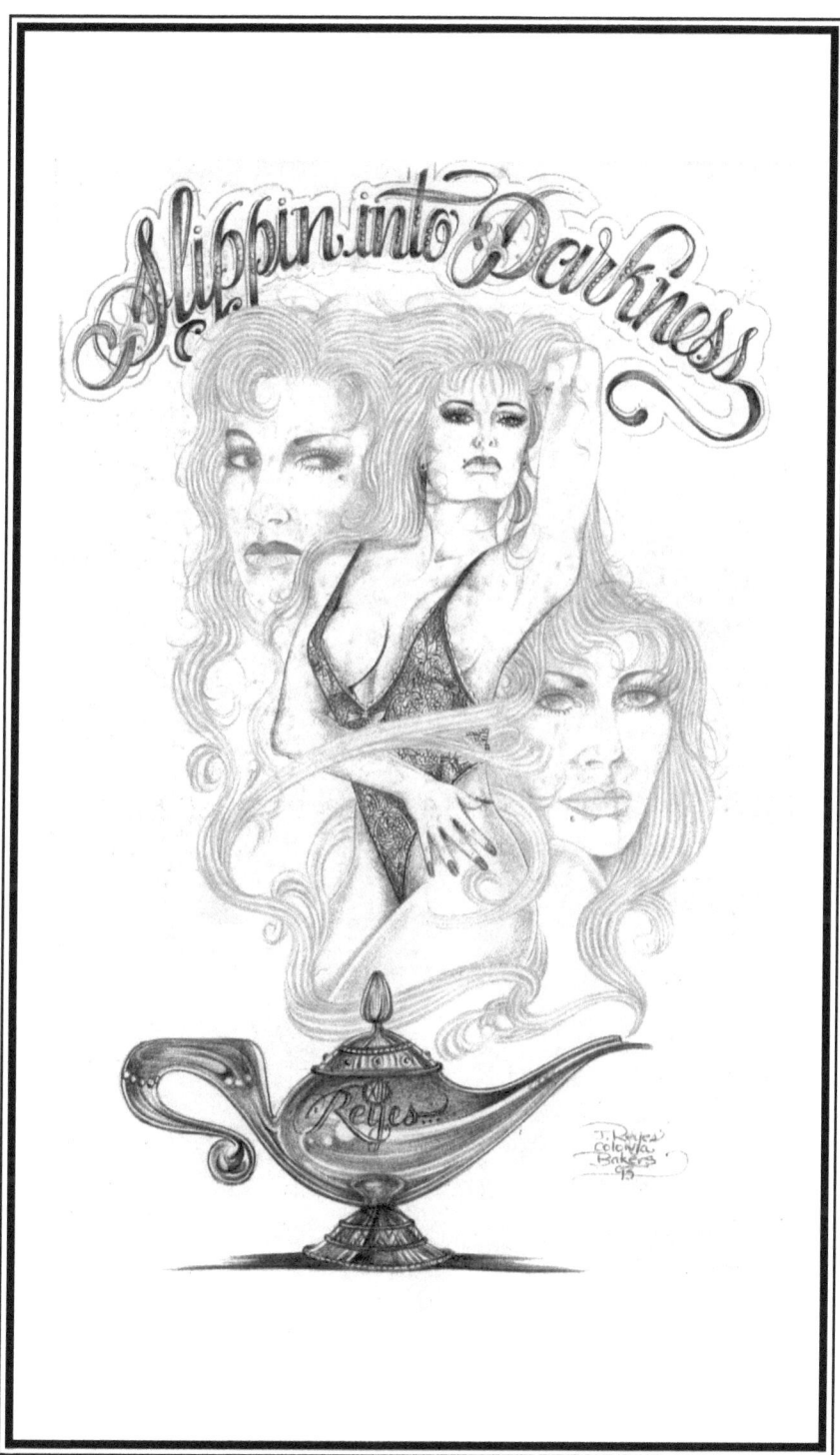

www.ingramcontent.com/pod-product-compliance
Lightning Source LLC
Chambersburg PA
CBHW030907180526
45163CB00004B/1739